MY BOOK OF
FLOWERS

MY BOOK OF

FLOWERS

by Princess Grace of Monaco

WITH GWEN ROBYNS

DOUBLEDAY & COMPANY, INC. GARDEN CITY, NEW YORK

If the honye that the bees gather and of so many floures of herbes, shrubs and trees may juselye be called the bees honye . . . so may I call it that I have learned and gathered of many good autoures (and not without great laboure and payne) my book.

—The Seconde Parte of William Turner's Herball, 1562

Printed in the United States of America
All Rights Reserved

Layout: Kristen Reilly / The Glusker Group, Inc.

The authors and publishers would like to thank the following
for permission to reproduce certain copyrighted poems.

Daisies, by Andrew Young. Reprinted by permission of Martin Secker
and Warburg, Ltd.

Clover, by John Masefield. Reprinted by permission of the Society of Authors
as the literary representatives of the Estate of John Masefield.

Poppies, by Gladys Mitchell. Reprinted by permission of the author.

A portion of "The Last Flower," by James Thurber. Reprinted by permission
of Mrs. James Thurber.

The Everlasting Mercy, by John Masefield. Reprinted by permission of the Society
of Authors as the literary representatives of the Estate of John Masefield.

"A Passing Glimpse," from *The Poetry of Robert Frost,* edited by Edward Connery
Lathem. Copyright 1928, © 1969 by Holt, Rinehart and Winston. Copyright
© 1956 by Robert Frost. Reprinted by permission of Holt, Rinehart and Winston,
Publishers.

CONTENTS

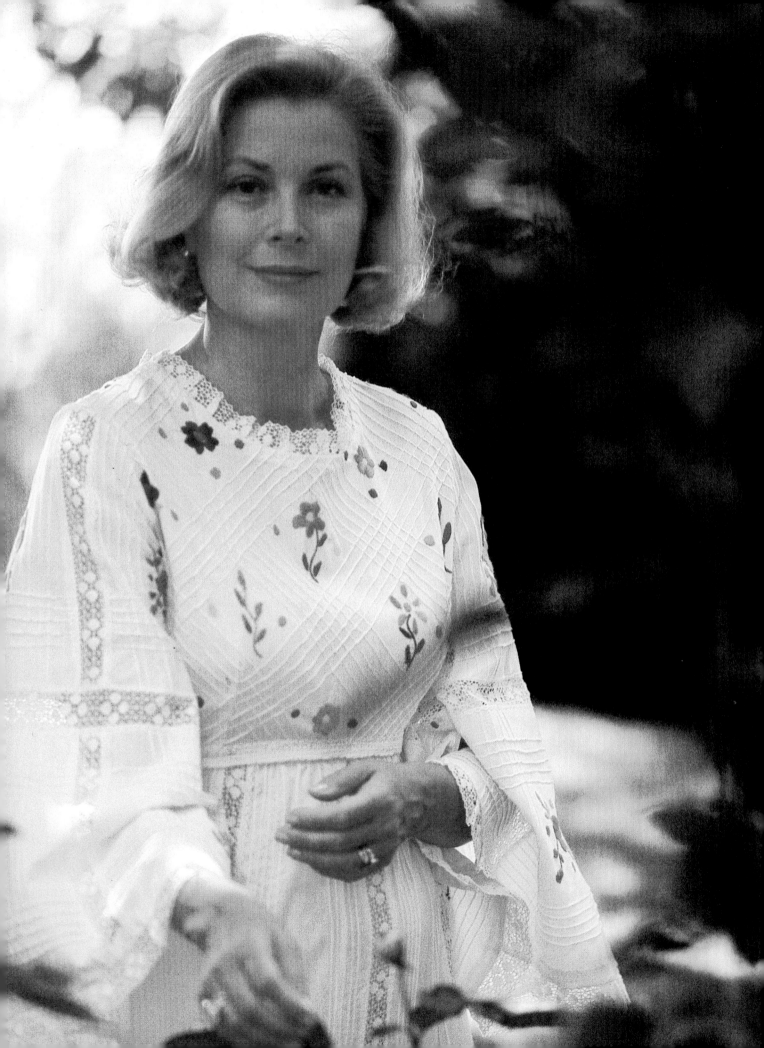

1

Joy and Discovery

Savons-nous ce que serait une humanité qui ne connaitraît pas la fleur? Si celle-ci n'éxistait pas, si elle avait toujours été cachée à nos regards . . . notre caractère, notre morale, notre aptitude à la beauté, au bonheur seraient-ils bien les mêmes?

(Where would we be if humanity had never known flowers? If they didn't exist and had always been hidden from view . . . our character, our morals, our aptitude for beauty, for happiness would they be the same?)

—*Maurice Maeterlinck (1862–1949)*

*T*his is a book about flowers and the enchantment that they bring into your life when they become an active part of it. It is not a book by or for experts, merely one that I hope will bring joy and contentment.

Like many American women, all my life I have been involved in some way with flowers. As a small child, I used to help my sister sell flowers to passers-by to raise money for my mother's pet charity, Women's Medical College and Hospital of Pennsylvania. Naturally most of our customers were the neighbors. Little did they know that some of the flowers came from their own gardens. I used to be sent by my big sister, Peggy, to raid the

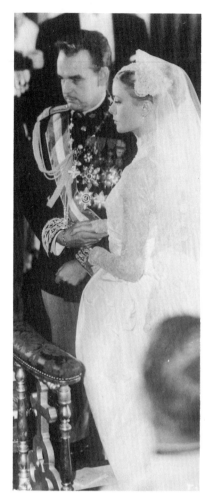

In 1956, Prince Rainier and I were married in the Cathedral of Monaco.

nearby gardens at night, and quite unashamedly we sold these same flowers back to their owners next morning.

We were also encouraged during the World War II years to help grow vegetables in our own backyard. There is a picture in the Kelly family album of us young children all hoeing in the vegetable garden with our father. What the readers of the newspaper in which it appeared did not realize was that when the picture was being taken our mother, who did all the real gardening, was in the house changing her clothes in readiness. By the time she appeared the photographer had all he needed and had left.

We all had our own little corner in the garden. I remember that mine mostly had irises. Why? I wonder. As I grew up, there were those early breathtaking moments when the boy in your life sent a corsage before taking you to the school dance. It usually arrived in the morning and was kept fresh in its transparent container in the refrigerator. I still have several of these corsages pressed flat with age. The corners of the roses are brown and the maidenhair ferns fall to dust at the touch.

Then came my life as an actress, first on the stage in New York and later in films in Hollywood. As an actress, I was spoiled with bouquets of flowers on many occasions. One of my favorite recollections of being pampered was when an admiring young English gentleman took me to lunch at the Ritz in London. To my delight, my place at the table was filled with flowers of every kind imaginable. As I gasped with surprise, he said sweetly, "As I don't know which is your favorite flower, please start throwing over your shoulder the ones you don't like."

Flowers were also an extra you bought hastily on the way back from the theater or studio if some friends were coming in for a buffet supper. The flowers were there, but one was not conscious of them as a vital part of life. They were pretty, they added color to a dreary corner of your small apartment, and they even breathed sweetness into the air, but that was all.

The story of how I met and married Prince Rainier of Monaco has been told many times, of the wedding, in 1956, and moving to the palace on the hill. I was told how magnificent the flowers were at my wedding, but all I remember is that the flower arrangements in the cathedral were filled with Rolleiflexes, Hasselblads, and Nikons with telephoto lenses and flashbulbs.

It was not until my children were growing up that I really found time again to enjoy flowers and come to know those of my new country. For to have complete satisfaction from flowers

you must have time to spend with them. There must be rapport. I talk to them and they talk to me. This philosophy is not new, as it comes from Zen Buddhism. Everyone must adapt it to their own way of thinking.

When Gertrude Stein wrote, around the edge of a plate, "A rose is a rose is a rose is a rose," she was writing about words and experimenting with her intellectual pursuit of the concept of time and the continuous present. She was not writing about roses as such, for no two roses are alike. As with children, their faces change from moment to moment. From sunlight to shadow. What I like to read into her words is the mystery of the rose that gives us a glimpse of infinity.

I remember the story of Clark Gable, who was in Cornwall in the autumn of 1952, making a picture that was directed by the late Delmer Daves. They were on location in a little village. The sets were being changed and the work was taking longer than had been anticipated. Ever conscious of his star's well-being, the assistant director said to Clark Gable, "Why don't you and Delmer take a little drive in the country, and by the time you're back we'll be ready for you?" Once they left the village in the car they were in virgin country. Delmer Daves was a remarkable man. He was fascinated by every aspect of nature—botany, biology, geology—all the natural sciences that explain the wonders of the earth. He always carried a jeweler's magnifying glass to look at specimens that interested him, whether they were rocks, flowers, or insects.

When something went wrong with the car, Delmer was not in the least concerned and suggested that they take a walk. They were in the middle of nowhere when he suddenly said, "Look! Look at that field of anemones over there," and, turning to Gable, asked, "Have you ever looked into the heart of a flower?" Gable, that down-to-earth gentle giant, replied, "You're kidding!" With that, Delmer brought out his little glass and invited Gable to look for himself.

They were standing there deep in concentration when some people drove by and stopped to ask directions. They drove off, but, soon realizing who was standing among the anemones, turned the car back and pulled up again. The man said, "I've been having a discussion with my wife as to why Clark Gable would be in this field in Cornwall. You *are* Clark Gable, aren't you?" Gable leaned all those six feet over and answered, "My good man, have you never looked into the heart of a flower?"

When at last I took the time to look into the heart of a flower, it opened up a whole new world—a world where every country walk would be an adventure, where every garden would become an enchanted one, where one could never again be lonely, bored, or indifferent. It was as if a window had been opened to let in the sun. My eyes were waking up, and for the first time I was

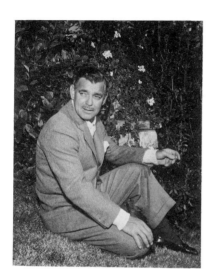

Standing in a field of uncountable wild flowers, Clark Gable asked: "My good man, have you never looked into the heart of a flower?"

seeing the unbelievable beauty of nature—the complex perfection of a wild flower or a blade of quivering grass, the infinite wonder of the smallest moss flower no bigger than a pinhead.

It was in 1959, when I visited the Floralies in Paris, that I realized it was possible to bring the beauty of the outdoors under one roof for all people of a large city to enjoy. It was so extraordinary to see this exposition hall filled with flowers. Not only were there huge banks of flowers of all kinds, but the arrangements, as well as the intoxicating fragrances, overwhelmed me. I remember seeing, for the first time, pale yellow lilacs contrasted with purple-black tulips, and I have never forgotten them.

The scene remained in the back of my head for several years, until in 1966 we started to plan the celebration of the first hundred years of Monte Carlo. At last I found the opportunity to see my idea blossom. As the French writer Colette once said, "Monaco is the country where the frontiers are only flowers."

It seemed so natural to me that, as we live on the Côte d'Azur, where some of the most beautiful flowers in the world are grown for export, we should have our own flower show. And this we did. But as all such events are, when it comes to practicalities, it was very difficult and very expensive to organize. We were fortunate in having a most capable man, Oscar Schneider from Cap d'Antibes, to accomplish this for us.

The flower-arranging competition was a very small part of this first show, which has since come into its own as an international event held each year in May. For this first time, the wife of our Minister of State, Claude Demange, gathered together a group of about twenty ladies. We invited Countess Malvasia, from Bologna, to give us some basic principles. At first we were all nervous and felt incompetent—which of course we were—but this was only in the beginning, for it became the first step toward the awakening of many hidden talents. Through working with flowers we began to discover things about ourselves that had been dormant. We found agility not only with our fingers but with our inner eyes in searching for line, scale, and harmony. In bringing out these talents within ourselves, we gained a dimension that enabled us not only to search for harmony in an arrangement, but also to discover the importance of carrying it into our lives and our homes. To create harmony in the home is the woman's right and duty. The home must be the oasis for the family—husband, children, and others close to us. It should be a place where they can find a sense of well-being and strength, replenishment and renewal.

Whatever the size of the home—a palace, a cottage, or a two-room apartment—the atmosphere is what counts. A home must reflect the personality and needs of the family. A sense of color and balance helps to counteract the tensions brought on by the hectic lives we lead. All our senses are continually affected,

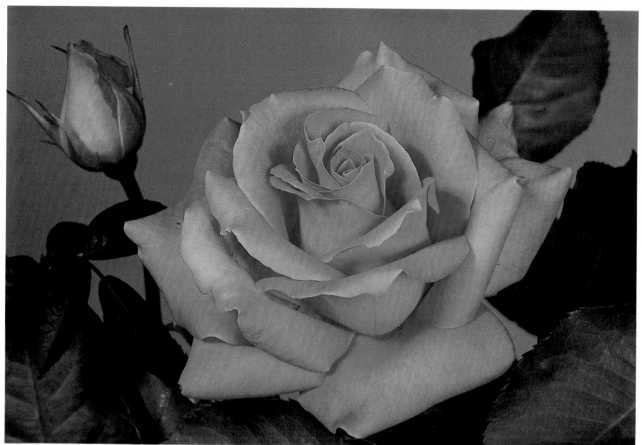

It is a lovely experience for a woman to have a rose named after her. In 1956 the Meilland nurseries at Cap d'Antibes created "Grace de Monaco," a glowing hybrid tea.

either consciously or unconsciously, by our environment. How often one goes into a room and feels nervous and uneasy without knowing why. When you stop and look at the colors and designs, you may well find many of them clashing and jarring. After all, there is more than enough to disturb our equilibrium in the outside world, so it is of great importance to find serenity and calm in one's own milieu. Fortunately city planners have become more conscious of this problem in recent years; they should be encouraged in their consideration of the needs of people who have to spend their lives in cities.

It was with these thoughts that I created the Garden Club of Monaco. Now with this experience behind me, I feel that every city, every town, every village should have a garden club. It is as necessary for the lifeblood of a community as a library, art gallery, museum, and horticultural societies. I feel not only that a garden club should fulfill its duty to the members and their interests, but that its members should help spread this love and respect for nature and contribute something of their knowledge to the community and to the world. For flowers have a language of their own that transcends international barriers. As with music, there is also a timelessness about flowers and a sense of communication. They bring people together in the most enchanting ways, and isn't this what life is all about?

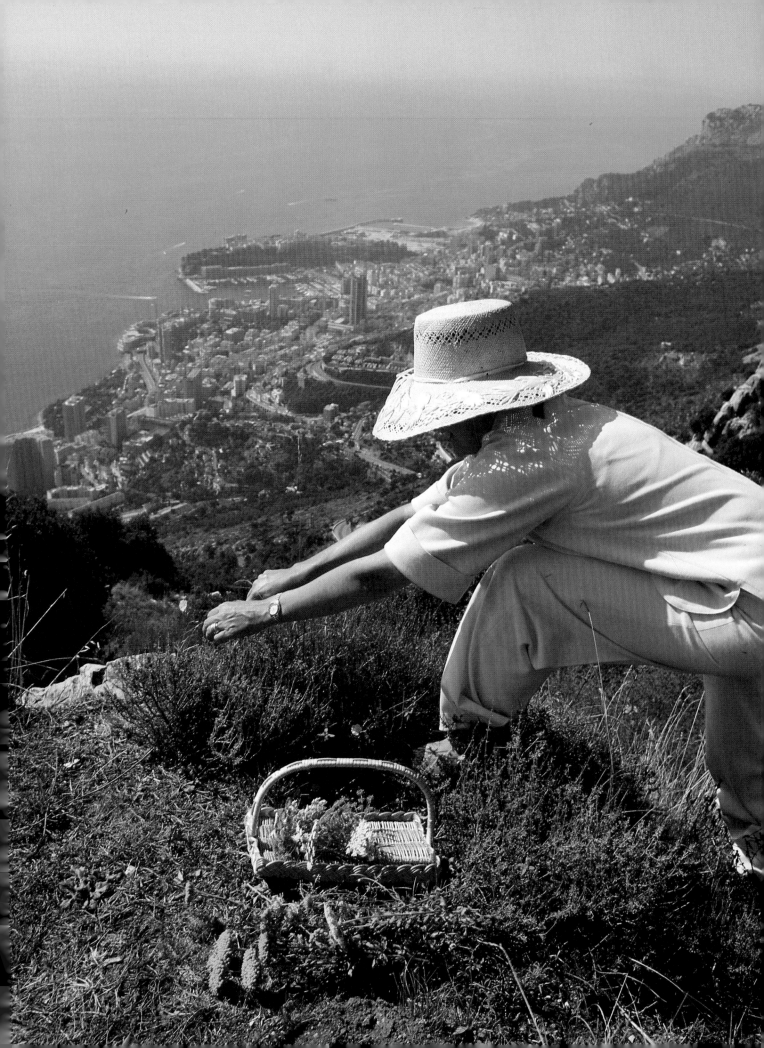

2

Monaco's Garden Club

Sympathy with nature is an evidence of perfect health. You cannot perceive beauty but with a serene mind.

—*Henry David Thoreau (1817–62)*

As the Garden Club of Monaco developed we found many ways to brighten the lives of people around us. We decorated chapels, churches, museums, old people's homes at Christmas time, and we participated in charity bazaars. Even the railroad station in Monte Carlo and the airport at Nice receive a bouquet once a year. We also give courses for adults as well as schoolchildren and have a competition every two years for the youngsters of the principality.

During the spring we often revive the old Riviera tradition of a battle of flowers, which consists of decorated floats usually following a theme and filled with children in costume who throw flowers at the crowds. It becomes a happy melee, everyone throwing wildly.

For our annual flower-arranging competition we have a jury of international experts. One of the first we invited was Julia Clements (Lady Seton) from England. Her criticism and comments on our first show were invaluable to me. In garden club circles

I never go anywhere without taking my little folding scissors in the hope of finding some treasures for pressing.

throughout the world Julia Clements is a legend. It was she who during those dark days after the war opened the eyes of British women to a whole new world of flowers. In 1947 she had just returned to Britain from America, where she had been to thank personally the Garden Clubs of America, which had sent seeds to Britain during the war years.

On her arrival at the Women's Institute, meeting at the Corn Exchange in Maidstone, Kent, she was appalled to see a crowd of women all shuffling into their seats looking "tired, dispirited and almost without hope." The strain of those sleepless war years showed on every face. With the coming of peace there had been no letup in food rationing, and there were no coupons with which to buy new clothes. The contrast to the American women she had met, in their pretty dresses and radiant health, struck her forcefully.

The first guest spoke on "Make Do and Mend," and the second one offered "How to Fill In the Egg Ration Form," which everyone needed in order to claim the one egg per person each week. When it came to Lady Seton's turn (for this is how the women knew her) this blond beauty sprang to her feet and, looking around excitedly, put down her prepared speech. Later she told me, "I began to feel like a lion on a soapbox."

In an impassioned voice she told the women that, instead of longing for things that they could not have, they should look around for something positive . . . something that would bring color and expression into their lives.

"Why—it's flowers" she cried. "Flowers we have in our gardens and countryside in greater abundance than almost any country in the world. Why don't we all become artists with flowers?"

She had brought along a few flowers with her, and then and there she began to make some simple shapes and arrangements, talking nonstop with enthusiasm. After the meeting everyone left their seats and clustered around her, inviting her to speak at their own institute branches.

And so through this one woman's *cri de coeur* began a whole new awakening and experience for thousands of British women. Through the years Julia has become an international teacher and speaker, author and judge of flower arranging. But the message she gave those women—loud and clear—thirty-two years ago is as fresh today as then. The knowledge of flowers and of ways to let them become part of our daily lives can open a new world.

I had heard of Julia Clements through my flower friends, so it was natural that we invite her to Monaco. But let her tell in her own words of those early days in the principality:

When the club had been going for some time I went down to give the members some more tuition: Why don't you expose what you are doing? Why don't you do something that will make people aware of flowers and

Most of us are very familiar with the delicate little yellow puffs of the acacia.

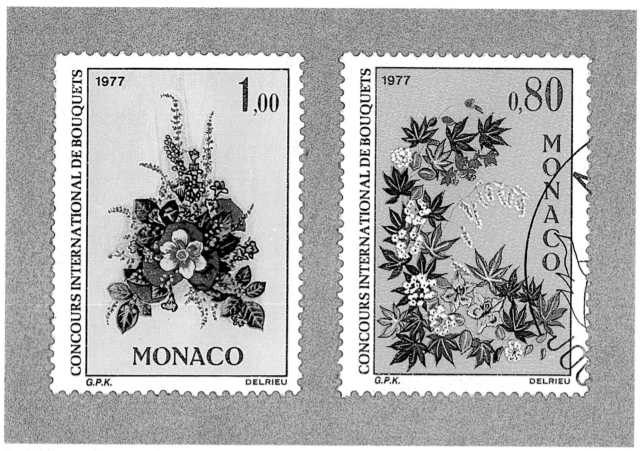

In 1977 two of my pressed flower pictures were used on our postage stamps, the one-franc and the eighty-centime. Flowers are often used as the theme for our stamp issues.

what they can do? Why don't you do it in a church? In England we have many church festivals.

The women were tremendously keen and we chose St. Charles church, the main parish church in Monte Carlo. But first we had to get permission from the priest. Princess Grace told me that she had him to the palace but there was still opposition and there was nothing she could do about it.

I said, "Would you let me try and I'll go and see him." I went up to the church and I had a long chat with him. I told him how much our flower festivals had widened people's minds and encouraged them to come into church. The flowers made them look up and look around. They saw much more than just coming in for Mass and sometimes looking around to see the pretty hats or whatever So and So was wearing. I told him how the festivals had brought thousands and thousands into churches in England, and I felt sure that he would find it beneficial if he would agree to having them in his church.

The priest finally said "yes."

From then on it was a question of getting the twenty or so women involved. I don't like the feeling that I "designed" the flower festival in St. Charles. I just more or less said what they could do, you know—a garland around a statue, a pedestal arrangement here, and why don't you have a wall drop there? It was important not to overpower the statues but surround them rather than cover them.

You had to have a main point of interest. The Virgin Mary was

ours. She was to be encircled with flowers just as she appears in early religious paintings.

I left them with a sketch of the church and of places the flowers should be put and what types of flowers should be used. I even said that they must bring people in from the streets in order not to have the displays all inside, and to have something outside the door.

There is a balustrade going up to St. Charles and I said, "Why don't you garland it—something to make people say 'What's going on inside the church?'?" In that way to entice people into the church even if they are only visitors.

Mr. Giovannini, secretary of the Garden Club, helped by preparing a long slat of wood which we covered with floral foam and wire netting into which the flowers were inserted for the wall drops. Then for the floor-standing groups he made several stands with a cross-section of wood at the base so that they would not topple, but when the ladies saw it they said, "Oh, we couldn't do anything as large as that!" and I said, "Of course you can do anything, so come on, let's have a go."

I showed them how to make it functional. The wooden construction was placed in a bowl on the floor and we went out and bought plastic food containers like the ones you put in the refrigerator. We pinned and screwed them to the center of the wood and filled them with styrofoam to hold the flowers. When it was finished it measured six feet high from the ground.

You see, it is the same principle working at six feet as at one foot. You put your main flowers running down the center, the finer and trailing flowers pointed on the outside. The outside must converge toward the center. If you are doing a pedestal, it is the same thing, but of course it changes slightly if you are going to surround a statue with a garland, because a garland is all uniform.

Julia was not there, regrettably, to see the final decorations and the crowds that poured into the church. It was a fantastic success and St. Charles had never looked more beautiful.

*I*n 1974 another ambitious project was the decoration of the interior of the cathedral for the Silver Jubilee of my husband's reign. It is a very large edifice, and the special problem was that the Garden Club members had only a few hours to do it because of other services taking place there. This is how Rosine Sanmori, who co-ordinated the decoration, remembers that effort:

As soon as the last people left, all the members jumped into the cathedral like bees. We had only six hours to do this huge job. We had been to the Nice market early in the morning and bought our flowers, but much of

While visiting the International Flower Show in Amsterdam several years ago, I was honored by Klaas de Jong of Holland when he named a lily "Lys Princess Grace." It is a lovely, fragrant flower—quite sturdy—and grows easily in our climate of the Côte d'Azur.

the construction work had to be done on the spot.

As lunchtime came, you saw women with a sandwich in one hand and clippers in the other, putting the final touches to a garlanded pedestal or standing back to see that the Virgin Mary was not swamped with flowers.

The most unlikely women were gladly working like Trojans. The statue of the saint in each chapel was given an appropriate decoration.

We finished just in time. During the service I could not see if the Princess was pleased or not, as there was such a crowd. It was only at the end of the day, when there was a big gala at the Hôtel de Paris to which all the officials had been invited, that the Princess came over to me and kissed me and said it was fabulous. I knew then that we had succeeded. Over six thousand flowers were used—roses, gladioli, carnations, petunias, lilies, and so on. On the columns along the nave there were huge bouquets of red and white carnations and gladioli, the national colors of Monaco. Lighter colors were used on the main and side altars.

In January 1978 we decorated the church that is dedicated to St. Dévote, the patron saint of Monaco and Corsica.

St. Dévote was born in A.D. 283 in the town of Mariano, a Roman colony in Corsica. Early in her life she became an orphan and was brought up by her nurse. From a young age she studied the Scriptures, prayed, and submitted her flesh to hard mortification by rigorous fasting. "There is in heaven," she said, "a God who supports me each day and comforts me by His goodness."

Toward the end of the year 302 the Emperor Diocletian began the persecution of Christians throughout the Roman Empire, and they were hunted down without mercy. Then began the process of eradicating the Christians on Corsica. Little Dévote was fearlessly present with Senator Eutychius, with whom she had taken refuge at the beginning of the persecutions. They were immediately arrested, Eutychius was condemned to death, and Dévote was imprisoned. On her refusal to denounce her faith she was tortured. During the hours she was on the rack she prayed incessantly. When she died, a white dove flew out of her mouth.

The priest Bennatus and Deacon Apollonius came to fetch the body of the saint, which they embalmed and placed in a boat belonging to a Christian named Gratianus. This tragic little party set sail from Corsica for Africa, in order to give her a Christian burial. That night a violent tempest arose. In the early morning the exhausted Gratianus went to sleep. Dévote appeared to him. "Arise," she said. "Calm is to follow the tempest. A dove coming out of my mouth will guide you to the shores of Monaco. It is there that you will bury my body."

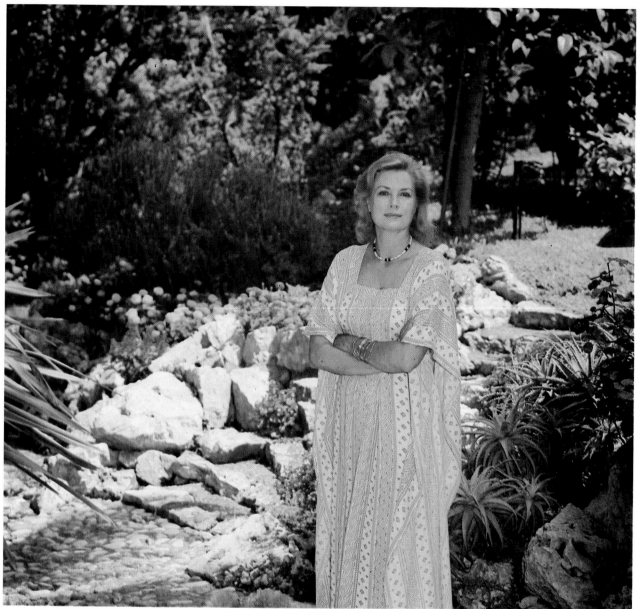

Our palace garden has many moods—perched on top of the famous rock of Monaco. Under the towering and twisting umbrella pines are orange trees planted a hundred fifty years ago, as well as mimosa, camellia, and many varieties of familiar and exotic plants.

And so it was that on January 27 of the year 304 they arrived in Monaco after burning the boat at the shore to eliminate any trace of their landing. They buried St. Dévote in the narrow vale of the Gaumettes, since renamed the Vallon of St. Dévote, and a chapel was built on the spot. Every year since then, ceremonies in her honor are held on January 26 and 27. On the evening of the twenty-sixth the Prince's family takes part in a ceremony. There is a Benediction in the chapel, then outside, by the water's edge, we set fire to a replica of the boat that brought the saint. Under the cold and starry winter sky, a light set on an offshore boat advances slowly toward the coast, and as it reaches land magnificent fireworks burst forth, symbolizing our joy and gratitude.

On the next morning a solemn pontifical Mass is held in

the cathedral. In the afternoon there is a procession that accompanies the martyr's relics from the cathedral back to the little church of St. Dévote. It was to this church that the Prince and I drove after the religious celebration of our wedding in the cathedral. I placed my bouquet of lilies-of-the-valley on the saint's altar.

Because this is a very small church, decorating it for the event had presented certain problems, and I had asked Danielle Saint Mleux of our Garden Club to organize the work. As St. Dévote was martyred when she was still very young, her story inspires a very special and tender understanding. In one of the paintings in the church depicting St. Dévote is a dove carrying a wreath of flowers, and the white bird was delicately reproduced in fresh flowers. The central altar was covered mostly with white blooms, and a halo effect was achieved by palm leaves sprayed with gold. Red roses indicated drops of blood on a white floral background. Modern and traditional styles were contrasted with other displays to dramatize the theme of this young martyr and to honor the other saints in the church.

For a special project, on another occasion, the Garden Club of Monaco decorated the Musée Ile-de-France in St. Jean-Cap Ferrat. The museum, which rests on a marvelous site, was once a house that belonged to Ephrussi de Rothschild.

*G*eorge Smith, who has had much experience decorating some of the great houses of England, is another frequent visitor to Monaco. He has given us many helpful suggestions. He not only has a lovely garden at The Manor House, Heslington, Yorkshire, but he is well known in the flower world for his lively lectures and his great talent as a flower arranger. I have asked him to write about his early association with our club:

My first meeting with Princess Grace was in 1966, when I was invited to give lessons to the Garden Club of Monaco. I was met at the airport by the club's treasurer, who asked me, "How is your French?" I had to say that it was limited. "To what?" she asked. I was forced to admit "A touch of je ne sais quoi *and* où est la plume de ma tante? *"You won't get far with that," she replied, and at once volunteered to be my interpreter.*

The first class was on a wet Monday morning, and I was feeling in a state of near paralysis and woefully unprepared when informed that Her Serene Highness would attend. At last I was to be face to face with my idol and my knees turned to jelly! On arrival she took the wind completely out of my sails by shaking hands and saying, "I've been so looking forward

English flower arrangers have a talent for combining form and color because their gardens are so rich in variety. George Smith has used lilac, roses, and even bleeding heart among the many flowers in this classical arrangement.

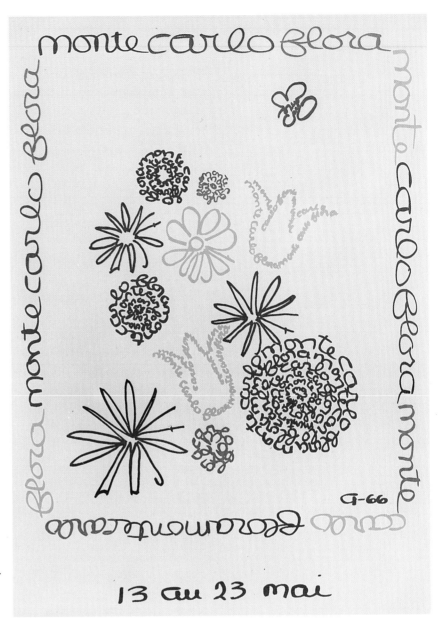

I drew this poster for the first flower show we had in Monte Carlo in 1966. The calligraphy spells out Monte Carlo Flora. Later this design was adapted for use as a scarf that is now sold in aid of our Foundation.

to meeting you." This was exactly what I was thinking but would never have dared to say to her.

The demonstration part of my class began, but my volunteer interpreter was soon out of her depth and reduced to such exclamations as "Oh là là" and "Oh mon Dieu," whereupon a gentle American voice could be heard repeating in fluent French the salient points of my discourse. My confidence returned and she had won my heart by her kindness. With true theatrical professionalism she could not bear to see me stuck. For one deliciously wicked moment I thought, If only my friends could see me now—a double act with Grace Kelly.

While I was showing slides of my garden and flower arrangements, the projector jammed. The secretary, Mr. Giovannini, was sent for. In the meantime the Princess grappled with the mechanism. I hovered and murmured, "I am so sorry," to which she replied, "I'm sick," which made

me realize her sense of involvement in everything she tackles.

Any international gathering is subject to problems, and flower judges are no exception. On one occasion the Japanese judge and a charming, if somewhat indecisive, frail Italian judge had reached a state of total deadlock. Judges rarely agree, and these two were barely speaking. As I worked at my own section, the Princess approached and, gently leading me by the forearm, murmured, "Mr. Smith, the Japanese and Italian judges are fighting. Do you think you could intervene?" "But I don't speak either Japanese or Italian," I replied. "Exactly," she said, with a winning smile that spoke volumes.

Our show in May is similar to many other ones held throughout the world, with the possible exception that we were the first to reserve a category for gentlemen only. This came about because of my husband's teasing me that I was overlooking male talent in this field. I decided to call his bluff and created a category limited to men.

Then the problem was to get my chosen victims to enlist voluntarily. I decided to have a dinner party and invited my most likely prospects for future flower arranging. I filled them with good food and wine, and while they were enjoying coffee and brandy in front of an open fire I had the dinner things whisked away. In their place were put vases, bowls of different shapes, buckets full of flowers, cutters, pin holders, and other paraphernalia for making the most intricate arrangements.

Before the men knew what hit them, they had been gently bulldozed back into the dining room and were balancing brandy and cigars in one hand with flower shears in the other. After the first dead silence they got my message and began timidly, quite obviously trying to be polite to their hostess. When the first flowers were placed in the containers, the wives offered unsolicited advice. This was immediately rejected, in some cases loudly and categorically! At this point I heaved a silent sigh of delight and retreated to the back of the room, where I could observe with satisfaction the beautiful scene, through clouds of cigar smoke, of men going about their work, no one copying another. Each was intent on creating his own thing. They were hooked.

Since this unusual beginning the men's class has become the one most anticipated by the public and has the biggest success of the show. My husband had not been spared either, and he has taken his revenge on me by not only entering every year but by winning several prizes. The men's class is usually based on a theme that is different every year. Once we had signs of

the zodiac, and another year we gave them a choice between a vice or a virtue. On the morning of the event it is fun to see them arriving at the hall quite unself-consciously with their baskets of flowers and tools, eager to get started.

We often include miniature arrangements in our annual show. They are some of the most interesting to judge, and are a tremendous favorite with the public. I like to see them when they are presented, like jewels in individual niches.

The smallest arrangement I have ever seen was made by Lelia Grether of Monaco. She had taken the tiniest speck of florist's sponge, wrapped it in linen, and then threaded that through the eye of a needle. Into this she placed her tiny flowers. The needle was then put into a small hoop of embroidery where the same flowers as those in the needle head had been worked. It was enchanting.

The miniature flower arranger does not have to spend money. A walk in the garden, along a grassy verge, in a field, or in the nearest park, will produce broken twigs, little known berries, moss, and interesting little stones. Your treasures will be so small and fragile that you can carry them home in your handkerchief. Look critically at each flower or twig, snipping away to give it the most appealing shape. It is amazing how they respond to a little attention.

Whether you are composing a conventional arrangement or trying your hand at a modern or Japanese design, the same principles that apply to life-size arrangements also work with miniatures. No matter how tiny your flowers and sprigs, they need height, width, and depth, and a steady hand with a great deal of patience.

The experts advise that you need a small pair of sharp-pointed scissors, a pair of tweezers, some sand or garden soil or, even better, oasis, the synthetic sponge that you buy from a florist, and, of course, the containers. The perfectionist also keeps handy an eyedropper for watering and an atomizer. I make do with single drops from the water tap and with the end of my fingernail or a toothpick for coaxing the flowers into place.

Collecting containers for miniatures can be fun. There is no need to have a large storage place; just a corner of a drawer in your desk or a cupboard is sufficient. The selection can be endless, and it can be added to through the years.

The trays of oddments that you find in junk shops or at the "white elephant" stalls of charity fêtes are fruitful sources of containers that cost next to nothing. Whenever we go to the beach on our travels, I always keep my eye open for shells, making sure that they are not only watertight but stand without wobbling or spilling over. If you find one that you cannot resist and it leaks, line it with kitchen foil before filling it with oasis.

Everything miniature has a special fascination about it, and with flowers collecting and creating become a real challenge.

This miniature cherub contains white jasmine. Julia Clements, whose hand you see, arranged this for me.

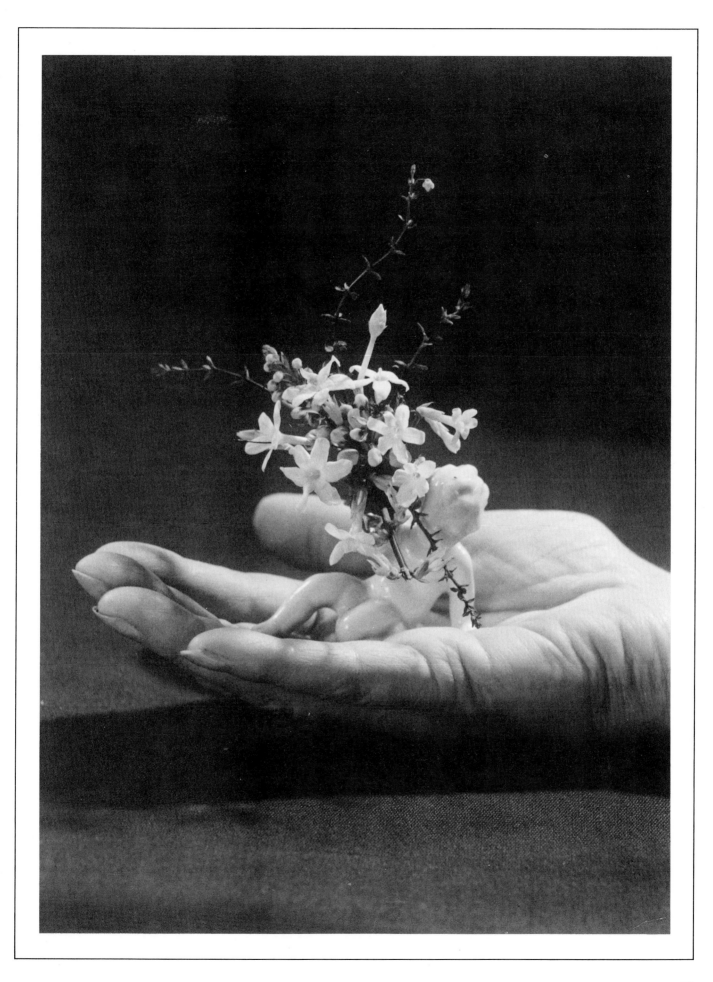

Some Gardens I Love

E chü à ditu ch'i arburi, ë ciante
Nun avu d'arima? ün verità
N'ò vistu ride tante, tante, tante
N'ò vistu finta d'autre se ciurà . . .

Who dares to say that trees and plants have no soul?
The truth is that I have seen many laugh and many cry.

—Louis Notari (Monégasque poet), 1879–1961

Monsieur Raymond Poteau shows me around his exquisite small garden in Roquebrune. Here he has retained the privacy and peace of a cloister by the use of miniature box hedges and walls tumbling with green creepers.

Have you ever looked into the heart of a cactus? It is a strange world of exquisite and precise geometrical shapes and arachnoid texture; of formations and combinations of color that belong to parts of our earth that are almost inaccessible to humans. It is the kind of perfection that cactus lovers cannot resist and are willing to travel to the highest mountains and hottest deserts just to gaze upon one single species for only a few minutes of time.

I've grown to appreciate cactus plants and flowers because the more you learn about them the more captivating they become. Through studying them I now understand the fascination that a botanist experiences by using a microscope. Cacti remind one

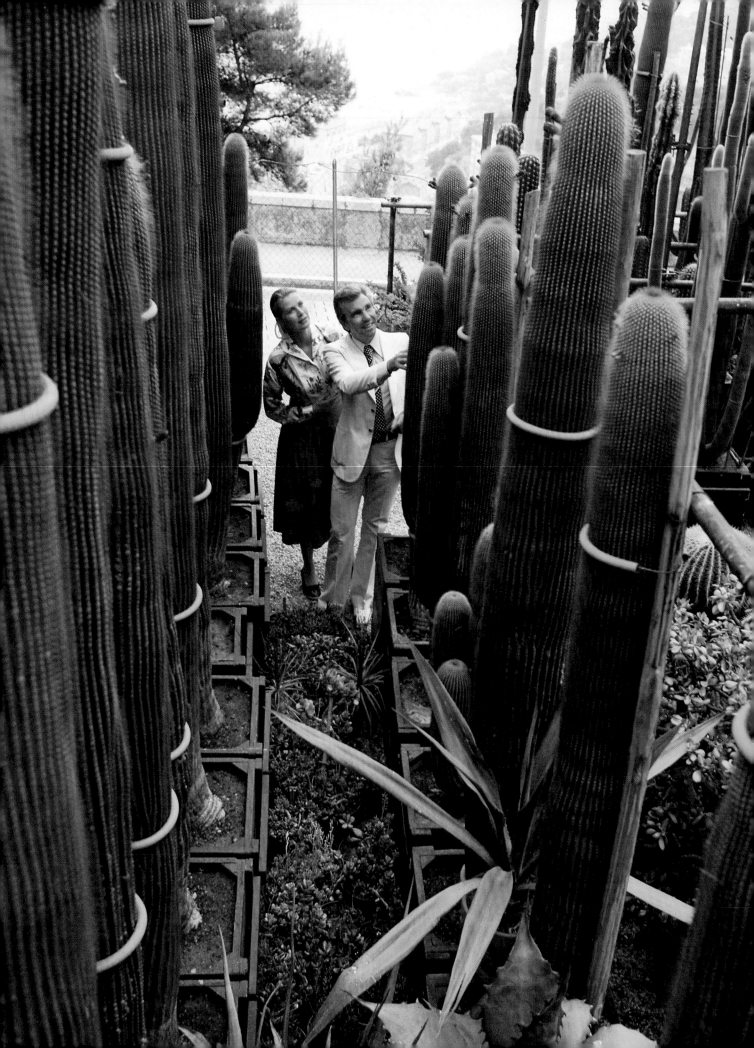

of other worlds and of substances that we still do not understand in the complexity of this universe.

It was toward the end of the last century that my husband's great-grandfather, Prince Albert I, began the collection that we now have in Monaco and that came from all over the world. A man of immense ability and natural curiosity, he was also the founder of our famous Oceanographic Museum. Though work on the Jardin Exotique was begun in 1913, it continued until 1933, when it was inaugurated by his son, Prince Louis II.

It was while Prince Albert was inspecting construction of the museum that he noticed the succulent plants that the head gardener had been cultivating there for many years. He became interested not only in developing these and adding to the collection, but in finding the right background where every plant would be as satisfied as if it were in its original setting.

Originally the garden was planted on the Rocher de Monaco, the old town of Monaco-Ville, near the setting of the future museum. But in the following year Prince Albert became so enthusiastic about the project that, wanting to share his interest with the general public, he decided that he needed more space. He wanted his garden to be of such originality that cacti lovers from all parts of the world would come to Monaco and enjoy it. A site was chosen to the west of the town on the middle Corniche Road, facing due south. It is sometimes called "the hanging garden," as it appears to cling to the cliffs with little means of support. Prickly pear already grew on the site, proof that the climate would be sympathetic to succulents from deserts as well as from mountains as far away as the Andes.

As the slope of the garden is at a forty-five-degree angle, the winter sun is approximately perpendicular, while in the summer some of its rays are deflected sufficiently to prevent excessive heat. As the site is also protected from the northern and western winds, the temperature in the day is extremely hot and the rocks act as natural heat conductors.

These rocks carry the day's heat far into the cool nights, but during the day in the summer the heat is so great that you cannot touch them without burning your hands. Though the site is exposed to all the heavy rains during the autumn until the end of November, it also has natural drainage that prevents the roots of the plants from rotting if too much water remains in the ground.

This, then, was the ideal spot, a natural windowsill waiting to be planted. The gigantic building program—for this is what it turned out to be—was begun in 1913 under the supervision of Louis Notari, with Prince Albert overseeing every step of construction. Whenever possible, beds level with the ground were formed and paths were cut into the rock, but in some cases were built up to allow visitors to examine the plants at close quarters.

Monsieur Kroenlein and I are walking along the allée des cierges *(alley of candles) one of the favorite tourist attractions in the Jardin Exotique in Monaco. Though their form is stark and primitive in season, they have tiny flowers that bloom for one night only.*

The building went on and on. Though the area of the garden is not large, the paths twist and turn for several kilometers. Bridges have also been built over clefts in the rock face. The remarkable thing about this garden, which is now considered one of the botanical wonders of the world, is that it consists only of succulent plants such as cacti and euphorbias. Succulents are greedy feeders, so their root systems go deep in their search for nourishment, far extending the original pockets in which they are planted.

The gardeners found, when they were doing some of the original planting, that half a sheep buried near the bottom of a pocket gave excellent nourishment. All over the rock face, pockets of soil were created for hanging succulents, while others were to climb up and attach themselves with their natural claws. Some of the euphorbias later grew into branched trees, some came to look like tropical palms, and still others now form impenetrable barriers.

It is a garden of strange shapes and sizes and of contrasting light and shade. Against the skyline fine examples of columnar cerei contrast with hard-leaved rosettes of agaves in the foreground. At the face of a cliff offering a panoramic view of Monaco are shrubby euphorbias with small aloes nestling at their feet.

The oldest cactus in the garden is now eighty years of age. Monsieur Marcel Kroenlein, the director, is still adding to the collection, and he makes regular trips to South and North America and Africa to find new species. It is heartbreaking for him to bring back a plant from a remote place, say, in the Andes, only to discover sometime later that a thoughtless visitor has chosen to carve his or her initials on the trunk. Twenty years ago there were fifty thousand cacti in the garden, and now there are more than a hundred thousand.

Many varieties flower during the night, the beautiful creamy heads opening at dusk and closing at dawn, never to open again. Late in the dark silence, when other flowers are sleeping, the torch thistle, with its dry, bare stem, unfolds its gorgeous vanilla-scented leaves. With this plant, as with others, nature is so organized that even during these short hours of the night there is time for pollination to take place.

Some of the most remarkable plants in this garden are the towering, candelabrum-shaped euphorbias, both the fleshy and arborescent types that look like living stalagmites and grow over thirty feet high. They come from South Africa, and their voluptuous green leaves are a spectacular sight among the gray rocks.

Like all visitors to the Jardin Exotique—Exotic Garden—I like to walk along the *allées des cierges* (alleys of candles) and pass under a vault formed by the entanglement of tree-like cacti. Though their flowers last for only one night, they form fruits that arrive during the summer and last for several months.

There are over three hundred twenty species of the genus

The heart of a cactus is a strange world of exquisite and precise geometrical shapes. I can understand the fascination they give collectors, for each species has its own character. In the Jardin Exotique in Monaco, created at the beginning of the century, we have 100,000 cacti, many of which have been brought here from remote places in the world.

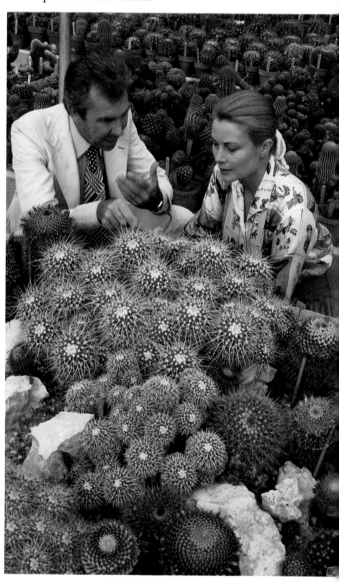

Monsieur Marcel Kroenlein, director of the Jardin Exotique, is a world authority on cacti and is enthralling to listen to when he explains their habits and origins.

We taste the exotic red fruit of the cactus Mammillaria centricirrha. Its taste is sweet and it is faintly scented.

31

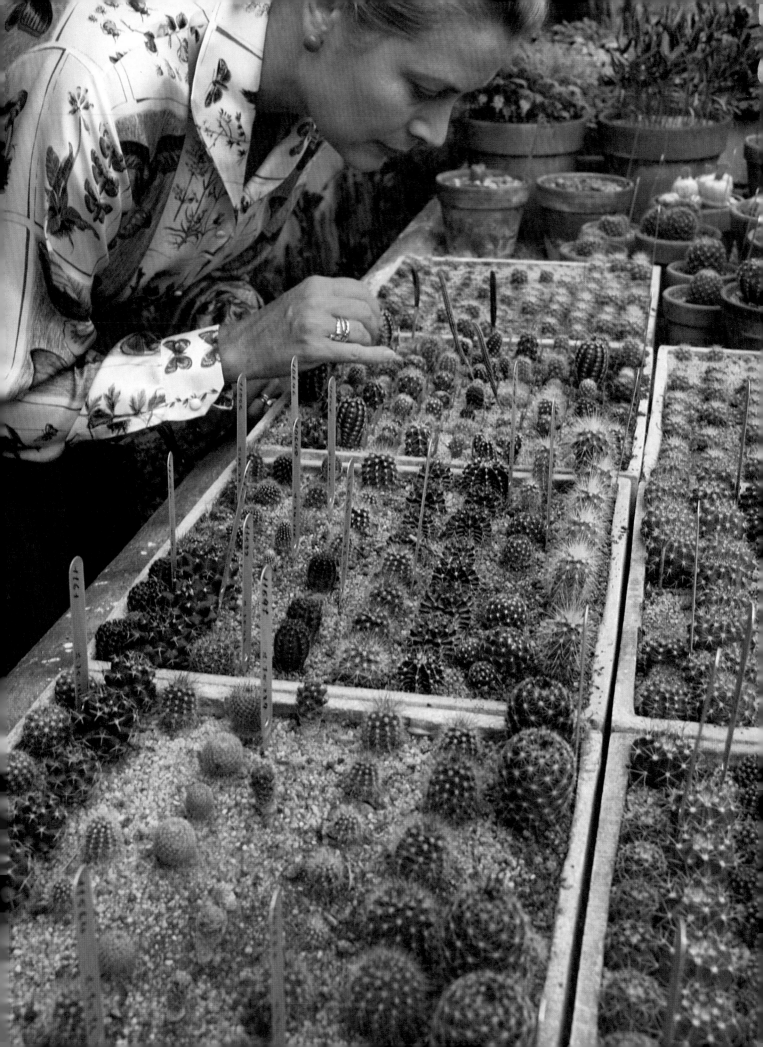

Opuntia, or prickly pear, coming from as far away as Canada and Patagonia. These strange plants have leaves shaped like large fleshy oval plates, and their exquisite silky flowers and fruit cling to the edges. The garden has hundreds, perhaps even thousands, of globular cacti commonly called *coussin de belle-mère* (mother-in-law's cushion).

The garden has color all year round, from the aloes, with their dazzling bunches of yellow flowers, to the giant cushions of African mesembryanthemum, which in spring look like giant pompons against the rocks. Their well-known generic name, *Mesembryanthemum,* means "midday flower," as it opens only in bright sunlight.

Across the road from the main garden is the nursery of the Jardin Exotique, where Marcel Kroenlein and the gardeners spend hours grafting cactus plants. I like to watch the hands of these plant surgeons—swift, sure, experienced. Collecting the seeds of the cactus is very difficult. Some of the baby cacti have taken ten years to grow just a few inches.

The public gardens facing the Casino in Monte Carlo look much as they were when first planted by Édouard André, and for sentimental reasons we like to keep them that way. In the late nineteenth century there was a respect for symmetry and orderliness, with beds of brilliant flowers, varying each season, set in equally vivid green grass. The gardens are still kept meticulously watered all through the hot summer.

Only one palm, the dwarf *Chamaerops humilis,* is indigenous to Europe, and this, alas, has now completely disappeared from the hillsides behind Monaco, though it still grows in all the public gardens. When the first English residents-to-be came to the Riviera, they planted their gardens with lemon and orange trees, cherry, peach, and almond. But when the palm trees became fashionable, many of the flowering trees were allowed to die out, so now they are comparatively rare along the roadsides.

For the midwinter beds the gardeners use primula and cyclamen, which are given backgrounds of *Pittosporum Tobira* and gray lichen. Sometimes you see red solanums, with their charming little cherry-red fruit like miniature tomatoes.

In early spring there are many varieties of flowering aloes, thrusting up their giant asparagus heads to unfold pale green buds in May. They are a dramatic sight.

One of the most romantic gardens of the Riviera belongs to the Princess de Bavière-Bourbon. It is only a few years since

Across the road from the Jardin Exotique in Monaco is the cactus nursery, where there are many thousands of small plants in their various stages of growing. As cacti are mostly slow growing, these trays of seedlings have taken years of patience and care to develop.

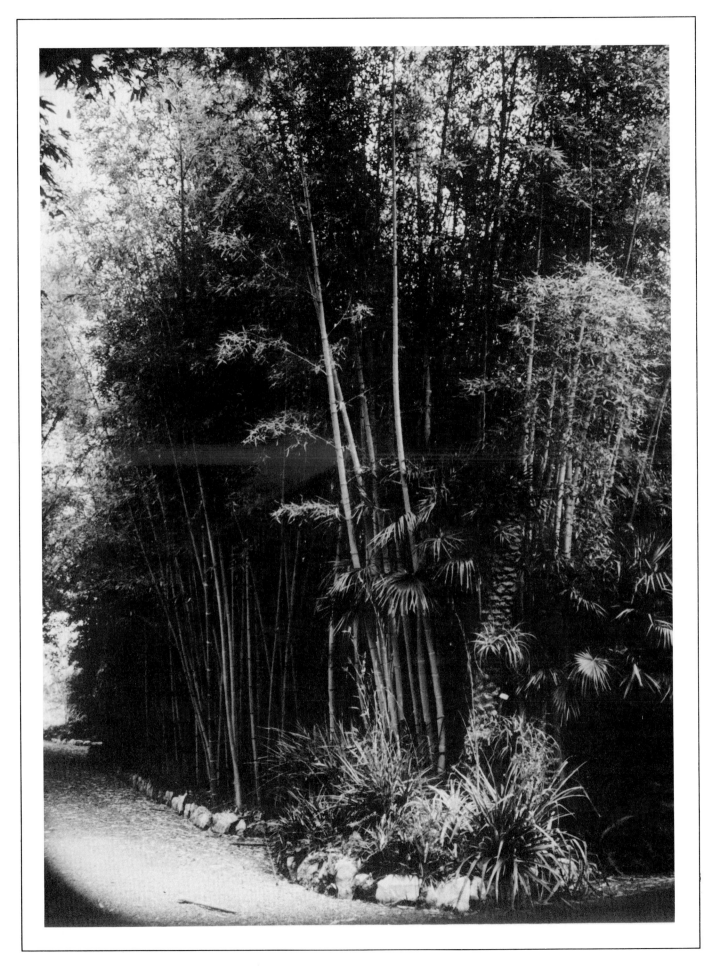

the death of her old gardener, who was over ninety years of age. From the time he was sixteen he had worked for the Empress Eugénie, who, when she died, left the house to the Princess.

Whenever the Princess wanted to change anything in the garden, the old man would say, "Oh no, those were planted by Her Majesty, and you can't change them." He would not let her trim, cut, or prune anything, but there was a certain plant that had spread all over the place. The Princess finally cajoled the old man by asking:

"How many did the Empress plant?"

"About three or four," he answered.

"Well, then, let's cut them back to three or four!"

Visiting gardens makes me think of the time when a group of club ladies were looking at one that was particularly beautiful. Enraptured by its loveliness, one woman exclaimed to its gardener, "Isn't it wonderful what beauties God hath wrought?"

The old man, with a touch of irony, replied, "Well, lady, you should have seen it when God had it all to himself."

Between Monte Carlo and Cap Martin and close to Roquebrune is a truly enchanting garden, created by a woman with a deep love for flowers and a discriminating taste in them. Since she began planning and planting at the beginning of the century, every flower in Mrs. Norah Warre's garden has been tended with infinite care. The charm of Villa Roquebrune is that here on alien soil she created what is really an enlarged English cottage garden, with winding gravel paths, steep stone steps, and wide borders packed with the brilliant colors.

When the late Mr. Emerson Bainbridge and his bride first went to Roquebrune, in 1902, they chose a steep, rough hillside, covered with limestone boulders and sloping down to the sea.

"This," said Mrs. Bainbridge with astonishing courage, "is where we will make our garden."

An early photograph of the site shows a barren chaos of rock. Today the garden covers about five acres and is so planted that it dips down to the sea in a series of terraces, on which no mechanical aids can be used, so all the cultivating and weeding have to be done by hand.

Sometime after Mr. Bainbridge's death his widow married Mr. George Warre, who helped her to maintain the garden. Though she can no longer take an active part in its maintenance, Mrs. Warre, who is ninety, still remembers where every plant is.

"Do go and look in the lower terraces to see if the *Bignonia Unguis-cati* is out," she will ask her companion. "Tell me how many yellow trumpets are in bloom."

This exciting plant from South America is also known as *Bignonia Tweediana,* and it cascades down the walls of the lower terraces, mingling with *Buddleia madagascariensis,* which was planted to grow up from below. This magic of contrasting plants, with

Gardeners from all over the world come to see Les Cèdres, the garden that belonged to the botanist Julien Marnier-Lapostolle at St. Jean-Cap Ferrat. One of the most attractive features of this thirty-acre garden was created entirely from many kinds of bamboo.

their gray or silver foliage, is a feature of Mrs. Warre's garden. For instance, she has large clumps of scarlet *Pelargonium* tumbling into a bright pink rock plant, all set off against the silver leaves of *Lantana elegantissima.* And she combines the scarlet *Russelia juncea* with the bluish-gray *Kleinia.* And if you are used to seeing the proud *Strelitzia reginae* cosseted in a florist's shop, Mrs. Warre has them here in dramatic groups with a back cloth of the dazzling blue Mediterranean behind them. The effect is breathtaking, like exotic birds craning their necks to peer at the incredible view.

But the most irresistible sight of all is the white wisteria cascading over a trellis like a billowing bridal veil. Down by the sea a spike of *Agave attenuata,* twenty-five feet tall, arches its back from a sheer wall of rock and is outlined against the gray-blue mountains behind. This is botanical theater at its most spectacular.

Mrs. Warre was sitting on her little terrace, wearing a straw sun hat, when I met her for the first time. She was lovely . . . tall, very English, gracious, and gentle, with great elegance and style. She offered me old-fashioned English tea and told me that their first house here had been a prefabricated one that had appeared in the Paris Exposition of 1900. During the summer she used to live in Scotland, coming to the Riviera only for the winter. In this way the whole garden had been created with winter and early spring in mind, and it is at its best from November to April. Even the roses are pruned in August because in that way there are two flowerings, one in October and another in May.

Jasmines are among the fine sights of the garden, rambling over stone walls and intertwining with brilliant blue *Lithospermum rosmarinifolium.* Then there is *Jasminum polyanthum,* which was brought from Western China by her friend and neighbor, the late Major Lawrence Johnston of Menton and England. Hidcote, his garden in the Cotswolds, England, is one of the most beautiful of all English gardens.

Mrs. Warre is an artist at under-tree planting. She treats her garden like a canvas. For instance, the ground under the majestic *Magnolia Delavayi,* with its large leathery leaves, she has carpeted with tall bearded iris. One of the few flowering summer trees in the garden is the rare Cape chestnut (*Calodendrum capense*), with its long spikes of pink speckled flowers.

Where there were once ten gardeners, now there are only two, but after all those years of skillful planting the garden appears to take care of itself, with ground covers everywhere. The biggest task is the pruning and cutting back into shape of the hundreds

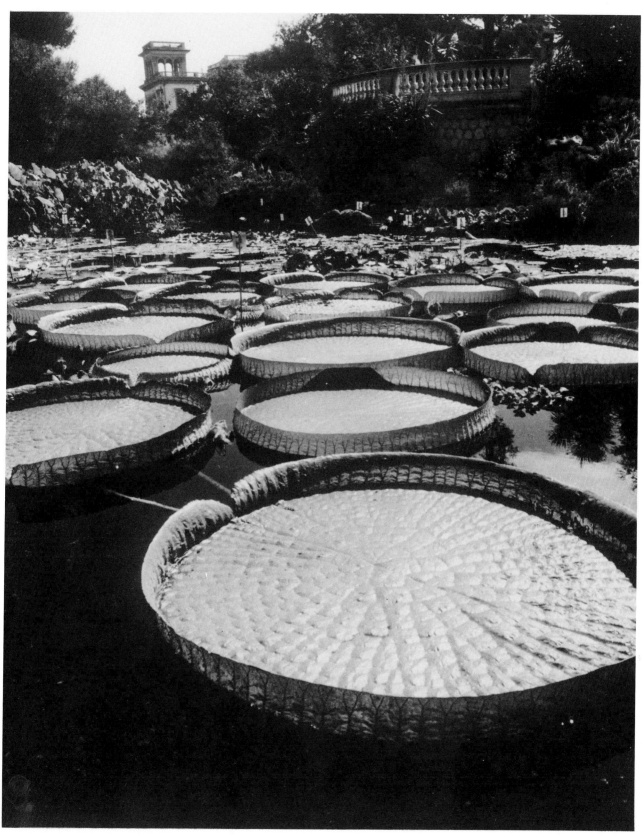

Victoria Cruziana (Nymphaeae)
*growing in the water garden
at Les Cèdres.*

of rare shrubs and trees she has collected from all over the world.

Though it was begun only seventy-eight years ago, the garden has a timeless quality. One can only hope that this very special place will be preserved in its present form for many years to come.

Another garden, small but precious, that I like to visit on a scorching summer day is the translucent green one of Monsieur Raymond Poteau at the village of Roquebrune. He bought the charming old house thirty-five years ago, when it was an intimate cloister of the church nearby. What I so admire about the house is that Monsieur Poteau left so much alone and the spirit of the cloister is as strong today as then.

The garden is laid out in small beds, some of them hedged with box. The flowers are unpretentious—pink belladonnas, white nicotiana, ginger plant, white petunia, all surrounded by luscious greenery. Monsieur Poteau calls it his "peasant garden," but it is much too secretive and special for this description. Its main charms are the small niches and grottoes where you happen upon a statue or come across a pot filled with geraniums. Clematis stretches happily up a wall, one sees splashes of color, and there is a small secluded water garden with a fountain that says plop-plop.

On the end of the house is a small chapel where the townspeople of Roquebrune store their costumes for the August procession that has been held annually for over five hundred years. It came about as a promise to the Blessed Mother, who answered the prayers of the village people asking to be spared from the plague that had already taken so many lives. At the end of their novena the plague stopped miraculously. They were so grateful that they vowed to enact forevermore the Passion of Our Lord and recite the rosary on this special day. Through wars and upheavals this vow has been kept. Even as recently as the last world war, during the German occupation, when many of the footpaths and hillsides were heavily mined, they persisted.

Les Cèdres, the botanical garden at St. Jean-Cap Ferrat, is one of the most astonishing in the world. Here, on over thirty acres of ground, Monsieur Julien Marnier-Lapostolle, the well-known botanist, created a wonderland of plants. Until 1909 the ground was part of a large estate belonging to King Leopold II of Belgium. It was bought by Julien Marnier-Lapostolle's father, Alexandre. The name of the villa came from the double row of cedars along the main walk.

The first garden the family created was the tropical one, which thrived in the mild climate of the Cap Ferrat peninsula. Serious collecting began in 1930, when the son was appointed chairman of the board of the Grand Marnier Company.

One by one different species from all over the world arrived. There were succulent plants, palm trees, acacias, alpine and

aquatic plants, orchids and tree ferns. Several greenhouses and shelters were built. Many of the rare arborescent species have grown there to great heights, and in the bamboo forest it is easy to imagine that one is in an Asiatic jungle. In recent years special attention has been given to the species of the *Bromeliaceae* family.

Although we do not have low temperatures very often in this blessed part of the world, there would have been a real disaster in the exceptionally cold winters of 1940, 1956, and 1971 if protection had not been available.

Monsieur Marnier-Lapostolle has financed several research expeditions to find rare plants. His wife, Suzanne, an outstanding photographer, has always helped him in this labor of love. Marcel Kroenlein, of the Jardin Exotique, has often been of great assistance.

In the villa there is a library that holds six thousand books, many of them very rare. Together with a card index file and a remarkable photographic collection of plants, the library is a valuable help to the many botanists and scientists who visit it.

It is a kind of escape from this world for me when I visit Les Cèdres, and I am grateful that, owing to the dedication of Monsieur Marnier-Lapostolle's wife and son Jacques, this exceptional and beautiful garden will endure.

The seventy-seven-year-old garden of Mrs. Norah Warre is one of my favorites on the Riviera. This Englishwoman and her husband turned a barren hillside in Roquebrune into a gardener's paradise. It contains rare trees, shrubs, and flowers from all over the world.

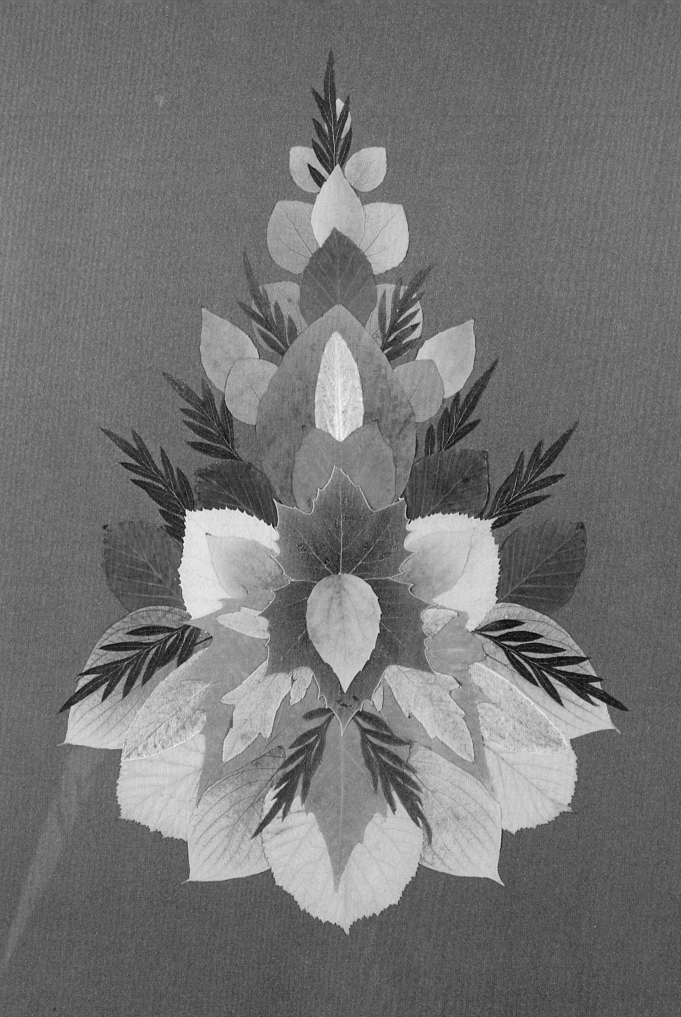

GPK-77

4 Pressed Flowers

How could such sweet and wholesome hours be reckon'd
But with herbs and flowers.

—*Andrew Marvell (1621–78)*

*L*ove of flowers has opened many doors for me. In the last twelve years I have made many friends throughout the world who fascinate me because of their love and outstanding knowledge of flowers.

This feeling for them has given me the occasion to travel to most of the countries of Europe, constantly learning and gaining techniques. When I founded the Garden Club of Monaco, I was probably the most ignorant garden club president in the world, but when you are really interested in a subject it is amazing how you can find the time to learn.

One of the people who awakened in me an unusual aspect of flower arranging was Mrs. Henry King of Philadelphia. When I talked with her, she asked whether our club did any pressed flower pictures. This was something that she had become very interested in and wanted to pass on her enthusiasm to us. The immediate result was that I returned to our club with photographs and a mimeographed sheet of instructions that I translated and offered to our members. I myself began to experiment, and as one thing led to another I found that I was becoming deeply

The various leaves forming this collage have been sent to me by the friends I have made through flowers from all over the world.

On our farm at Rocagel the Prince has his own workshop. One of his early attempts was a metal sculpture in the form of a flower.

involved in this new floral expression.

The first person believed to have had the idea of pressing flowers as an aid to study was an Italian—Lucca Ghini, a teacher of medicine in Padua around 1545. He decided to form a winter herbal of pressed medicinal plants to enable botanists to continue studying during the winter.

Creating pressed flower pictures suits my temperament. Since I was a child I have always liked jigsaw puzzles, and pressed flower pictures require the same kind of concentration. One of their most engaging aspects is that one is confined by the already formed shapes, sizes, and colors of the plant materials.

It is difficult for me to answer when I am asked, "How do you begin a picture? How do you get your inspiration? What is your approach? Is it all planned out in advance? Do you do a sketch first? Do you draw onto the background?" I can never find a satisfying answer to any of these questions simply because I have no fixed method. What would be true one day would not be so the next. When Gwen Robyns asked me to describe my work methods, I said, "Come and watch me do it, because showing would be easier than trying to explain." And she did just that, spending a fortnight at our holiday house at Rocagel.

When the children began to come along after our marriage in 1956, the Prince and I felt that it was desperately necessary to have a place of our own where we could lead a normal relaxed family life, away from the official one at the palace. We looked around the countryside in the steep rocky mountains above Monte Carlo and found a promontory of rock and land where an old farmhouse had once stood. Here we built our villa. The site was bare and desolate, but my husband was delighted. There was enough land to have a few farm animals, ponies, and eventually a vegetable garden, swimming pool, and tennis court. Perhaps best of all was the breathtaking scenery. On clear days the sky is wide and glorious with a spectacular view sweeping the coast of the French Riviera into Italy. When the day is especially clear, one can see Corsica. The air is also filled with the scent of the mountain herbs that grow wild everywhere.

Like all mountain people, we soon learned to live with the prevailing mists. Without warning, like gray blankets they roll down from the mountainsides or up from the sea, swirling around the house and sneaking through the cracks in the windows. At first our guests were mesmerized, and I recall that one friend said, when taking a telephone call, "Just a moment, I must close the window, a cloud has come in."

In the beginning there was no garden at all. It seemed an almost impossible task, but, little by little, we began to clear the soil, which had not been worked for years. My part was the vegetable garden. Of course I had no idea what a challenge this presented, before I learned that we had to turn over the hard clay-

like soil with a pickax. I read that the best way to cleanse the soil and break down the ground was to plant potatoes, so every square yard we cultivated that year, and subsequent years, I planted with potatoes. It was very hard work indeed.

Down from the house, right on the edge of the cliffs, is a plateau where the Prince decided to make an orchard. First the rocks and stones had to be cleared away, then he brought in his tractor to level the ground. He planted several hundred fruit trees, and now, after years of coaxing and care, they give beautiful fruit and in spring are a cloud of pink and white blossoms.

Among the Monégasques the house is sometimes referred to as "the ranch," but to me it is like any farm of the area, with our collection of pigs, chickens, cows, deer, and Sicilian donkeys. We even have two white camels that were a gift to my husband. Every summer, when the children were young, my husband used to bring animals from his zoo up to Rocagel for a holiday. They arrived in specially built cages, and some were even allowed to roam around the house. He felt that just as humans need a change of air, so do animals.

The interior of the house is like those of other families. We have a wide entrance hall that is always filled with family clutter— tennis rackets, games, cameras, half-empty boxes of chocolate, sweaters, magazines, and dogs. When the children are home, there

I create many of my pictures when I am on holiday at Rocagel. It is a kind of self-made clutter in the garden room, but strangely enough I mostly know where to put my hand on the pressed flowers I need. I think every woman develops her own personal radar system.

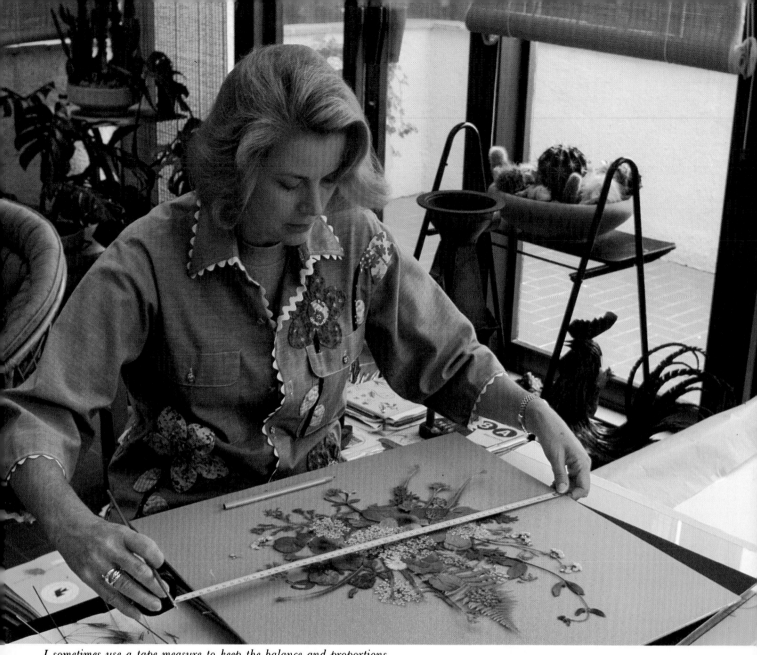

I sometimes use a tape measure to keep the balance and proportions.

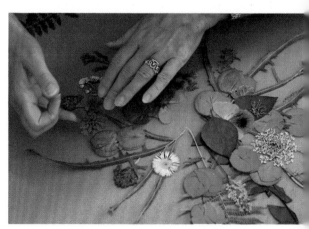

Though I have used flower presses, I prefer using telephone books and blotting paper (left). I found this antique stand complete with a collection of flatirons. It is decorative, and the irons add weight after pressing (center). I jiggle my flowers around with a twig or the tip of my fingernail (right).

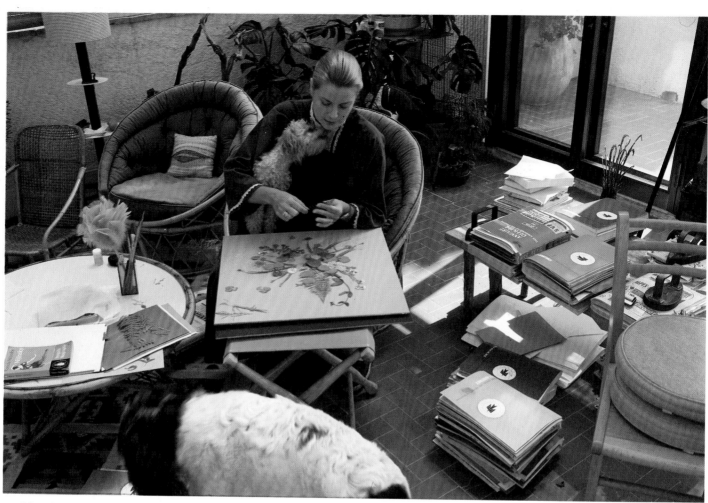

I seldom begin a picture with a preconceived idea. Making pressed flower collages is like doing a jigsaw puzzle. By moving the flowers around, the main shape gradually falls into place. From this beginning it is easier to work toward the finished picture. As the design begins to take shape, you get the same feeling of tranquillity as doing needlework. No wonder the Victorian ladies became so skilled in this art. Timmy is determined to get into the act too!

Below: I always keep a quantity of Queen Anne's lace and hydrangeas, as I find these are so useful (left). Whenever possible I try to store the various types of pressed flowers in books according to type and color (center). For gluing I use a small paintbrush and either rubber cement or acrylic medium. It needs a light touch, otherwise the flowers can break (right).

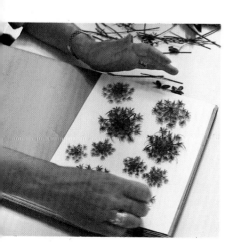

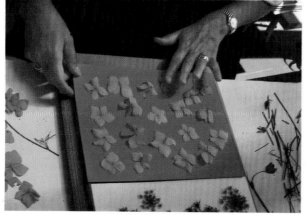

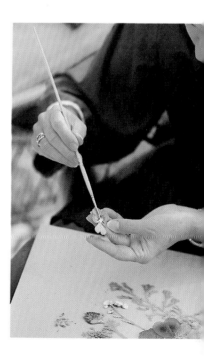

is music in every room. We particularly wanted it to be a place where everyone is allowed the freedom to do his or her own thing. It is a complete contrast to the formality of living in a palace.

Though I do my pressed flower pictures in the palace and in our Paris house, as well, I enjoy it most of all at Rocagel. It is here in the garden room that Gwen Robyns and I sat talking. Three walls and the ceiling of this room are made of windows, but there is never a strong glare in it, owing to straw blinds that are hung across the ceiling, giving a soft and somnolent light. I got the idea from Alfred Hitchcock's country house near San Francisco and decided that it was just what we needed at Rocagel.

The garden room has a lived-in look about it, as all the family dump themselves in it when I am working. Having people around me when I make pressed flower pictures does not bother me, simply because I treat them as a form of relaxation and not serious art. I am fortunate in being able to concentrate no matter how much talk or noise is going on—one of the advantages of growing up in a large family.

One really needs a corner or a room to oneself for this work so that no one will touch or disturb your things. I have experimented with various ways of pressing, and find that I rely mostly on telephone books. I put the flowers between pieces of blotting paper, but the leaves are simply slipped between pages. Then they are weighted down with pieces of iron, bigger books, or anything heavy that I can put my hands on. I pick up in antique shops old irons or book presses that come in handy. Many of the experts have flower presses or use corrugated cardboard that they pile up into quite tall stacks. I have heard of one enthusiast who built a stack four feet high. I have tried both methods but still prefer telephone books. If you are not careful, the hard ridges of the corrugated cardboard will mark the flowers. I have used newspaper with success and find that it is rare indeed that the actual print transfers to the flowers. No stack can be totally safe with our family dogs around.

I leave the material pressed (without peeking) for a month or two, then I try to catalogue what I have (still using telephone books) according to size, color, and variety. When I feel particularly efficient, I put green material on green sheets of blotting paper, yellow on yellow, red on red . . . but when I am in a hurry it gets put in any which way, making it more difficult to find later on, of course. I live in a kind of self-made clutter. My

husband can never understand my untidiness, but the odd thing is that I really do know where everything is. If you were to ask me to put my hand on a pink forget-me-not, I would know pretty well just where to find it in my dozens of telephone books. I am fortunate in having a fairly good sight memory.

I am rather casual about my equipment, too. Many people use tweezers for handling the delicate flowers, but I prefer to use the tip of my fingernail or a small stem to move the petals into place. It is not only that the eyes find pleasure in finishing a pressed flower picture, but just sliding the flowers into place brings the same kind of tranquillity as doing needlework, crocheting, or knitting. No wonder the Victorian ladies spent hours making pressed flower albums and pictures. As with gardening, time just slips by.

I never have a fixed plan when I set out to make a design. Sometimes I start with a color or shape in mind, and it just grows. I move the flowers about until I feel that I have harmonious grouping, then I leave it for a bit and come back to it with fresh eyes and maybe add something or make a few changes or sometimes start all over. One thing you cannot do with this kind of work is to sit back with a sigh. If you do, everything goes on the floor and one sneeze can bring disaster!

The actual gluing is rather tricky, as the dried material is fragile and breaks or crumbles easily. I apply either rubber cement (which unfortunately tends to yellow but is easy to use) or acrylic medium.

The final result should be put under glass as soon as possible. I have had fun along with a few disappointments trying different textures as a background, but I usually come back to paper and cardboard. I have also used plastic sprays. They do little toward preserving the material or color but do add a luster that can be interesting with certain compositions. All plastic sprays should be applied out of doors where there is plenty of air.

George Smith, who comes to Monaco to judge at our international show, always speaks of the "jaundiced eye of the flower arranger." What he means is that you must not always look for the perfect specimen but for the more interesting one. Even a sick or tired leaf can give a new dimension to your pictures.

I once heard of an Englishwoman who had decided to brighten up her hall and "papered it" with pressed flowers and leaves of all kinds. She then varnished this to keep them in place. Once you have the pressed-flower fever, there is no end to where your enthusiasm will lead you.

The family tells me that when I am engrossed in making a picture I tend to talk to myself like a cat purrs. I suppose it is all part of that pleasant feeling you get as the design takes shape. It is a kind of deep satisfaction to know that without any formal training it is possible for everyone to express themselves.

A Portfolio of My Pressed Flowers

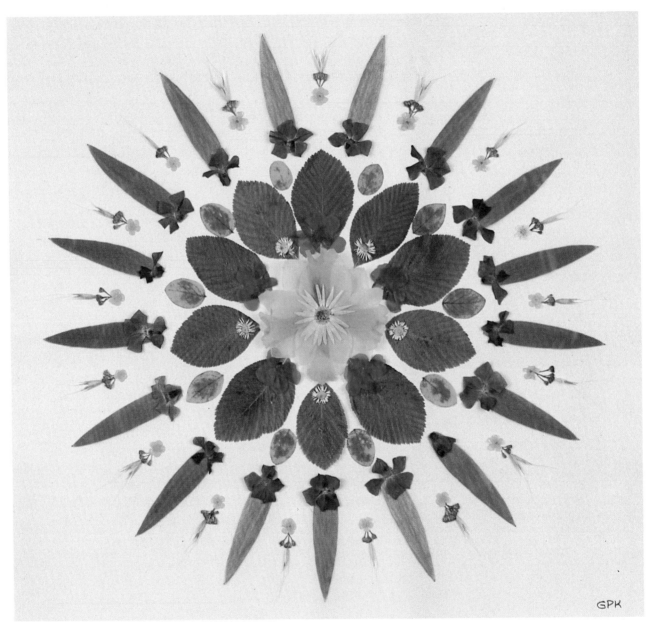

Geometrical patterns are a challenge and are fun to create. It takes a sure eye to space the design accurately, otherwise it loses its pristine formality. Here I have combined protea leaves, periwinkle, viola, daisies, and a yellow daffodil as the centerpiece.

Fragile white phalaenopsis orchids, which were sent me from Ceylon, ended up in this picture combined with bougainvillaea and periwinkle. Each picture you make often becomes a personal memento of a special occasion.

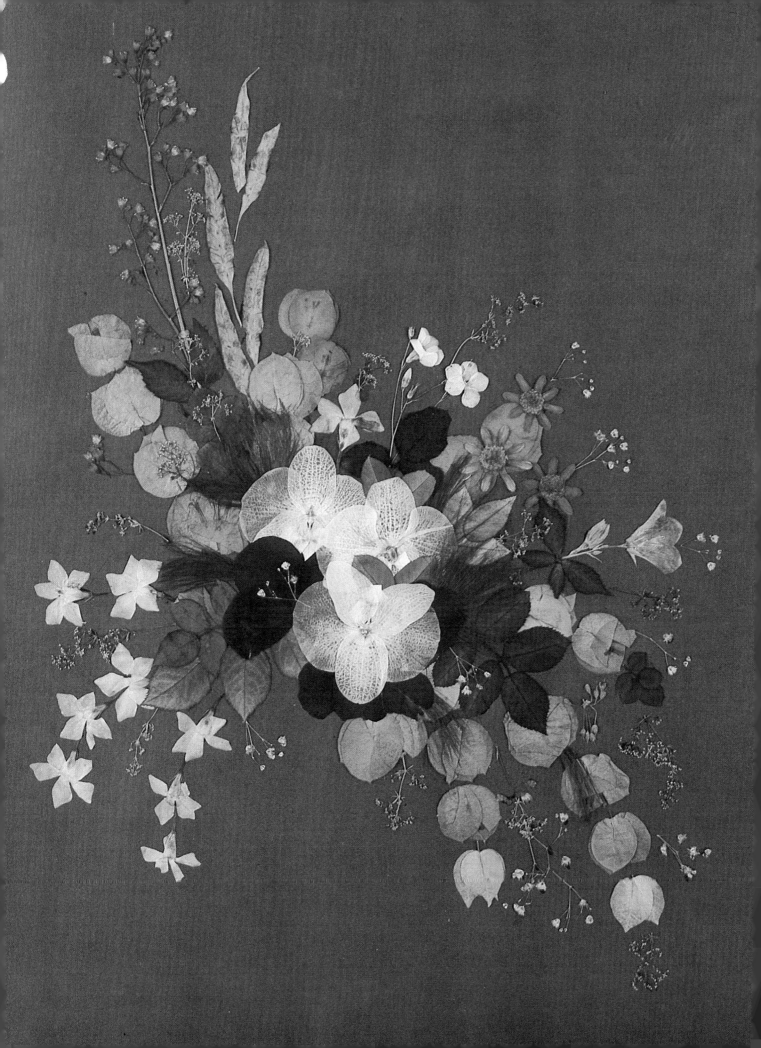

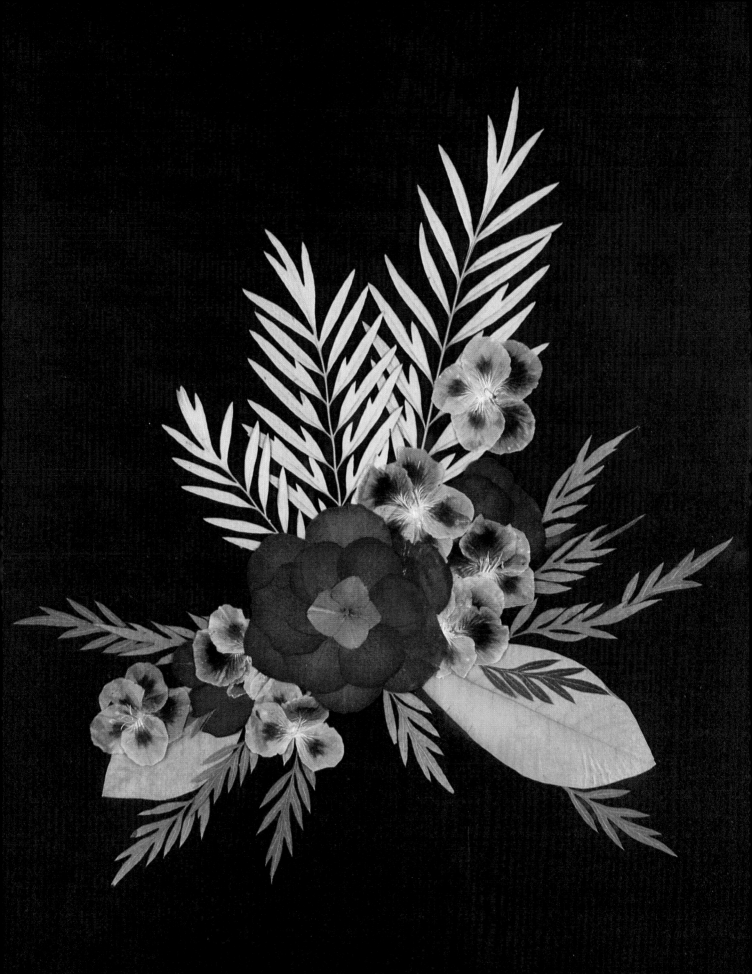

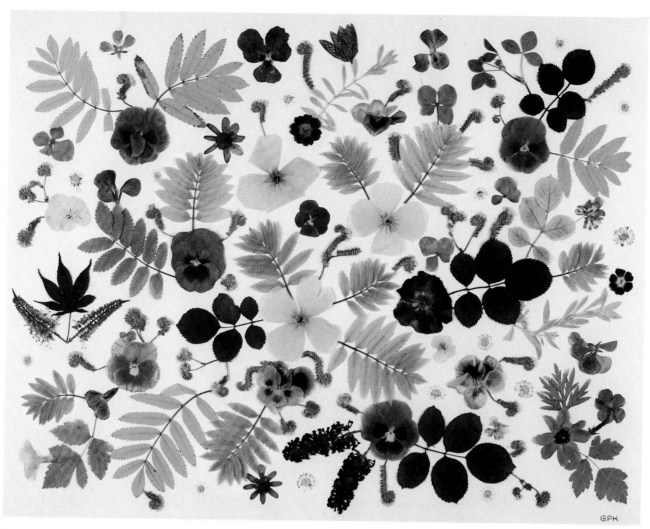

By mixing different types of leaves and garden and field flowers, the effect is like a Provençal print or a Liberty fabric. The design may look casual, but it took me some time until I was satisfied with this flowery jigsaw puzzle.

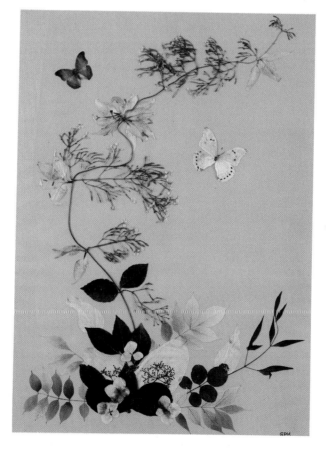

This design began with a branch of jasmine, then I added prunus leaves and the pale davidii *leaves known as "the handkerchief tree."*

Here I have reconstructed a red rose from individual petals with a hydrangea flower as a center. The foliage was gathered in California. The deep pink pelargoniums from Spain add a splash of color.

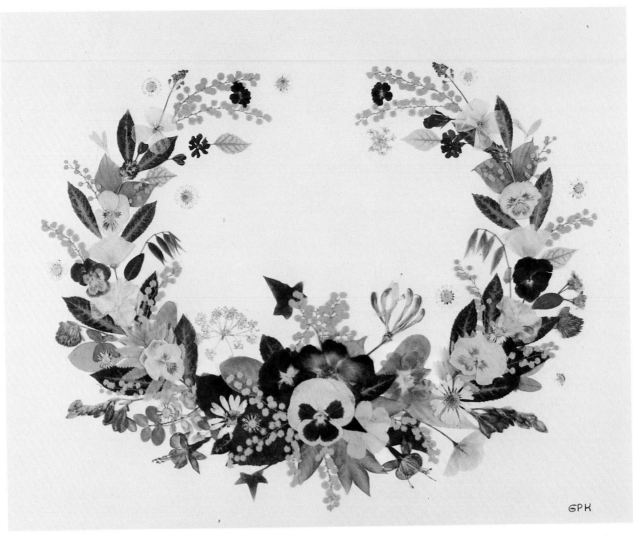

GPK

This half crown of flowers is similar to those in fashion in the nineteenth century. It contains mimosa, pansy, periwinkle, primrose, johnny-jumps-ups (viola), and daisies. I used this on the invitation to my first exhibition in Paris at the Galerie Drouant.

Pheasant feathers and orchids may seem a strange mixture, but the unexpected often yields surprising results. These delicate orchids were brought to me by the charming stewardesses of Singapore Airlines.

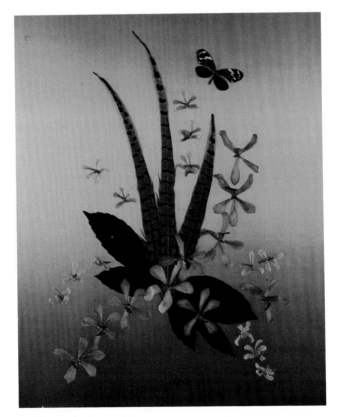

To capture the feeling of Christmas, snowflakes, and a starry sky, I used pale hosta leaves and Queen Anne's lace and lavender.

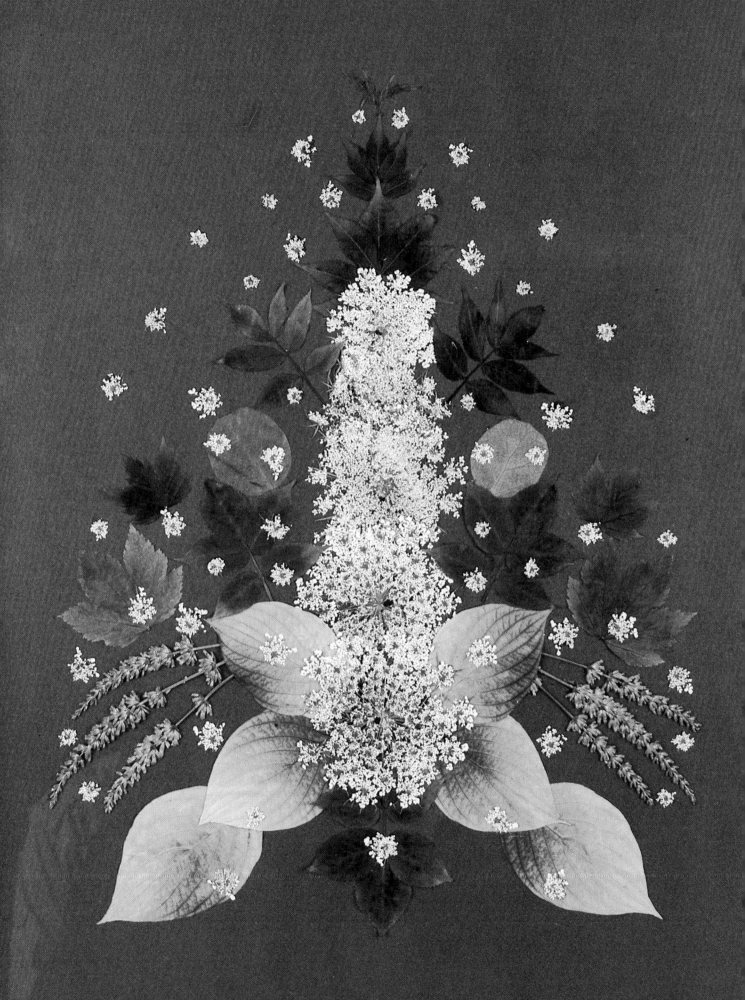

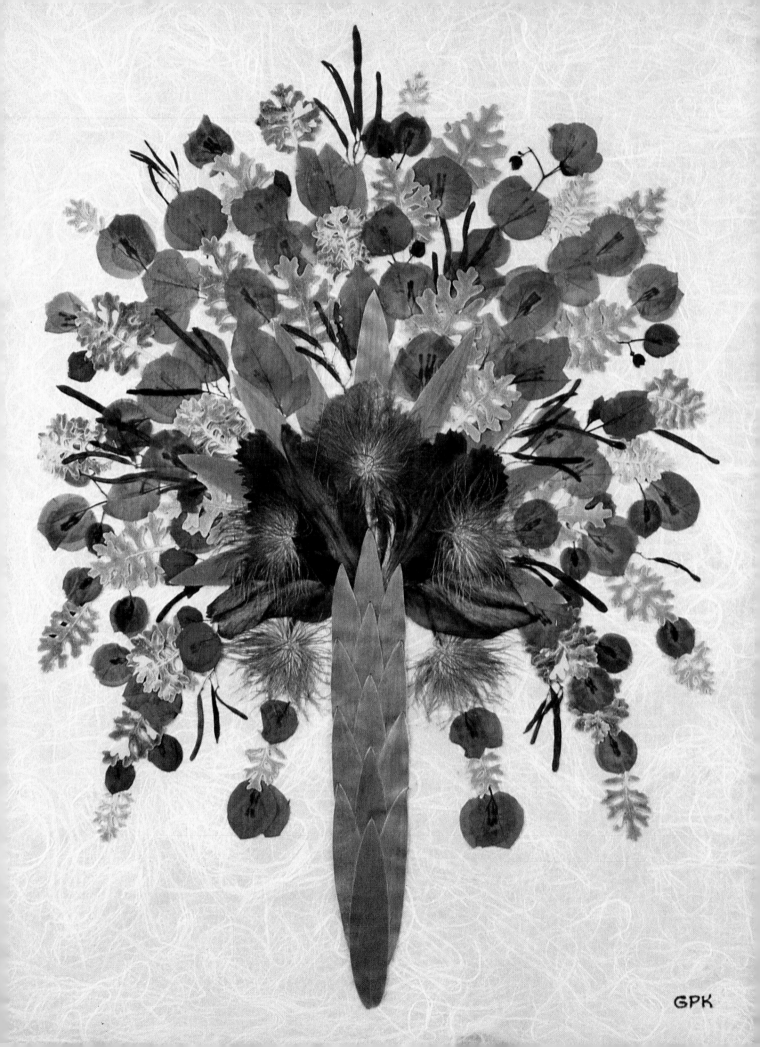

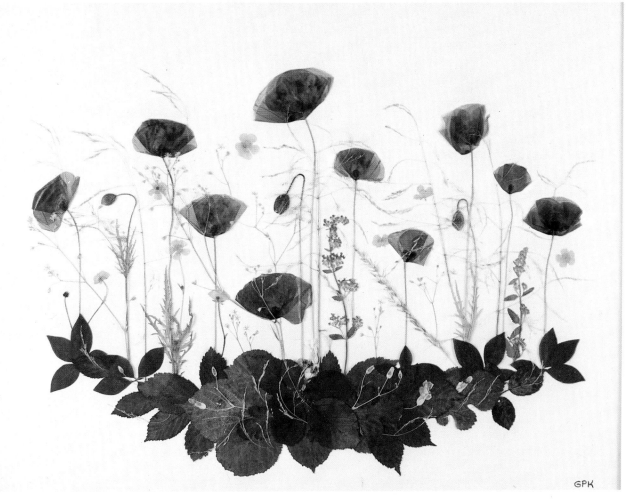

Here I have tried to recapture the mood of a summer's day with field poppies, buttercups, and wild grasses. I was delighted when this picture was bought at my Paris exhibition in the Galerie Drouant by the art connoisseur Paul Louis Weiller.

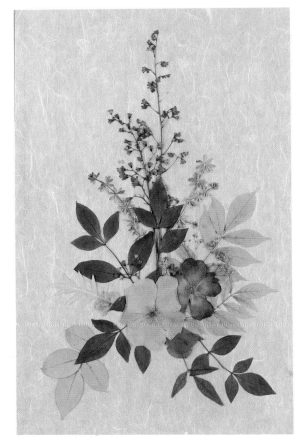

It is amusing to experiment with different backgrounds in making pressed flower pictures. This modest arrangement glows against a background of rice paper on shocking pink. In other pictures I have used non-reflecting glass.

Bougainvillaea is like hydrangea and mimosa in that it keeps its natural color pretty well after pressing. I used it here in a make-believe bouquet with contrasting, textured gray foliage. The stylized holder is formed from protea leaves.

55

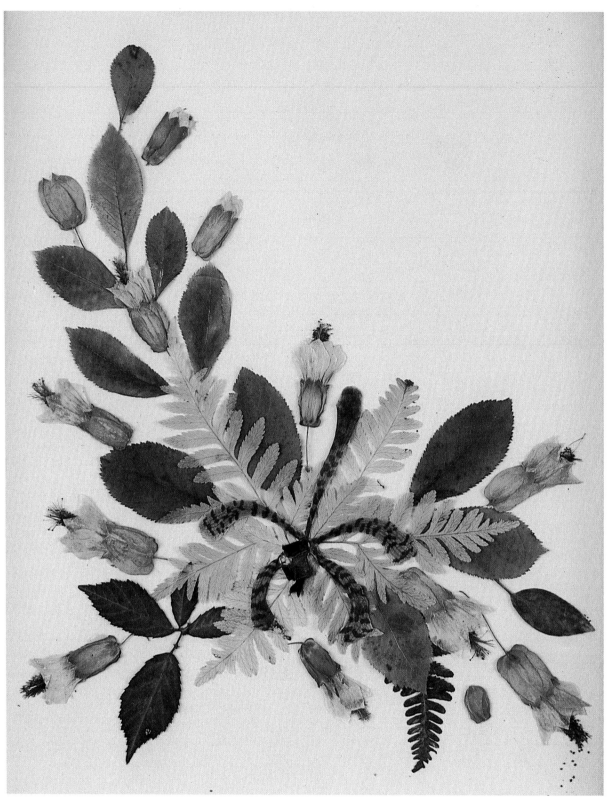

I like to go collecting in the autumn, when some of the most colorful leaves can be found in the country hedgerows. Many retain their natural colors, but sometimes dehydration turns them into subtle sepia tones.

The charm of pressed flower pictures is that there are no fixed rules and you are free to experiment and create your own fantasies. In this design I took a collection of gray tones and gave them life by placing them against a background of bright coral and adding one black butterfly in flight.

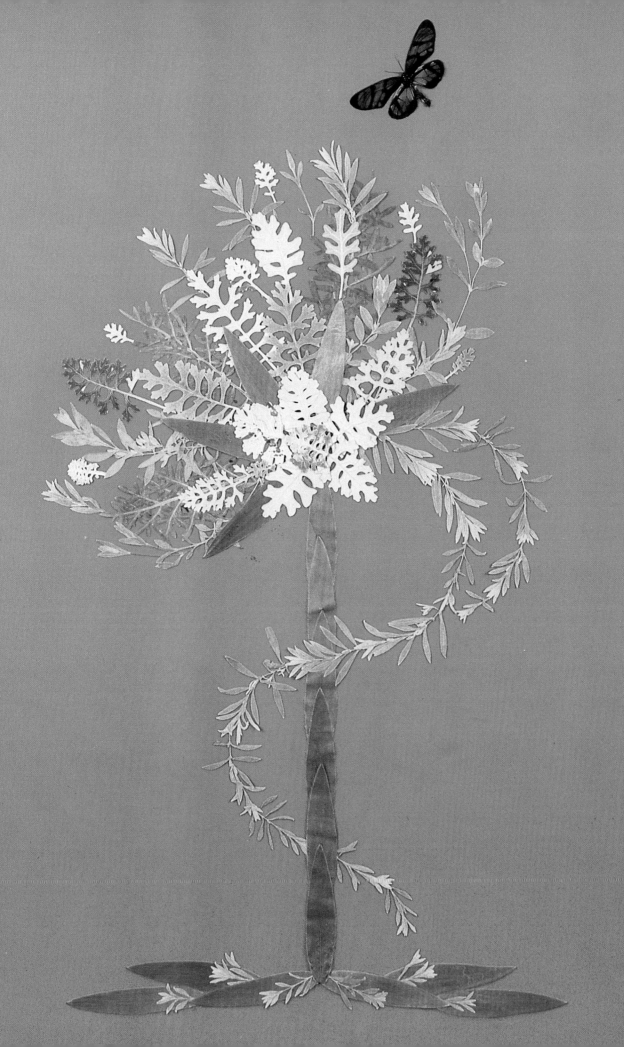

5

Herbs and Potions

There are certain People
Whom certain herbs
The good digestion of disturbs
Henry VIII
Divorced Catherine of Aragon
Because of her reckless
use of Tarragon.

—*Ogden Nash (1902–71)*

*I*n the last few years there has been a happy revival in the use of herbs, not only for flavoring food but as tisanes for health and beauty purposes. Our great-grandmothers knew about the magic of herbs and berries and the vast store of healing properties hidden in the heart of small mountain flowers like the celandine. But alas, with the discovery of patent medicines and twentieth-century technology, many of the original family recipes in England and America were lost or thrown away. Fortunately in Monaco and the Provençal area the old herbal recipes are still in constant use.

The younger generation of my daughter Caroline has a natural curiosity about the culture of herbs and their various healing

. . . the vast store of healing properties hidden in the heart of small mountain flowers like the celandine.

properties. Perhaps part of this is due to the newly awakened interest in Eastern cultures and religions. There is also, of course, the health food craze that has swept the Western world in the last few years.

My interest in health foods began when President Roosevelt asked my father, John B. Kelly, to head a health program at the beginning of World War II, when statistics showed so many young Americans physically unfit.

After a great deal of research it was found that there were many factors besides lack of exercise that contributed to this deficiency. Overly refined foods and the bleaches used in sugar and flour were depriving us of the full nutritive value of foods. From this moment on my father never allowed white rice, white sugar, or white bread to be given to us children. It did not take us long before we really preferred brown bread, as I still do today.

In the early days of American history the Indians, having no knowledge of medicines prepared by scientific skill, devised their own cures from the herbs gathered in the forests and on the plains. Indian women gathered wild flowers and berries, mentally classifying their healing properties. As their language was written by picture signs, they drew a tree with a pair of human legs—a mandrake in fact—to signify an herbalist, while a doctor was denoted by a drawing of a figure with a plant for its head and sprouting wings.

We owe much of our knowledge of herbs to the Greeks, Egyptians, and Romans, and later to the Indians and Chinese. It is a fascinating thought that thousands of years ago our ancestors knew that when the hairy leaves of the common stinging nettle are cooked they not only taste like spinach but have a soothing effect on the stomach and aid digestion. Or that the innocent white daisy flowers of the chamomile plant, when infused with hot water, can calm upset stomachs.

Herbal medicine was neglected during the early Middle Ages, but was reintroduced by traveling monks later in that period. News of the magic properties of herbs was whispered from mouth to mouth until the great manor houses of Europe converted part of their cellars into stillrooms to house the crocks and jars that contained these precious herbs. In this way all the normal illnesses of a family were treated within the manor.

In the early colonial gardens of America herbs were given a place of importance, and many of the seeds were brought from England. The early settlers' wives also had their storerooms of herbs for use during the harsh winters.

The expression "cut and dried" comes from those far-off days when the ladies of the house brought in their herbs to dry, so the cycle of the year was completed.

I have dipped into one of the earliest known beauty books written for women in England. Compiled in 1594 by a royal cour-

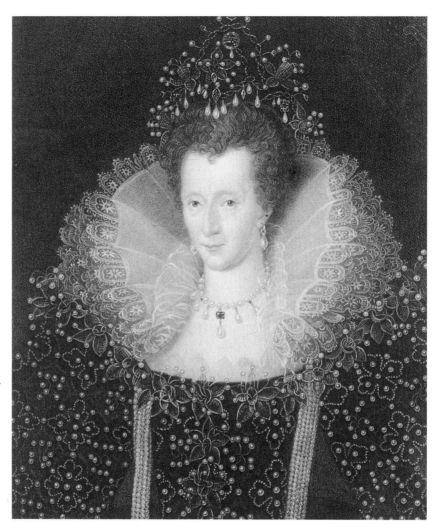

Queen Elizabeth steeped herself in "sweetly scented vapour baths"—the forerunner of the sauna, and she shampooed her well-cared-for hair in a mixture of wood ash and water, following this, most likely, with a rinse perfumed with rosemary.

tier, Sir Hugh Platt, it was called *Delights for Ladies,* and is now in the British Museum. It contains an assortment of beguiling recipes for flower and herb tisanes, scents, soaps, face washes, and herbal baths for medical purposes.

I quite understand why the ladies of the English manor houses rushed to acquire copies and experiment with his potions. Queen Elizabeth used several of his recipes—or receipts, as they were called in those days—adapting them to her own requirements. She was known to love scent in liquid form as opposed to the dry potpourri sachets that most women of the court carried. One of the many gifts given the Queen by her favorite, Lord Leicester, was an amber scent bottle engraved with his golden crest. The Virgin Queen even had special burning perfume made for her by steeping marjoram and benjamin in water and heating the mixture until it gave off sweet fumes.

Another of Sir Hugh's prized receipts was for a potion to *take away spots and freckles from the face and hands.* Though it does not belong to this book of flowers, I cannot resist the temptation to pass it on to you just as he wrote it:

This is a fine example of embroidered headwear and was obviously worn by a woman of stature.

The sap that issueth out of a birch tree in great abundance, being opened in March or April with a receiver of glass set under the boring thereof to catch the same, doth perform the same most excellently and maketh the skin very clear. This sap will dissolve pearls a secret not known to many.

London air was heavily polluted in those days and houses were damp and had bad ventilation. The Queen ordered that all her closets and chests were to be kept fresh by sprinkling the floor with woodruff and tansy, which were also known to be moth repellents.

I was fascinated to read, too, how proud the Queen was of her white skin, and about the pains she went to keep it. One of her drastic toilet preparations was a specially made cosmetic water for preserving whiteness. It contained the whites of freshly laid eggs, powdered white eggshells, powdered burned alum, powdered white sugar and borax, and seeds of the white poppy. This was all blended with "water from the mill." After a monstrous amount of beating by a girl servant until it "frothed into peaks" the lotion was strained through a fine cloth. It was said to keep for twelve months.

Another foible of this formidable woman, who was known to be "fastidious about her person," was her preference for distilled oils from flowers such as roses and orange, which she kept specially for softening and perfuming her delicate long-fingered hands. She also insisted that her gloves be delicately scented, though she made it known that strong perfumes offended her nostrils. She preferred the sweet, musky perfume of meadowsweet to those of all other herbs.

In those days people became attached to various herbs and flowers just as we choose a perfume today and make it personal. Cardinal Wolsey, a man of exquisite taste and refinement, always had his study strewn with saffron, which by today's prices would have cost a fortune.

In sickrooms thyme, especially when in flower, was always chosen because of its strange healing properties. And when a person was known to be dying, it was common practice to place a sprig of rosemary in his or her hands. Rosemary was also part of the burial ritual, each mourner throwing a sprig into the open grave. Friar Laurence in *Romeo and Juliet* makes reference to this custom when he says:

Dry up your tears, and stick your rosemary
On this fair corse . . .

Small bags of the same dried flowers and herbs were always carried on travels, and even prisoners took their herb bags into prison with them to ward off the evil smells of the appalling prisons of the day. The nosegays that English judges carry today, when they walk in processions to the law courts, follow a tradition handed down from those days when strong-smelling herbs were

believed to keep away the plague and jail fever.

The ladies of that age dabbled in all kinds of beauty treatments much as we do today. Whereas Queen Cleopatra is said to have bathed in ass's milk to keep her skin soft, Queen Elizabeth steeped herself in "sweetly scented vapour baths"—the forerunner of the sauna. These she took in a small room that had been converted to that purpose at Windsor Castle. And though she was always seen in public in one of her many fanciful red wigs, she did, in fact, have a healthy head of hair, which she kept astonishingly clean for those days by shampooing it with a mixture of wood ash and water. After this was completed, her maid rubbed her scalp with toilet water made from flowers to keep the scalp healthy and sweetly perfumed.

It is more than likely that the Queen used rosemary, as it is a particularly suitable rinse for the hair. All you have to do is to steep some sprigs, preferably with the flowers, in boiling water and let it cool. This rinse leaves the hair supple and shiny as well as delicately scented.

Because of its chlorophyll content rosemary is better for dark hair. For blond, gray, and white hair use the flowers of the yarrow mixed with chamomile. Lime blossoms infused in boiling water make another rinse for conditioning the hair and actually promotes growth. Used as a compress, it is also very good when your skin looks dull.

*D*ue to the fume-filled air of today, and perhaps from our modern diet, many women suffer from greasy hair, especially if it is fine. Though I have not tried this old recipe, I am assured that it really does work. *Take 4 ounces of lavender water, half an ounce of borax, 3 ounces of rose water and a quarter of an ounce of tincture of cochineal. After washing rinse well with a little borax in the last water.*

The petals of marigold steeped in hot water and used as a rinse are also good, leaving the hair clean and shining. All these flowers, of course, give the best results when they are freshly picked, but if this is not possible, then the dried ones bought in herb stores are a good substitute.

Though this has nothing to do with flowers, I am passing on to you this recipe given me of a lotion for baldness. I guarantee no cure but some husband may like to try it out: *Take of box leaves four handfuls. Boil in eight pints of water in a tightly closed pan for fifteen minutes. Add an ounce of eau-de-Cologne. Wash the head every evening.*

It seems, too, that from time immemorial mothers have had

Flower-decked wigs reached heights of fantasy in France during the eighteenth century, as shown in this fashion plate from the period.

problems with adolescent children who had troublesome skins. It was possibly worse in the Middle Ages, when diets were restricted and people were deprived of many of the health-giving vitamins that we derive from fruits and vegetables. Today we put our children on a diet containing fresh fruit juices and vitamin pills, but in olden times they drank a cup of tea made from yarrow flowers and gave themselves facial compresses containing the flowers of chamomile or lady's-mantle.

The highly spiced foods of those days, so necessary to preserve them and camouflage the strong taste of overhung meat, also caused dilated veins, similarly as too much alcohol does today. Again, chamomile tea or coltsfoot tea was the common remedy.

Herbal compresses were a favorite beauty aid used by the fine ladies in the large country houses. These were applied regularly to help keep those famed peaches-and-cream complexions. Thyme, chamomile, dandelion, cowslip, and daisy were all used especially in the spring, either in a facial steam or as a compress. Elder flowers mixed with curd were said to be beneficial in softening the skin and preventing discoloration. Today one can substi-

tute yogurt for the curd and place the mixture between thin layers of muslin.

The list of herbal tisanes is very long, but as my book is about flowers I will mention only the teas containing flower petals. Among the more usual ones are elder flower, lime, lavender, thyme, cowslip, dandelion, hibiscus, verbascum, violet, lavender, chamomile, sage, and red rose petals. The bouquet and flavor are more pungent if fresh flowers are used, but the dried ones bought at an herb store are astonishingly good.

It is strange that from the fragile white blossoms of the elder tree come so many potions for improving the health. Drunk purely in a tisane, elder flowers have a diuretic effect and are known to cleanse the blood. A weak solution of elder flowers in water is also very soothing when used at night and in the morning as an eyewash.

Instead of making a hot toddy of whiskey or rum when you have a cold coming on, try the soothing combination of elder flowers, chamomile, and lime blossoms. I mix mine with a teaspoon of honey when I have a sore throat.

That esteemed French herbalist Maurice Mességué, who lives not very far from Monaco in Cap d'Ail, probably knows more about using herbs and flowers in medical treatment than any other living person today. Followers of his simple herb treatments have included such worldly wise men as Sir Winston Churchill, Chancellor Adenauer, Prince Ali Khan, Robert Schuman, Maurice Utrillo, Jean Cocteau, Admiral Darlan, and King Farouk.

I love the story of how, when Mességué was invited to visit Sir Winston, who was staying with Lord Beaverbrook at Villa Capocina, he was asked to prescribe a medicine for the British Prime Minister's cough. The herbalist explained that for coughs phytotherapists use vegetables that are good for the palate, too—plants such as garlic, cabbage, watercress, onion, thyme, marjoram, and mint. "But," he added with a twinkle, "for you I would also include violet," which is known for its quality of fidelity in that favorite Old World book, Kate Greenaway's *Language of Flowers.*

The French herbalist's treatments are disarmingly simple. He prescribes hand and foot baths from mountain-gathered herbs and flowers. I find his book *Of Men and Plants* simply fascinating, and for newcomers to herbal medicine it is like magic. It is filled with loving and intimate knowledge of plants and flowers. Though his treatments are valuable for the whole family, there are many selected specially for women.

In our grandmother's day even unsightly warts were cured naturally. The well-proven recipe was to rub the wart daily with the furry inside of a broad bean pod, but the juice of flowers was also used. The gaily colored spring ranunculus was often referred to as a "wart flower," and other plants whose milky sap was used include poppy, celandine, and marigold.

The elder tree, which bears the invaluable white blossoms for many ancient uses; the wonderful marigold, and the great plantain.

For chilblains or chapped red hands in the winter there is a recipe for elder flower ointment. In olden days it was made from pure lard, but today commercial petroleum jelly or Vaseline is so much simpler and purer to use: *Melt a half pound of Vaseline with four pints of elder flowers; simmer for a half hour, strain into pots, then bottle.* If you like your hand creams to be fragrant, add a few drops of flower-scented bath oil. There is even an infusion that claims to help a bad memory. It is made from one ounce of fresh or dried rosemary steeped with one pint of boiling water.

Charlotte, Countess of Lichfield, daughter of King Charles II, left a book of three hundred "receatyes," written in 1681, that is a mine of strange herb lore. The book that claims to be written in "most part in her own hand" contains *King Charles II medicine for men and beasts that is bitt with a mad dogge.*

Take of the root of agrimony, primrose, dragons, single pyons of each one handful, of starre of ye earth two handfulls, of the black Crabbe claws prepared and Venice Treacle of each one ounce, the roots and herbes being bruised together with the crabbes claws and Venice Treacle, let it be infused in warm embers in 2 quarts of strong white wine for 12 hours at least, then being strained, the party bitten should take 4 ounces evening and morning 3 days before the new and full moon. It may be sweetened with sugar or any cordiall syrup. It will be necessary to lett blood before you give this drink.

Personally, I'm fond of girls with freckles. It is just a question of how you wear your freckles—boldly, for all the world to see, or hidden under unnecessary layers of makeup. But there is a great difference from a dusting of freckles over the nose to a

Sage and chamomile and orange—what riches in words and fragrance and flavor.

faceful of large brown spots. Here is a remedy that helps fade freckles. It is from Thomas Newington's receipt book compiled in 1719. Again, though I have not had to try it myself, I feel sure that it cannot harm the skin and is so simple that it is worth a try.

Wash your face in the wane of the moone with a sponge every evening with distilled water of elder leaves letting the same dry into the skinne. Your water must be distilled in May.

The marigold is a charming-faced, happy flower. How true is the old herbal saying that you have only to look at a marigold to "drive evil out of the head." Usually only the florets are used in cooking. Apart from its joyous colors the blossom is rich in medicinal properties, as our ancestors were quick to realize.

In his *Herball*, John Gerard, the father of English herbal gardening, writes:

Conserve made of the [marigold] flours and sugar taken in the morning fasting, cureth the trembling of the heart, and is also given in time of plague and pestilence, or corruption of the air. The yellow leaves of the flours are dried and kept throughout Dutchland against Winter, to put into broths, in physical potions, and for diver other purposes, in such quantity, that in some Grocers and Spice-sellers houses are to be found barrels filled with them, and retailed by the penney more or lesse, insomuch that no broths are well made without dried marigolds.

Homeopathy pharmacists sell a cream for the face that is made from marigolds and that softens the skin. But perhaps this flower's most unexpected use is the soaking of its petals in oil,

then applying it to tired feet for its soothing effect. This balm is also used to heal old scars. In the days before antibiotics, when children were so often left with scars from chicken pox, mothers bathed these blemishes regularly with marigold oil, and, it is said, they just faded away.

Even sprains and bruises can be treated with herbs and flowers. The seventeenth-century English physician Nicholas Culpeper, whose knowledge of herbal lore was almost uncanny, suggests in *The English Physician*, published in 1653, the following cure:

Take of whole swallows (the greater celandine, chelidonium majus) sixteen, rue, plantain the greater and lesser, bay leaves, pennyroyal, dill, hyssop, rosemary, sage, Saint John's wort, costmary, of each one handful, common oil four pounds, Spanish wine one pound, make it up according to art. This is appropriated to old bruises and pains thereof coming, as also to sprains.

A more practical recipe for bruises is this oil, which can be made and stored: *Take a handful of balm, rosemary, chamomile flowers, rosebuds, feverfews, sage, lavender tops, southernwood, betony and wormwood. Place in a stone jar with enough oil to cover. Let stand for a fortnight, stirring often, then simmer gently till the oil is extracted and the ingredients become crisp. Strain through muslin and keep well corked.*

Even the lily-of-the-valley has its medicinal uses. John Gerard used it for gout. Here is his recipe:

Flowers of lily-of-the-valley being close stopped up in a glass, put into an ant-hill and being taken away again a month after, ye shall find a liquor in the glass, which being outwardly applied, helpeth the gout.

During World War II the Germans made use of herbs and plants. Here is a fragment of a speech delivered by Heinrich Himmler, head of the secret police, to naval officers at Weimar in 1943:

We have also created a garden of six hundred acres where all the medicinal plants existing in our country are growing. We raise each year a million and a half gladiolas: gladiolas are rich in Vitamin C, we can make powder for soup and other similar dishes. We are very much concerned with the nutrition of the troops, as we want to give our men healthy and wholesome food.

Incidentally, though parsley is an intruder in this book of flowers, I have a secret about this herb that is really worth sharing: placing a bunch of it on the solar plexis prevents seasickness and all other kinds of motion sickness. I have tried this and it really works.

Garlic is a useful friend in the rose garden. In early spring two or three cloves buried a few inches deep around the roots of a rose not only deter disease but actually promote growth.

For nearly four centuries, garden lovers have known of the astonishing Herball; or General Historie of plantes, *of the Englishman John Gerard. He claimed that a conserve made of marigold flowers and sugar "cureth the trembling heart" and added that "Grocers and Spicesellers" kept barrels of these flowers on hand.*

6 The Wild Ones

To see a World in a Grain of Sand
And a Heaven in a Wild Flower,
Hold Infinity in the palm of your hand
And Eternity in an hour.

—William Blake (1757–1827)

Turk's-cap lily—Lilium martagon—*stands tall and erect, yet its several soft purple and pink nodding blooms have a somber and mysterious quality.*

Wild flowers are perhaps the most enchanting of all for me. I love their delicacy, their disarming innocence, and their defiance of life itself. All through the winter, beneath forgetful white, these tiny entities remain asleep, recharging their energy until the first thaw of spring. Then, as if touched by magic, within days the mountainsides bloom with patchworks of color. The miracle of nature once more unfolds. This is the time when I like to go up into the mountains behind Monaco. Outside the small villages, perilously clinging to the slopes, the people are busy on their land. The growing cycle for the year has started and the markets begin to fill with tender, pale green spring vegetables.

The Riviera is an interesting geographical phenomenon. The Alpes Maritimes, once thickly wooded with luxurious trees, are now almost treeless except for the pines on the mountains and the plane trees that were planted in the small towns to give shade

in the summer. This great limestone range towers above the coastal towns and seems almost to crush the cities along the coast from Nice to Ventimiglia. In contrast to this is the volcanic range of the Estérel, with its towering jagged peaks and olive- and pine-clad hills. In many places the rocks of this range are either of red porphyry or of sandstone, with the result that vineyards flourish in the rich volcanic soil. It is the presence, side by side, of these two geographical formations that encourages such a variety of wild flowers along this part of the Mediterranean coast. They may not be as prolific as the flower carpets of Greece, but in the Vallée des Merveilles, in the Alpes Maritimes, they do rival those of Switzerland.

For considerable distances along the coast the limestone cliffs form an almost continuous wall, but at intervals, such as at Nice, Menton, and Bordighera, there are deep, rich valleys running up into the mountains. They cross the old Roman Via Aurelia, which runs through La Turbie, a town at the foothills of Mont Agel.

Many successive armies have walked along these old routes, remains of which can still be seen today—from the conquering Roman legions to the troops of the Emperor Charles V, twice penetrating as far as Marseilles. It was in the first half of the fifth century B.C. that the Greek historian Hecataeus of Miletus first mentioned the Ligurian town of Monoikos, which is the origin of the name of Monaco.

Many of the olive trees growing there today were planted by the Romans. Our friend David Niven has some of these Roman trees in his garden at Cap Ferrat. In the village of Gorbio, behind Menton, there is an olive tree that is said to be three thousand years old.

There are also many varieties of palms growing along the whole coast of the Riviera, the commonest being the date palms, the fan-leaved *Phoenix dactylifera.* Now they are only grown for ornament and to give an air of grandeur to the boulevards, but for many years at Bordighera they provided a regular industry dating from the sixteenth century. Pope Sixtus V granted to the Bresca family of San Remo the privilege of supplying Rome with palm fronds for Palm Sunday. There is an old custom that, in order for the hearts of the palms to be as pure white as possible for use on that day, the outer leaves are bound tightly together to keep them from the sun. After they have been blessed, the women take them home to place in their bedrooms to bring them good fortune.

Almost the first true spring flower to be seen is the crocus (*Crocus versicolor*), the delicate small white variety often striped with mauve. This crocus grows on the limestone around Vence, for instance, but it is scarce near Cannes simply because the soil is more volcanic there. My rule applies here as everywhere: I

never pick a wild flower unless it is prolific and will not be missed. But if it does grow in quantities, I carefully select a few blossoms, especially for pressing, taking care not to disturb the plants. Some people take their flower presses along on picking expeditions so that they can press the flowers within seconds of picking and so avoid external bruises. I am not nearly so methodical as this. I pick a small bunch and take them back home to press.

The crocuses are followed by the hepaticas, which grow freely on the limestone. Another early spring flower is *Alyssum maritimum,* which has small tufts of tiny flowers that smell like honey. They creep into cracks in the rocks and walls, clinging to a few grains of soil. These I love to use in miniature arrangements. If you take a magnifying glass and examine each bloom, you will marvel at the perfection of nature.

Other very early flowers are the varieties of fumitory, which flower continuously all through the spring. Even the ditches burst into bloom with the nectar-laden nettle, *Lamium maculatum,* with its small pink-tinged blue flowers so delicate that they look like orchids.

Then come the blue grape hyacinths, *Muscari neglectum,* which first push their heads through in early spring and continue growing until the beginning of May. In April there arrives a near relation called *Muscari comosum* (*Muscari à toupet,* as the French call it). It is taller than the ordinary grape hyacinth and has a brownish color that I like very much.

These are followed by the wild anemones, perhaps the most beautiful of all mountain flowers. When they are gathered in their natural state, they droop immediately. The delicate little flowers are natural barometers, as they fold their petals in a tent fashion when a shower approaches. Some writers thought that their name was given to them because they could not endure the wind, but Pliny says the reverse—that they never open but when the wind is blowing. An early English poet alludes to this in these lines:

> And then I gather'd rushes, and began
> To weave a garland for you, intertwined
> With violets, hepaticas, primroses,
> And coy anemone, that ne'er uncloses
> Her lips until they're blown on by wind.

The earliest, and one of the prettiest, is *Anemone stellata,* its petticoat of petals ranging from white through mauve to a deep reddish purple. This wild anemone thrives in volcanic soil. Sometimes

you find it growing in company with the scarlet *Anemone hortensis.* When nature plays a trick and the pollens cross, the result is a new range of tints. Horticulturists have taken advantage of this and have now produced a collection of star anemones in various shades. Around Grasse, where many years ago the scarlet anemones used to grow as prolifically as poppies, you can find *Anemone coronaria.*

In May I love the little fritillarias, which are endemic to the area. These harlequin-like flowers are among the loveliest of our wild flowers on the Riviera. *Fritillary involucrata* grows below four thousand feet and has large single bells of brilliant jade green checkered with reddish purple. The flower heads nod on stems about six inches to a foot high, and though they are not so large as the cultivated snake's head *(Fritillaria Meleagris),* they are even more exquisite in their subtle coloring. For experts there are at least three types of fritillarias growing on the Riviera.

It always surprises me to see the ethereal mountain *Primula Allionii* squeezed into clefts, its delicate little mauve flowers defiant of the rocks around them.

Later in the spring the white *Allium neapolitanum* appears in profusion, followed by *Allium roseum.* The *roseum* has a very strong smell of garlic, which seems to have escaped the white bloom.

The Stars of Bethlehem make patches of beautiful color, both *Ornithogalum Divergens* (which the French call *dame de onze heures* because it opens in midday) and *Ornithogalum narbonense,* its greenish white pyramidal spikes poking up through the grass.

You do not have to be a plant collector to enjoy the excitement of seeing a flower growing in its native habitat. The vermilion *Lilium bulbiferum* is a fine sight on these sun-baked mountains. You can still find the brilliant scarlet *Lilium pomponium* growing wild if you have the eyes to search it out. It is easy to recognize by its shining turk's cap of flowers.

The Alpes Maritimes are also rich in the commoner alpine plants. The gentians (named after Gentius, King of Illyria, who lived two thousand years ago), the saxifrages (*lingulata* is undoubtedly one of the most spectacular), the small orange marigold *(Calendula arvensis),* and the pale yellow wood sorrel *(Oxalis cernua),* which was originally imported from the Cape of Good Hope and has now naturalized itself in parts of the Riviera. In the hills above Menton and Grasse you can still find *Lavandula officinalis* from June to August.

If you are very lucky, and patient, on the level of the Upper Corniche Road in the Nice area, you can find the beautiful white *Leucojum nicaeense*, the most delicate of all snowflakes, only three to four inches high. I always resist the urge to pick this elusive mountain flower.

The grass under the olive trees makes a pretty background for the scarlet *Gladiolus segetum*, which mingles with the scarlet field poppies.

The fragile sea mallow *(Lavatera maritima)*, with its woolly leaves and lovely mauve flowers with a crimson blotch at the base of each flower, grows on the face of the precipices above the sea between Monte Carlo and Ventimiglia.

By May the fields are patterned with clover, the most interesting being *Trifolium stellatum*, with its star-like seeds, and *Medicago maculata* has on its leaves three dark red splashes that are said to have fallen from Christ's wounds on his way to the Crucifixion.

Little pea vetches of all colors grow in the valleys among the wild love-in-a-mist *(Nigella damascena)*, linaria, helianthemums, the tall purple thistle *(Galactites tomentosa)*, and the fairy bells of *Campanula rotundifolia.*

In fact, all through the year in the hills behind Monaco you can find wild flowers to delight the eye.

The striking Star of Bethlehem is a well-known addition to the myriad blooms of the Mediterranean spring.

7 Fragrant Gardens

Scents are the soul of flowers: they may
even be preceptible in the land of shadows.

—*Joseph Joubert (1754–1824)*

*Gardens for the blind have in
common the braille plaques that
tell of the special qualities of
the plants and trees that have
been carefully selected
according to height, texture,
and scent. Such descriptions in
braille appear in the Nature
Center of Mystic, Connecticut.*

he idea of a sweetly scented garden especially for blind
people is one that appeals to me. Every city should be encouraged
to plant one. I know of four, but perhaps there are more through-
out the world. The ones I have been told about are in Hove,
Sussex, one in Vienna, and another in Jerusalem, which has been
modeled on the one in Austria.

The Viennese garden is part of the Wertheimstein Park in
Döbling. Since it was first opened in 1959 it has been greatly
improved, so that now the plants are completely at home as they
have "taken over" the specially planned beds. (A list of these
plants appears in Appendix 1.) The garden began with a competi-
tion inviting architects to submit plans, then it was up to the
town garden department to make the paper dream become a real-
ity.

One of the garden's most practical features is the maps in
relief at each end, giving visitors a feeling of the garden. Every-
thing has been done so that people can move freely and comfort-

ably without any fear of loneliness or insecurity. Many of the flower beds have been raised so that one can easily bend over to smell the flowers and touch them. By each plant is a plaque with braille letters giving information about it. Apart from special seats for resting there are benches and chairs where the guests can play chess or cards, and there is a radio. If the weather is bad, visitors can go into the small clubhouse at the end of the garden, and there are even kennels where they can leave their guide dogs.

Apart from all the fragrant plants, part of the area has been turned into a water garden where water spouts up from the ground and cascades down onto metal discs, producing tinkling music that enchants its listeners.

This garden has brought untold joy to people of all ages who have lost their sight, and especially to children who have no memory of a sighted world. It is of great psychological importance that the children feel in this safe, sweetly scented world that they can move freely everywhere without any outside help from either grown-ups or their guide dogs. Plants and children are in harmony.

Perfume power is something that even sighted gardeners tend to forget when planning a garden. Most of us have become so obsessed with color that the joy of perfumed air on a summer's evening tends to be overlooked. There are many differences between flower and leaf odors. The flower scents lie almost on the surface of the petals, but with leaves it is quite different, as the scents are much deeper and the surfaces have to be bruised or pressed to release the fragrance. Most leaf scents, too, are simpler in composition than flower scents and have stronger aromatic qualities.

The gentlest and softest of all spring perfumes is that of apple blossom. To walk in an apple orchard in full bloom in May is a joyful experience. But even if you do not own an orchard, one apple tree planted near a window that opens is enough to bring this soft perfume into the house.

Spring brings more garden fragrance when the hyacinth, grape hyacinth, and narcissus are in bloom. I wish that other nurseries would follow the example of an English one that is now selling a package of sweetly scented bulbs labeled "Antique Fantasy Mixed."

In Monaco for many months of the year the gardens are filled with the scent of orange blossom, jasmine, mimosa, and pittosporum. By midsummer, when I give outdoor parties, most of these are no longer blooming, so I cheat. I have some special metal tubes that hold water, and I fill them with tuberoses. I place these under the trees or in the flower beds and the air becomes fragrant and flowery.

In planning a perfumed garden remember that some flowers

This garden for the blind is part of the Wertheimstein Park in Döbling, Vienna. It has raised beds filled with sweetly scented flowers, and rails that make it easy for its special visitors to move about unattended. I wish that more cities would copy this excellent idea.

are more highly scented at certain times of the day. Few are at their best in the early morning, and come into full scent only when the sun goes down. The tobacco plant *(Nicotiana)*, evening primrose, night-scented stock, sweet rocket *(Hesperis)*, jasmine, and lily are among these. When you are browsing through the seed and plant catalogues, look for the key words *odorata* or *fragrans* after a name, for these will give you a clue to fragrance.

I was fascinated to read that only one in five people can smell freesias, yet they have one of the most powerful fragrances, especially on a sunny day. Certain flower scents appeal to some people but not to others, and not everyone likes those of phlox, marigold, and nasturtium. Also one should be careful in using strongly scented flowers as a table center. It may keep people from enjoying your food.

The grape hyacinth *(Hyacinthus azureus)* has one of the strongest of all spring perfumes. The little spikes of blue bells bloom in April. John Ruskin describes their pungency: "As if a cluster of grapes and a hive of honey had been distilled and compressed

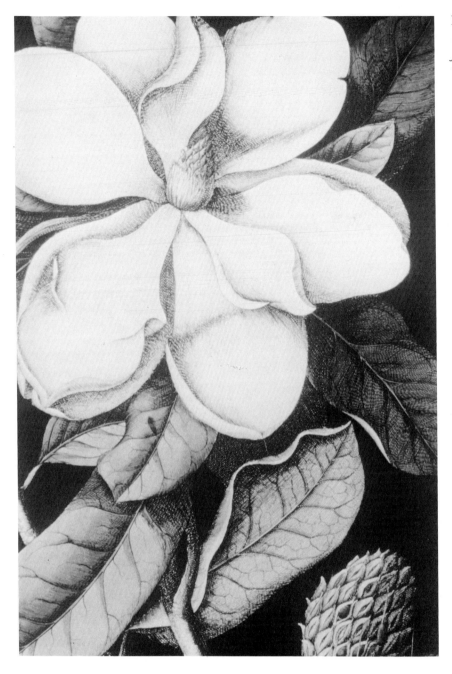

Magnolia grandiflora, *one of the greatest of the fragrant flower-bearing trees, is revered wherever it grows.*

together into one small mass of celled and beaded blue.''

In France the white narcissuss is often called by the name Jeannette. Its sturdy corolla is a trap of pure scent. It is a pretty custom in Paris for florists to make Easter eggs of its tightly packed white flowers. Tied with yellow ribbon, Jeannette eggs are the prettiest Easter greeting of all. They also do this with daffodils so that they look like floral pineapples.

Lilium regale is one of the most heavily scented in the European lily family. Every garden should have a clump of perfumed lilies. They are so undemanding out of season and will give you six weeks of sheer joy when they are in bloom.

For a more permanent waft of perfume there are so many

scented shrubs to choose from that need little attention apart from a yearly mulching. Shrubs like *Daphne Mezereum,* the witch hazel *Hamamelis mollis,* and the wintersweet *Chimonanthus praecox* all give fragrance to a garden besides charming sprays of winter flower arrangements when cut flowers are expensive. (Incidentally, the witch hazel was given this popular name from the fact that early settlers in America used a forked sprig as a substitute for a branch of the hazel tree when divining for water.)

It is a good idea when planning a garden to plant a buddleia tree in a sunny spot, not only because it gives off a sweet perfume, but also because it is a playground for butterflies in the summer. They seem to be attracted by its pollen. Other plants that add fragrance to a garden are berberis, corylopsis, tree lupine *(Lupinus arboreus),* many of the ericas *(australis* in particular), mock orange blossom *(Philadelphus), Wisteria venusta,* the allspice *(Calycanthus occidentalis)* from North America, azaleas, and lilacs. The Persian lilac, with its jasmine-like flowers, has an even sweeter scent than that of the common lilac. Richest and sweetest of all the tree scents is that of the magnificent laurel, *Magnolia grandiflora.* In the courtyard of the Hermitage Hotel in Monte Carlo is one of the most beautiful magnolia trees I have ever seen. The great primeval waxy, blooms shining amid the dark foliage spill out their perfume into the night air. Our Mediterranean myrtle bush, too, has few equals when it comes to sustained scent, especially if you crush the leaves in your fingers. The delicate flowers are white with a cluster of fluffy stamens like pins in a pin cushion, poking out from the petals.

I always marvel at the amount of intense scent that lurks in the fragile flowers of *Daphne odora* and *Daphne Mezereum.* When Australians are abroad, they are often homesick for the exquisite scent of the boronia bush. A small bunch of this sophisticated tiny brown bell, with bright lime-green lining, is enough to scent a room. There are over ninety varieties, many of which grow wild in Australia today.

In Victorian times it was fashionable to plant mignonette in pots that could be brought into the house from the greenhouse. Some Paris florists still sell them like this, and they can be cultivated to bloom year round if you keep cutting off the seed heads when they form. This quiet flower is astonishingly beautiful if you place an individual bloom under the microscope.

For summer fragrance the old-fashioned *Dianthus* (a pink), variety Mrs. Simpkin, is a splendidly scented border flower and mixes happily with the perfumed *Iris florentina.* It is this iris that for centuries has supplied the orrisroot of the perfumery trade.

Cherry-pie *(Heliotropium)* is another favorite from bygone days. Its perfume, which might have been used by La Grande Sarah Bernhardt, is sweet and sensuous. The ten-weeks stock *(Matthiola incana)* is another heady lady, and one or two spikes

should always be tucked into a summer flower arrangement for mid-year fragrance.

Of the climbers, no garden should be without a honeysuckle tumbling over some forlorn wall. If you find that it attracts wasps, plant a couple of lavender bushes nearby. You will have no more problems. For my pressed flower pictures I grow the common honeysuckle, *Lonicera japonica*, but there are many other, even sweeter-smelling honeysuckles. Some of the clematis family are scented but most are not. Try to find *Clematis Flammula*, which has bright green leaves and delicately scented white flowers. The heady jasmine (*Jasminum officinale*) looks bewitching when it mingles with the delicate white clematis.

I know of a great beauty who lives in Marbella, Spain. She always wears one jasmine pinned onto her blouse or dress, and it has become a kind of signature. Her friends find it so romantic and always associate her with jasmine just as Marguerite is associated with camellias in *La Dame aux camélias,* of Dumas *fils.* The real reason is that one jasmine is sufficient to keep a hundred angry mosquitoes at bay!

One of the most delicate of all flower scents belongs to the

old-fashioned sweet pea *(Lathyrus odoratus)*. Alas, horticulturists have sacrificed much in the interest of growing top-heavy sweet peas instead of the darling little scented varieties. They can be trained up sticks in wigwam fashion, grown in window boxes, pots, or in hanging baskets, filling a balcony with their tender perfume. Thoughtful seed merchants make up packets of the scented varieties.

And of course, there are roses. A Japanese girl once described the rose as having a "high society smell." Maybe the hybrid teas are becoming too inbred, but a garden filled with old-fashioned roses has a wondrous smell. It is strange that the chemist, with all his scientific wisdom, has not yet been able to produce a sweeter smell than the perfume of a cabbage rose on a hot summer's day. It has been proved that in the essential oil of the rose there are at least eight substances, the dominant one being geraniol. For commercial use the breeders have concentrated on creating new varieties for their durability as well as beauty. Fortunately, there are awards given to breeders for new roses with the sweetest perfume. It was a delightful experience for me in 1969 to be a member of the jury to judge this class in Monza, Italy.

The damask rose *(Rosa damascena)* has quite the loveliest fragrance of all, being a truly rosy perfume. Incidentally, they were originally brought to Europe from Damascus by the Crusaders. It is this rose that is used for making attar of roses. For every fifty grams of true attar two hundred twenty pounds of rose petals are needed.

Rosa alba, which is descended from the English white rose of York, is heavily fragrant, but there are few roses, I believe, that can equal the French Bourbon *(Rosa borboniana)*, which flowers almost continuously for five or six months. The French *gallicas*, which were grown in temple gardens by the Persians three thousand years ago, are ideal for the small garden, since they grow in compact little bushes. *Albertini*, with its delicate pink petals overlaid with an almost silver sheen, makes a garden redolent with its feminine perfume. There are several kinds of roses, such as *Fritz Nobis*, that have a special clove scent. But for me it is enough to bury my nose deep in the petals of *Ena Harkness;* there is no more rosy smell in all the world. *Grace de Monaco* is not bad either!

Most plants are nonpoisonous and therefore relatively safe in a garden planned for children or the blind. But there are some that are decidedly poisonous and should be treated reverently when small children are around.

Here are the names of some of them. Not all are fatal, but they can make anyone tempted to eat them very sick indeed.

Buttercup, cherry, crocus (autumn), daphne, elderberry (leaves), foxglove, hemlock, hyacinth, iris, jimsonweed, larkspur, lily-of-the-valley, nightshade, oleander, rhododendron, St.-John's-wort, wisteria, and datura.

Extrait de Miel.

8

Potpourri
and
Perfume

Je suis un vieux boudoir plein de roses fanées.

I am an old boudoir full of faded roses.

—*Charles Baudelaire (1821–67)*

Whether the heady fragrance of honey is tinged with orange blossoms or clover or wild flowers, the very word "honey" awakens feelings of pleasure and richness. An early-eighteenth-century perfume bottle of extrait de miel *suggests the delights of this ageless source of sweetness.*

I enjoy having bowls of potpourri around me, for they add a sweet scent to a room all year round. In olden days sweet-smelling plants were believed to have "a certaine magneticke qualitie." The physicians of the day, as well as fine ladies, carried small posies of scented herbs to ward off germs and diseases. According to an Elizabethan doctor, William Bullein, "the swete perfumes of the smoke of Olibanum, Benjamin and Frankencense" were the instant room fresheners of the day, and were capable of sweetening sickrooms filled with vile plague odors and making them fresh again.

In addition to carrying scented herbs as precautions, many of the ladies wore magical charms and amulets to ward off the terrible diseases that ravaged their bodies and especially their complexions. The three most common charms used were periapts, zenextons, and pomanders. While the pomander has remained with us up to modern times, the periapt and zenexton have almost

disappeared. But I found it fascinating to read about how they were used.

If you are lucky, you can still find later reproductions of peri-apts in antique shops. You can recognize them, as they are usually made of silver or ivory on little stalks and at one end there is perforated bowl that you fill with herbs. Apart from herbs such as rosemary, rue, and dittany *(Dictamnus albus)* they sometimes contained crushed pearls and emeralds and even powdered toads!

The zenexton is a sealed cylinder usually made of silver or gold and often engraved at one end with a talismanic figure of a coiled snake, and at the other end a scorpion. The filling, which contained quicksilver and myrrh, was carefully prepared according to astrological rules. In seventeenth-century England noblemen used to wear these charms tied with a ribbon over the heart, but the ladies of the day preferred to wear pomanders and each family specialized in its own design.

The pomander, a charming little notion, was mentioned as early as the thirteenth century, when it was given its Latin name, *pomum ambrae*, meaning apple of amber. Whether the pomander really did have any curative properties one does not know. But it was a lovely conceit and it lifted the mind, which is perhaps just as important.

As Oswaldus Crollius wrote in 1670: "For the odour, drawn by the nostrils, is conveighed to the heart and by it the comprest and suffocated spirit is excited."

It was from this prophylactic background that perfumed bracelets came into being, and no lady of fashion would be without her bracelet, which she wore, not only when she went out in the pest-infected streets, but always when she visited the sick.

This receipt, as I have mentioned that a recipe was then called, comes from *The Ladies Dictionary* of 1694. It contains roses and lavender and is great fun to make. Tied up with ribbon, pomanders make exceptionally pretty and unusual Christmas presents to hang in linen closets and to perfume drawers full of clothing.

Beat musk and ambergreece of each forty grains with two ounces of buds of damask roses to white being clipt off, and civet twenty grains; also a little labdanum, being well mix'd and fine beaten, make them up with gum-tragacanth disolv'd in rose water and so make them, when harden'd into small beads, and string them; the scent is rare and comfortable, or for another sort take labdanum and styrax calemite each a dram and a half: benjamin one dram, mace and ambergreece of each four grains, a little turpentine and gum-tragacanth dissolved in rose water, as much as will suffice, beat and mix well together in a warm mortar, and make them into pomander according to art.

To make this recipe work today, substitute for the ambergris and musk about four drops of essence of ambergris and the same of oil of musk. Instead of real civet use about 1 drop of civet essence. The damask rosebuds or a richly scented hybrid tea like

A romantic miniature called Unknown Youth Leaning Against a Tree *was painted by Nicholas Hilliard (1537–1619).*

Two delightful scents are those of the lavender and the May lily-of-the-valley; the air seems filled with their memorable unique fragrance.

Ena Harkness should first be dried and then ground in a mortar to a fine powder. The paste of gum tragacanth is made by stirring one teaspoon of the powdered gum into four tablespoons of triple rose water, which you can probably buy from most pharmacists. For "styrax calemite" use an equal amount of powdered frankincense. Instead of the turpentine, try using a little oil of cedar or some Venice turpentine.

It is very easy to make your own scented sachets. In the glove compartment of my car I always keep an herb sachet that was given to me while we were staying in New Hampshire one year on holiday. On hot, muggy Riviera days, when the mistral is prickling my nose and burning my eyes, I bury my nose in the sachet and in a moment I am right back in the pine forests of New Hampshire. There is no other smell like it, and though I have had my sachet for several years, the perfume is as strong as the day I was given it. I do not know the contents of my pine-scented sachet, but here is a suggestion for a delicious herbal mixture:

Take what you will of balm of gilead, fir, mint, bay leaf, sweet bazil, bergamot, a good deal of thyme, lavender, winter savory, potted and knotted marjoram, plain mint, lemon mint, thyme, musk, cinnamon, cloves, gum benjamin, one pound of coriander seed, one pound of caraway seed, one pound of rue, and a bunch of dried juniper berries. All these must dry well in the shade. Pound them to a fine mixture and pack into a bag.

To make your own flower-scented sachet here is a guiding

The heliotrope, whose name indicates that it turns its blossoms toward the sun, is known for its enchanting, delicate scent. And the citron fruit, whose pungent rind retains its strong perfume for a long time, has been used for centuries as an ingredient of sachets.

recipe by William Salmon in *Polygraphices*, which was written in 1701. It is said to keep its perfume for twenty years:

Take roots of orrice, damask roses, of each one pound, sweet majoram, twelve ounces, flowers of rosemary, and Roman camomil, leaves of time, geranium moschatum, savory, lignum rhodium, citron peel, storax, labdanum, cloves, cinnamon, of each one ounce; musk two drams, civet one dram and a half, ambergrise one dram, pouder and mix them for bags.

Again this can be made quite easily today by altering just a few of the ingredients. Instead of *Geranium moschatum* you are much more likely to grow the rose geranium *(Pelargonium capitatum)*, and this does just as well. Ten drops of oil of musk, six drops of essence of civet, and four drops of essence of ambergris make a reasonable substitute for the expensive natural substances. If all this sounds too complicated, why not make your own personalized potpourri? It is a pleasant experience to take a basket, with a clean sheet of blotting paper in the bottom, and walk from plant to plant around the garden, picking from this and that, not only with a nose for scent but an eye for color.

There are no hard or fast rules in making potpourri, but you must first decide upon the method: there are the dry one and the moist one. The dry method is perhaps the more convenient because you can add to it flower petals gathered during the whole of the summer period. All you do is to collect them and spread them out to dry on a garden sieve lined with muslin. This

lets the air circulate around them; otherwise they might mildew. They should never be dried in direct sunlight but rather in shade, as the fragrance is broken down by the ultraviolet light. It is important to gather the flowers when the blooms are on the point of opening and not after they have reached their peak. This captures the essential oils at their best, and it is these which give off the perfume. Leave your picking until the middle of the day, when any dew or moisture has completely evaporated.

Once you have collected enough petals, seal in the perfume by adding a basic mixture: to 2 quarts of dried petals and herbs, add a half ounce each of salt, orrisroot powder, cinnamon, nutmeg, cloves, and mace, and a quarter ounce each of benzoin and olibanum. A few drops of oil of geranium, orange blossom, or jasmine can be added for extra depth.

I have never succeeded very well with the moist method, but I am assured that it can be done most successfully and has a longer lasting perfume.

Select a basis of dried flowers and place them in a container. Top with a handful of bay salt and then more layers of petals and so on. When the jar is complete, seal and leave for a month. Here then is the foundation. From then on you merely add the heads of any fragrant flowers. To perfume your room, lift the lid and out comes a delicious perfume.

Roses are the best base for both the wet and dry methods, and the fragrant *Rosa gallica* or the deep pink damask rose (*Rosa damascena*) gives the most perfumed results.

Dry potpourris have the advantage that they even *look* pretty. Here are some flowers that are particularly suitable not only for their scent but for their color: jasmine, lavender, honeysuckle, heliotrope, mignonette, buddleia, carnation, daphne, philadelphus, orange blossom, lilac, peony, rosemary narcissus, lily-of-the-valley, and pink. Scented leaves can also be added, as well as dried herbs, but you must dry them carefully or mildew will ruin the whole pot. Some of the Elizabethan recipes I have read add the dried peel of orange and lemon to give a tang and to offset the slightly sweet perfume of a heady potpourri.

The most exotic potpourri that I have read about was made entirely of violet petals. It comes from *Ada Gibson's Receipt Book* of 1900. Mistress Gibson was a specialist in growing violets and she set out to achieve the perfect violet potpourri recipe:

Place alternating layers of petals in a crock with a handful of orrisroot and common salt mixture in the ratio of one to two. When the crock is complete moisten the whole with a strong rose water. To keep the potpourri moist and pungent, keep adding a tablespoon of rose water every month and gently stir it to bring up fresh petals to the surface.

Here is the English herbalist Nicholas Culpeper's recipe, handed down from 1650, for lemon-scented potpourri. It leaves a tired smoke-filled room smelling like a lemon orchard:

To about 4 pounds of dried rose petals add 3 cups of lemon verbena, lavender and lemon thyme, with the powdered rind of one lemon and one

orange (dry in the sun or very slowly in a cool oven or hot water cupboard). Leave for 48 hours. Then add half an ounce of spices (all spice, cloves and bay leaf all ground into powder) and half an ounce of orris root to fix the perfume. Stir daily for a week. The pot pourri is then ready to put out into dishes but keep tightly sealed when not in use.

Archaeologists working recently in Cairo claim to have discovered at least one secret of Queen Nefertiti's legendary beauty: she took care of her skin. To keep it soft, she used a potion of orchid leaves and honey. In her bath went the oils of eighty different herbs and fruits. For cleansing the pores of her face she used beauty masks made from honey, milk, and flower pollen.

One of the most beautiful complexions I have ever seen belonged to a lady well into her eighties—Lady Bateman, who wintered for many years in Monte Carlo. She confided to me that she used rose water on her face every day of her life. Since then I have done the same, hoping that by the time I reach eighty I may achieve the same result.

Most pharmacists sell rose water, but if you wish to make your own, fill a saucepan with petals from heavily scented red roses, add water just to cover, put a lid on the pan, and bring to a boil. Allow it to cool with the lid still on. Strain it when cold.

To give a room a rosy fragrance, simmer a little pungent rose water with a couple of spoons of sugar.

Nefertiti, beautiful Queen of the Nile, was elaborately attentive to her appearance, using countless potions and balms, oils and perfumes to achieve an effect that most likely is as well known now as it was more than three thousand years ago.

9

Food and Drink

Iseult's mother gathered herbs and flowers and roots and steeped them in wine, and brewed a potion of might, and having done so, said, "Take then this pitcher and remember well my words. Hide it so that no eye shall see no lip go near it . . . For this is its power: they who drink of it together love each other with every single sense and with their every thought, forever, in life and in death.

—"Tristan and Iseult," translated by Hilaire Beloc (1870–1953)

Love potions and magical brews have been dreamed of and talked about for as long as human imagination has conjured them, but no such potion is more real to us now than the one that inseparably and fatefully joined Tristan and Iseult—and it was made of flowers and roots and herbs.

During the month of August, when our family has its vacation, we move to our farmhouse behind Monaco. We enjoy so much the produce from our garden. This is a time when we can forget about sophisticated foods and eat the local specialties. As we can see Italy from our windows, we are influenced by Italian and Provencal foods, and of course our traditional Monégasque dishes.

One of the summer delights for eating out of doors is fried chicken with fried zucchini flowers. We grow the plants, which eventually creep along the terraces in the vegetable garden. They spill over, covering the supporting stone wall with their large, opalescent green leaves and trumpet-shaped brilliant orange flow-

ers. At first I hesitated to pick them, as they looked so decorative, but I soon learned that the flowers are much more delicate to eat than the vegetable, which in French we call *courgettes*. To capture the elusive flavor of the flowers, they should be dipped in thin batter and deep-fried in oil until crisp and curling at the edges. Pile the fried chicken pieces in the center of a platter and arrange the cooked flowers around the edge. It is an appetizing sight when served with a green salad sprinkled with mountain herbs. All our friends love it.

For decorating party fare, it is quite simple to crystallize flowers such as violets, and the petals of roses and carnations. I was entertained to read that Dame Agatha Christie, the Queen of Crime, who killed off so many people in her books, was at heart a shy, tender woman. Violets were her favorite flower, and a jar of crystallized violets or a box of violet cream chocolates sent her into paroxysms of happiness.

William Rabisha, who in 1675 wrote *The Whole Body of Cookery Dissected*, gave this recipe for candying all manner of flowers in their natural colors. It is similar to the way it is done today by professional cooks:

Take the flowers with the stalks, and wash them over with a little rose water, wherein gum arabick is dissolved; then take searsed [powdered] sugar, and dust over them, and set them a drying on the bottom of a sieve in an oven, and they will glisten as if they were sugar candy.

If the flowers are to be used almost immediately, they can be dipped in a thin syrup made from water and sugar and then rolled in sugar and set to dry in a warm place.

When sherbets were served as palate refresheners during those mammoth banquets at the turn of the century, a favorite was violet water ice. This is made as follows:

Clean a quarter pound of violet petals. Pour over them one and a half pints of syrup made from eight ounces of sugar cubes and a pint of water, gently boiled for ten minutes. Let it stand for ten minutes before straining and cooling. Add the juice of three lemons, then freeze the mixture. Decorate each serving with a violet bloom.

The gay little petals of the marigold, with their unusually pungent taste, have myriad uses. They should be blanched in hot water first and well drained before sprinkling them, petal by petal, over food. The French use them, instead of expensive saffron, in fish soup. They also give a distinct taste to creamy scrambled eggs. Two or three teaspoons of marigold petals added to a *risotto* make it look colorful and give it an unusual flavor. My favorite way of using them is to add two or three teaspoonfuls to a fresh green salad. The peppery nasturtium flower can also be used in salads, also the leaf of the dandelion, which is called *pissenlit* in French. I am told, though I have not tried them, that even chrysanthemum and dahlia petals are interesting in salads.

Country cookbooks often have recipes that call for flower

The sweet little old sisters of the comic drama Arsenic and Old Lace *lulled their lodgers to sleep (permanently) with a tasty new kind of elderberry wine made from the pretty elder flowers.*

petals in the making of wine. (Whenever elderberry wine is mentioned I think of Josephine Hull in that wonderful play *Arsenic and Old Lace*.) This recipe could not be simpler, but you can leave out the arsenic! On a hot summer day choose:

two or three large heads of elder flower. Strip off the little florets so that none of the bitter green stalk is left. Place them in a crock with one and a quarter pounds of sugar, the juice and rind of a lemon, and two tablespoons of wine vinegar or cider vinegar. Stir until the sugar is dissolved, cover, and let stand for twenty-four hours. Strain and bottle. It will be ready for drinking in a fortnight.

For a longer maturing wine with a glorious color, such as Hungarian tokay, I recommend the marigold again:

Pick four quarts of flowers on a sunny day and wash well to remove any little insects. Place in a large container and grate over it the rind of one orange and one lemon plus the juice. Add the marigold petals, which have been stripped from the stalks. Cover and leave for four days. Strain off the liquid and bring to a boil. Put three pounds of sugar into a bowl and add the liquid, stir until the sugar has dissolved. When it cools to

body temperature, stir in a quarter ounce of yeast, cover the bowl, and let stand for three days, stirring daily. Bottle and cork loosely at first. Top up the bottle if any of the liquid oozes out. Keep for six months. Delicious as an apéritif or with desserts and fruit.

The elder flower, with its haunting taste like that of the muscatel grape, is useful when cooking rhubarb, gooseberries, or plums. Once you have tasted gooseberries cooked with elder flowers, you will never eat them in the nude again. Just add a bunch tied in muslin to the berries when they are stewing. Gooseberry Fool, flavored with elderberry flower, is worthy of the angels. Even more delicious is an old-fashioned syllabub made with these useful flowers.

Cowslip wine is an old favorite with country folk, but as a nature conservationist, I beg you to pick the flowers only where they are really plentiful. Our countrysides are being denuded by people indiscriminately picking the wild flowers.

Again, you must pick your cowslip heads on a fine day. Press them down lightly into a jug, and pour over a gallon of boiling water. Leave for ten days. Now strain off the liquid into a bowl and stir in three pounds of sugar and a lemon thinly sliced. Spread a half ounce of yeast on a slice of toast like a raft and float it on top of the liquid. Cover and leave for three more days. Remove the toast, strain through muslin, and bottle. Though this can be drunk at once, it improves with keeping.

In ancient Rome roses were part of every festival. During the reign of Augustus they were served in some way at every meal, adorning the tables and the guests as well. The epicure Apicius left us this description of rose wine:

Thread together rose petals from which the white part has been removed and steep them in wine for seven days. Then take them out of the wine and in the same way put in other fresh rose petals threaded together, for another seven days. Repeat a third time, then strain the wine and add honey to make a rose wine. Take care to use only the best rose petals when the dew has dried off. Make violet wine in the same way.

The Compleat Housewife, by E. Smith, was the American Fannie Farmer or the English Mrs. Beaton for housewives in the eighteenth century. Here is the recipe from this book for making a syrup from any type of flower. It is refreshing in the summer topped up with soda water and makes a delicious poolside drink.

Clip your flowers and take their weight in sugar; then take a gallypot, and put a row of flowers and a strewing of sugar, till the pot is full; then put in two or three spoonfuls of the same syrup or still'd water; tie a cloth on the top of the pot, put a tile on that, set your gallypot in a kettle of water over a gentle fire, and let it infuse till the strength is out of the flowers, which will be in four or five hours; then strain it through a flannel and when it is cold bottle it up.

Rose petal jelly, which originated in Persia, is one of the most delicately flavored conserves that I know. This is made the same way as apple jelly, but the jelly is flavored with red rose

petals in the last quick boiling. The jelly turns a rosy pink and the petals become beautifully opaque.

Gwen Robyns lives in the country in Oxfordshire. In the sixteenth-century kitchen of Hollycourt Farm, where once the monks broke bread, she has tried many strange and exciting recipes. She tells me that her broom wine is like nectar, with a clear golden color. She uses the ordinary wild yellow broom but maybe our South of France genista (genêt) would give the wine a better bouquet. Here is Gwen's Château Hollycourt broom wine:

One gallon of water. Three pounds of lump sugar. One gallon of broom flowers. Rind and juice of two lemons and two oranges. Two table-spoons of yeast. Boil the sugar and water together with the lemon and orange rinds for a half hour. When lukewarm, pour over the flowers, picked from the stalks, and juice of the lemons and oranges. Stir in the yeast and allow to ferment for three days. Put into a clean dry container and allow to work for about a week to ten days. Then seal tightly and keep for six months or longer, when an excellent drink will be ready.

In Persian tradition meals are taken in a variation of the position shown in this detail from a 16th century Persian painting of a man receiving wine. Also traditional are the subtle flavors of mint, saffron, dill, parsley, turmeric, and rose water. Rose petal jelly, which originated in Persia, is one of the most delicately flavored conserves I know.

10 Roses

Mystery glows in the rose bed,
the secret is hidden in the rose.

—*Farid un-din Attar, twelfth-century Persian poet.*

The rose was consecrated, long ago, to Venus, Cupid, and Aurora . . . and to the Hellenic god of silence, Harpocrates, depicted with a finger to his lips.

I was walking around the palace garden one day with Julia Clements, when she said, "Oh, I have got you in my garden, but you haven't got me in yours." She had noticed some bushes of the *Grace de Monaco,* the highly scented, bright pink rose that the celebrated Meilland nurseries of Cap d'Antibes named after me. So when Julia went back to England, she arranged to send me a half-dozen *Lady Setons,* to be planted in our rose garden, to join friends such as *Madame Meilland, Maria Callas, Fleur Cowles, Bettina Grazziani, Baroness de Rothschild,* and many others. It is a lovely experience for a woman to have a rose named after her, and I am especially delighted since mine is grown by a special nursery that was created by a very special man.

Before we dip back into the history of the rose, I must recapitulate the creation of the rose *Madame Meilland,* better known throughout the world as the *Peace* rose. Once upon a time there lived in the French village of Chamboeuf a boy who loved roses more than almost anything else in life. From the age of eleven

Antoine Meilland worked among them. In the morning he helped his parents on their small farm, but after school he entered a world of his own when he was allowed to help the widow of a retired schoolmaster in her garden. Madame Mivière loved flowers, all flowers, but most of all she loved roses. Her garden was filled with the sweet-smelling old-fashioned ones like *Jean Liabaud* and *Duchesse de Ausstadt*, but the rose that fascinated young Antoine most of all was *Rosa Noisettiana*, which had also grown in the rose garden of the Empress Josephine at Malmaison.

*A*ntoine grew up from a sapling of a boy into a fine specimen of manhood, and his love of roses continued to increase. Few love stories are more satisfying than that of Antoine Meilland, who married Claudia Dubreuil. They had a son called Francis, who became a brilliant hybridist and many years later was to give the world the *Peace* rose as well as many other well-loved roses. There must have been a fairy godmother at the christening of Francis, for in time he fell in love with and married Louisette, the daughter of Francesco and Marie Elisabeth Paolina, friends of his parents.

One day in 1935 when Francis and Papa Meilland were looking at a trial bed of fifty new rose seedlings that had been culled from eight hundred, they noticed and remembered one in the corner labelled "3-35-40." Four years went by of watering, nourishing, and loving the small rosebushes before the first buds began to bloom. It was June 1939, and the air was filled with talk of roses as growers from several countries arrived at the nurseries at Tassin la Demi-Lune, near Lyons, in the early morning sunshine, for this is the time, when the dew is still on a rose's petals, that it is at its best.

There to welcome them were Papa and Francis Meilland, and the lunch table laden with many tempting specialties of the region, prepared by Louisette Meilland earlier that morning. The wine flowed as the sun climbed higher in the sky and in the trial beds the buds were beginning to uncurl their petals in the warm air. The growers walked among the roses and all eyes turned to 3-35-40. To the strong, satiny green leaves. To the sturdy, taut stem. To the roses themselves—such luxurious, generous blooms shading from the deep rich yellow of their throats to petals of old ivory fringed with a delicate pink. There was something so defiant about this rose as the growers clustered around, praising it in their various languages. The talk all that day was about the

The exquisite embroidery in Queen Marie Antoinette's bedroom at Versailles has recently been restored by Maison Brocart in Paris. The task took nine people eleven years to complete.

glorious 3-35-40. It even overshadowed any dark suspicions and rumors of war, which these men of roses were only too aware of.

Before leaving the nursery that night, they wished each other well with the hopes of making this meeting an annual event. They were not to meet again for several long and terrible years.

In September the new and costly cold storages that had been prepared to meet the rush orders and the new ground that had been prepared for the new graftings stood idle. War had been declared in Europe. The world had no time for roses. The rose nursery was turned over to the growing of vegetables to feed the people of France.

Just before communications throughout Europe were taken over by the various armies, Papa Meilland and Francis worked late one night making two small parcels of budded 3-35-40 and sent them away, one to a rose grower in Italy and the other to one in Germany. There are no international barriers among rose growers. But there was to be a third parcel. On a gray November day, in a mysterious way, there came a message from Mr. Whitting-hill, the American Consul in Lyons, himself a rose lover: "I'm

about to leave. If you like I can take a small parcel for you to America. Maximum weight—one pound."

Just one pound, but it was enough, and within an hour the Meillands had delivered to the American Consulate a bundle of budded 3-35-40 and one or two other favorites. It was addressed to Robert Pyle of Pennsylvania. This meticulously packed parcel traveled in one of the last aircraft to leave, along with precious consulate documents.

The months went by before news trickled through that the German consignment had not only arrived safely but was in bloom. The German rose grower called it *Gloria Dei* (Glory Be to God). Sometime later the Meillands heard that the other parcel had reached Italy. The Italian grower had searched for a suitable name and called it *Gioia* (Joy). But there was no word from America.

The war dragged on and the Meillands continued to survive, growing vegetables and budding and preserving what roses they could. They were long, hard, desolate years. Until September 1944. A month to the day after the liberation of France, by one of those miracles that are hard to explain, a letter from America was delivered to the Meillands in Tassin. It was one of the first to arrive in this once enemy-occupied country. The letter was from Robert Pyle. It told how the roses had arrived and been sent to growers in America who had not only raved about the perfection of the bloom but had placed their orders so that many Americans could grow it in their own gardens. The revenue from the sales had been carefully banked in the name of the Meilland family, and by now it was considerable.

It was also a letter filled with joy and blessed news. Mr. Pyle wrote: "Whilst dictating this letter my eyes are fixed in fascinated admiration on a glorious rose, its pale gold, cream and ivory petals blending to a lightly ruffled edge of delicate carmine.

"There it is before me, majestic, full of promise, and I am convinced it will be the greatest rose of the century."

*D*uring the years it had been in its new home 3-35-40 had been planted in many parts of America and had reacted favorably to most of the different kinds of soil. The American Rose Society had studied all the tests and agreed to organize a ceremony at which this remarkable new rose would be given a name. Two things had impressed the growers: the rose unfolded more slowly than other roses and it lasted longer. This meant that its over-all life was more than that of other roses.

There had been no way of knowing whether the Meilland

Madame de Pompadour was a great French beauty who filled her life with flowers. She often held a rose and wore elegant flowered dresses when she was painted. This portrait by François Boucher, named La Belle de Crécy, *was one of her favorites.*

family would receive the letter from Pennsylvania before that great Sunday, April 29, 1945, when all the rose growers of America gathered at Pasadena.

As two white doves soared into the California sky, 3-35-40 was given the symbolic name of *Peace* by Jinx Falkenburg at a christening ceremony. And just as fact is so often more compelling than fiction, on that very day, which had been planned so long in advance, Berlin, the key city of the European war, surrendered to the Allies. For the first time in six years peace reigned in Europe. Stranger still is the fact that a few months later the most discerning of American judges of roses gave the highest honor, the All-American Award, to the *Peace* rose at the same time war with Japan ended.

During the first nine years of its life outside France, entirely due to Robert Pyle's initiative, it was estimated that thirty million *Peace* rosebushes were flowering all over the world. With the accrued royalties the Meilland family were able to buy a nursery at Cap d'Antibes, where they are still to this day.

So that is the story of the Meilland family of Cap d'Antibes

and the *Peace* rose. It is this same nursery that in 1956, at the time of my marriage, named a rose after me, and I felt grateful and honored.

In the early 1970s a rose was named *Princess Stephanie* after our second daughter. She was there to christen it—a lovely, sturdy, bright young coral—and she is very proud of it. Our daughter Caroline has also had a rose named after her. It is a vivid red to match her personality. It comes from the Val de Loire nurseries.

People constantly ask me what is my favorite flower. The answer is that I have no favorites. Each has its own place in the flower lover's heart. Who can say that a buttercup shining in the sun like yellow enamel is not as enchanting as a white butterfly orchid tumbling out of a tree trunk in a Brazilian jungle? That the delicate beauty of a white wild anemone excels the orderly perfection of the petals in a white camellia?

My only distress is when I am given bouquets of wired flowers, stiff and tortured. For me a sheath of natural flowers is a sheer joy. They give me the same delight as, for instance, driving through the Delaware Valley in spring at the time of the dogwood and cherry blossoms. Or spending a summer evening in a Mediterranean garden. Or walking in an English garden in July through bowers of old-fashioned roses.

*W*hat is so special about a rose that it seems far more than a flower? Perhaps it is the mystery it has gathered through the ages. Perhaps it is the joy that it continues to give. Humans have constantly used it to transmit sentiments that they lack words to express, for the rose is different. It is one of the great visual contributions to human life. Its beauty is remarkable—from the wild rose to the immaculate beauty of the hybrid tea.

The story of roses began a long time ago. The oldest species is the dog rose *(Rosa canina)*. It is thirty-five million years old; a fossilized specimen was found in Montana. Naturalists examined the specimen and found it to be similar to the pale pink wild rose of summer, with its delicate set of leaves and cheerful red hips in the autumn. Its name is said to have come from Rhodanthe, a celebrated Corinthian, whose fame was such that even kings were suitors for her love. So numerous were her paramours that she sought refuge in the Temple of Diana, but her lovers were insistent and broke open the gates. Diana was enraged and turned the fickle Rhodanthe into a rose and her suitors into thorns. Rhodes, the isle of roses, is said to have taken its name from *rhodon,* the Greek word for rose.

Most of the roses in ancient Greece were grown near Mount Pangaion, but the sweetest scented of all were those of Cyrene. Greek gardeners were skilled in the propagation of roses. Theophrastus, a pupil of Aristotle, says: "Roses can be grown from seed, which is to be found below the flower in the 'apple' . . . As however the plant comes slowly from seed, they make cuttings of the stem, and plant them. If the bush is burnt or cut over, it bears better flowers; for, if left to itself, it grows luxuriantly and makes too much wood. Also it has to be often transplanted for then, they say, the roses are improved."

This extraordinary habit of setting fire to rosebushes was common practice, as the Greeks firmly believed that unless this were done there would be no roses the following year.

They consecrated the rose to Venus, Cupid, Aurora, and also to Harpocrates, the god of silence. From its dedication to Harpocrates probably arose the custom of suspending a rose from the ceiling of a lively meeting to make known that anything said then was of a confidential nature. No matter how late the night, how long the wine cup might circulate, how free the speech, as long as a white rose hung from the ceiling everything said was secret. Hence the phrase, used even to this day, *sub rosa.*

The saying may have been the origin of the papal custom of placing a consecrated rose over the confessional and may also have inspired the pontifical decoration of the Golden Rose, used in recognition of service to the Holy See.

The roses grown in the Greek countrysides were brought to Athens, where they were sold in the street markets, along with violets, lilies, cornflowers, iris, wild cyclamens, wild anemones, and so on. Wreaths and chaplets of violets or roses were so popular that they were worn on all festive days. The beautiful young men of Greece used to wear garlands of rose petals even in the morning! It was also the custom at the feasts of both Greeks and the Romans to decorate the tables with roses, in the belief that the flowers had a magic power that protected one from becoming intoxicated.

The Egyptians made their gardens in the fertile valleys of the Nile, where the soil was renewed each year when the river overflowed its banks. Here the rose gardens flourished and thousands of blooms were picked each day to be exported. The Egyptians were the first commercial gardeners. Whole shiploads of roses were brought from the warmer south to Alexandria. As the journey from Egypt took at least six days, the market gardeners invented their own way of keeping the flowers fresh. They put the flowers into copper vases called *amphorae,* which were open at the top and pointed at the base. These were then stood upright in slots in wooden containers. Though I have not tried it myself, I have heard that even today a good number of florists prefer to store their roses in copper because of the minerals that the

water absorbs from the metal containers.

The Egyptians did not know about pin holders for arranging flowers, but they developed their own technique, especially with roses. They simply arranged the stalks of the flowers in a base of sand, mud, or even clay, just as we use oasis, floral foam, or Styrofoam cones today.

Queen Cleopatra once had a whole lake scattered with different colored rose petals to impress her guests. When she set the scene in which to woo Marc Antony, she had an entire floor covered with rose petals up to twelve inches deep (some historians even say eighteen) over which a net was stretched. To reach her rose-strewn chaise longue, he had to pick his way over this heavenly scented mattress of petals. The effect, alas, has not been recorded by history.

The rose wreath as worn by the Romans was similar to the tightly packed flower leis that are made in Hawaii. The petals were threaded through the center and squashed flat together. It took many hundreds of petals to make one softly scented garland. The Roman nobles luxuriated in roses, and it is written that when Gaius Verres took up residence as governor of Sicily he not only wore a wreath of roses on his head but was carried about in a litter with cushions stuffed with rose petals.

The rose knew no generation gap in Roman times. Babes in arms were crowned with roses, and they were used for the dead to adorn the tombs. Young and old all wore garlands and crowns of roses. Lovers entwined each other with roses on their amorous trysts and at grand banquets even the slaves who served the food, the musicians, and the dancing girls were all rose-garlanded. In art print shops it is often possible to see sugary impressions of Roman banquets of that time where the whole canvas is one bower of rose petals. These prints do not exaggerate.

Nero is said to have spent a fortune by today's standards on roses for a single evening. The Romans ate rose pudding, crystallized rose petals, and rose honey. They drank rose wine, used rose vinegar in their salads, and filled their washbasins with pink rose water. Pliny estimated that thirty-two medicaments were prepared from roses. The Emperor Heliogabalus showered some of his luckless guests with so many rose petals that they were completely buried and finally suffocated!

The expression "a bed of roses" comes from the story of the tax man from Rome who was sent to collect dues in Sicily. He found the life there so spartan, compared to the comforts

The Rose of Malmaison *is part of a series of little paintings commissioned by Empress Eugenie on the life of the Empress Josephine. It depicts the idyllic life of Napoleon and Josephine at Malmaison where it hangs today.*

of Rome, that he had made a large mattress stuffed with rose petals on which he slept when he traveled.

Syria is said to have been named from a species of rose called *suri,* and the famed garden of Gulistan in a Persian saga was named from the roses that grew there in such fantastic richness. It took a five-day camel ride to thread through this colorful maze of roses.

With the spread of Christianity the growing of roses was spread throughout Europe by the Benedictine monks, as well as by other religious orders. The procession of Corpus Christi is

The Empress Josephine is responsible for bringing to Europe so many of the lovely flowers that grew in her homeland, Martinique. Hibiscus, camellia, mimosa, magnolia, and geranium were planted in the gardens she created at Malmaison, her palace near Paris. This painting of her, dated 1801 and completed when she was still Madame Bonaparte, hangs at Malmaison.

an old tradition of the Catholic Church. As a child, I took part in the procession we held in the grounds of my school at Ravenhill, where, along with several other little girls, it was my job to strew rose petals in the path of the Cardinal carrying the Blessed Sacrament. We did our strewing at a given signal from one of the nuns, and I always remember her anxious expression as she indicated that we should empty our handfuls and move along without getting under the feet of the Cardinal. Our shame and embarrassment were visible when we had thrown too enthusiastically in the beginning and had run short of petals before the end of the procession. Happily the custom of having such a procession still exists in Monaco.

In the world of public relations, flowers have often been used

to soften the images of political figures and parties. In France the rose is the symbol of the Socialist Party. In England it was the emblem of the Wars of the Roses in the fifteenth century. They were fought for thirty years between the two houses of York and Lancaster, and when they went into battle the soldiers of the House of York had the emblem of the white rose *(Rosa alba)* on their caps, while the Lancastrians chose the red rose *(Rosa gallica).* The end of these bloody wars was brought about by the union of the two houses by the marriage of Henry VII, of the Lancastrian line, to Elizabeth, heiress of York and eldest daughter of Edward IV.

*N*o story of roses is complete without mentioning the most famous book of all—*Les Roses,* by Pierre Joseph Redouté, who was born in Belgium in 1759. He was the grandson, son, and brother of artists and he himself has been called "le Raphael des Fleurs." His meticulous and poetic paintings of roses have never been surpassed. The first botanist to recognize his skill was Charles de Brutelle, who was at that time working on the Peruvian plants that had been collected by the French naturalist Joseph Dombey. Brutelle was ordered to hand over these collections to Georges de Buffon, then the Director of the Royal Botanical Gardens in France, but instead he brought them to London and worked on them in the library of Sir Joseph Banks, the eminent English naturalist, President of the Royal Society. Redouté accompanied Brutelle in order to learn the English method of stipple engraving. It was during this period that Redouté visited Kew Gardens, near London, and made a study of many of the rare exotic plants that were arriving there from all over the world.

Redouté's first important work was *Les Liliacées,* in eight folio volumes (1802–16). During the time of the Revolution, in his capacity as her former drawing master, he visited Marie Antoinette many times when she was imprisoned in the Temple, bringing her drawings of his plants and sometimes even the plants themselves. His visits were as if spring itself had come to her dreary prison quarters.

At Versailles, Marie Antoinette's bedroom has recently been restored. The embroidery itself was redone by Maison Brocart in Paris under the direction of the late Madame Brocart. The embroidery took nine people eleven years to complete. It would have taken one person ninety-nine years to do!

Two other great beauties, Madame de Pompadour and Madame Du Barry, had roses named after them. Rose Du Barry is

still a favorite color with French interior designers.

Redouté was more faithful to flowers than to royal causes, and it was during his period as floral master to the Empress Josephine that he attained the eminence he deserved. The capricious Josephine was a remarkable woman. As a lighthearted little girl called Marie Josèphe Rose Tascher de La Pagerie, she lived in the fertile islands of Martinique and grew up loving flowers. She went to France, and when she later married Napoleon Bonaparte she brought to the court her joy in gardening. Under her knowledgeable patronage, public parks and gardens burst into bloom. She introduced some one hundred eighty species of plants to France. Her exotic choices reflected her homesickness for the tropical paradise that she had left behind—hibiscus, camellia, purple magnolia, mimosa, geranium, and, strangely, the sweet potato. But roses were Josephine's favorite flowers.

At Malmaison her spirit is still everywhere. Roses provided her chief consolation during the sad days of her retirement and banishment from the man she loved.

An English gardener named Kennedy, who owned vine nurseries at Hammersmith in London, was given a passport during the Napoleonic Wars to enable him to go to and from Paris to prune the roses at Malmaison. There are no longer any of the same roses at the palace as in the time of the Empress, and they are difficult to find in rose growers' catalogues, as many of the names have been changed through the years. At Malmaison today there are a hundred fifty species of roses dating from 1912, but the rose beds are no longer laid out in the same way as they were in Josephine's day. Three roses from the Napoleonic period were donated by an Englishwoman, Miss Margaret Weiner, who was a great admirer of Josephine. They figure in one of the volumes of Redouté.

His magnificent work *Les Roses,* which was published in 1817, two years after Waterloo, and dedicated to the Empress, brought him fame and perhaps fortune. There is a touching story how, when Josephine lay dying with a desperately infected throat, she asked Redouté to go into the garden and pick some roses for her. This sensitive man, with the clumsy hands and homely robust looks, picked the most beautiful spray in the garden and laid it on the breast of the woman he revered. It was his personal gesture of farewell to her.

When Redouté, an old man of eighty, died in 1840, on his coffin was placed a wreath of roses and lilies bearing the inscription:

Oh peintre aimé de Flore et du riant Empire
Tu nous quittes le jour où le printemps expire

Oh, artist loved by Flora and the laughing Empire
You leave us the day the springtime dies

Rosa damascena aurora *in an engraving by Pierre Joseph Redouté, the brilliant French painter who has been called "le Raphaël des Fleurs." When the Empress Josephine lay dying, this sensitive man who was her floral master plucked a spray of roses from her garden and on his last visit to his beloved patron placed them on her breast. Redouté also created the elegant engravings of* Iris monnieri *and the rich* Dalea double, *which appear on the following two pages.*

Rosa Damascena aurora. *Rosier Aurore Poniatowska*

P. J. Redouté pinx. Imprimerie de Remond. Chardin sculp.

Iris Monnieri *Iris de Monnier*

Dahlia double

11 Legends

I don't share the opinion of those who think that people who love flowers are necessarily good. Even those who love animals are not always so; certain people love flowers and animals because they are incapable of getting along with their fellow human beings.

—*Sigrid Undset (1882–1949)*

*I*n this part of my book I bring you a collection of flower legends that I hope you will enjoy. They are about the flowers that we see in our garden throughout the various seasons of the year. Some may be true, others not. I leave it to you to decide. But they do make a walk around the garden more entrancing when you can say to the forget-me-not, "Oh, I know all about you."

Forget-Me-Not

I never look into the tiny flat face of the forget-me-not that my heart does not skip a beat. For in reality this flower with the innocent face is one of the most tragic of all. I am reminded of the legend of the knight and his fair lady:

They were walking by the side of the river when the bright blue flowers of the little myosotis growing among the weeds on

This nineteenth-century fashion plate is called "The Lady of the Lilies" and was designed by the French painter Horace Vernet in 1815. Flower-trimmed gowns were much in vogue at that time.

the bank attracted the lady's attention. The knight bent to gather some of them, but his foot slipped, and he fell into the stream, which was swift and deep. He was carried off by the current and only had time to throw the flowers to his ladylove with the words "Forget-me-not."

From all the legends about this tiny blossom, here is the one that touches my heart the most. I found it in a musty old book that had been written in 1845 and was now lying deep down in the bowels of the British Museum. Here is the legend just as I read it:

Forget-me-not
(*Myosotis*).

When the heaven and earth had been summoned into being, and man had been called to taste the joys and glories of the celestial Eden, every living thing was brought into Adam that it might inherit from him its befitting name.

And flowers of every varied hue were among the lovely objects that his eye did rest upon; and he named each of them according to its own peculiar form, or fragrance, or colour. He added, "Be ye mindful of the name by which the Image of your Creator hath called you". And it was yet but a short time afterwards that a floweret arrayed in the meed azure of the firmament, spake unto Adam, saying: "Lord! by what name didst thou call me? Of a truth it ashameth me that I did not heed it".

And the first man answered saying, "Forget me not". Then the flower drooped its head and went and hid itself in the lonely shade, beneath the bough that waveth over the murmuring brook, and there it biddeth mourning, and when the gentle hand of Friendship, or the finger of Love, stoopeth to pluck it in its lowliness, it still doth whisper softly—"Forget me not".

Then there is a modern story of two men trying to outdo one another in stories about the cleverness of their dogs.

The first related how his dog obeyed his every command—he brought his slippers, his pipe, his newspaper, and wouldn't touch his plate until given the signal to eat.

The other man said, "My dog does all of that, but he also speaks to me as well. One evening when dinner with my guests dragged on too long, I was suddenly aware of him at my elbow. In the excitement I had forgotten to feed him. Do you know what that dog did? He came across and placed in my lap a sprig of forget-me-not."

Marigold

"Flowers are happy things," P. G. Wodehouse wrote, and surely no flower is happier than the marigold. All yellow flowers are said to be "plants of the sun," and as the botanist Lyte wrote many years ago "the marigold hath pleasant bright yellow floures, the which do close at the setting of the sunne, and do spread and open againe at the sunne rising." The marigold was even called by early naturalists *sposa solis*—the wife of the sun—because

Marsh marigold
(Caltha palustris).

Marigold
(Calendula officinalis).

"it sleeps and is awakened by him."

The *Calendula officinalis* that we grow in our gardens is dedicated to the celebration of the Annunciation of the Blessed Virgin. The name calendula was given simply because this flower is in bloom in the calends of nearly every month.

A marigold wrought in silver is still among the prizes presented to the winning poet at the *Jeux Floraux* of Toulouse, simply because the marigold is associated with the founder of these flower games, Clémence Isaure. There is a story about the young Clémence. At birth she was dedicated to the Virgin Mary and placed in a convent not far from the old castle that belonged to the Count of Toulouse. A young boy of the village named Raymond fell in love with the gentle recluse, and as she sat one evening by the fountain meditating, she heard her name mingled with the plaintive notes of a guitar.

The young girl approached softly to the hedge and, parting the leaves, looked into the eyes of the young troubadour, who on seeing her said, "A flower be my reward. You have inspired my verses."

Clémence plucked a marigold and passed it through the hedge. The next day and many succeeding she went to the fountain to listen to the sweet songs of her Raymond. At length there came an evening when so sad, so pathetic was the song she heard that tears welled in her eyes and dropped on the marigolds that she held upon her lap. Little did she realize that Raymond was singing his last song before he left, as Count Raymond, to join his father at the head of a cavalcade going to war.

The days went by and the tears of Clémence fell beside the fountain as she prayed for the return of her loved one. But he never came back. As he charged with his horse he was slain, among the first to fall. When his body was found, over his heart was placed a withered marigold, the last bloom to have been passed through the hedge by Clémence.

In France the calendula is known as *souci*, which means anxiety, as traditionally and poetically this flower is associated with sadness. I have heard that in parts of America marigolds are called "death flowers" because of a tradition that they sprang from ground that had been stained by the blood of the Mexicans who were the victims of the cruelty of the early Spanish settlers.

Few plants have had so many popular names or so many legends woven around them as the marsh marigold. It has been called kingcup, butterwort, water-dragon, pool flower, and even drunkard. Sometimes, when growing with buttercups, it has been called publican or sinner. In Germany it is *Dotterblume* (yolk of the egg flower), in Holland it is *Goudbloem* (gold flower), in Italy *fiorrancio* (orange-colored flower), in Spain *yerba centella* (shining plant) and in France *caltha des marais* (cup of the bog).

Wallflower
(Cheiranthus).

Wallflower

I know of few sweeter experiences than to walk in an old-fashioned garden during the golden hours of a summer afternoon and brush by a border of wallflowers. They are not the prettiest of our garden flowers, nor the showiest, but their perfume is unforgettable. The generic name for wallflower is *Cheiranthus,* but the French know it as *giroflée violier* because it has the same heady, clove-like smell of all the stock family.

In some parts of the Middle East the wallflower is known as "blood drops of Christ," but I have not been able to check this derivation. I think much more credible is the name "bloody warrior," which it is called in certain parts of England. This is because of the steadfast way in which it clings to walls, sows itself in stony crags, and thrives on the barest land.

Like many other flowers the wallflower has an unhappy legend woven around its name. This time it comes from Scotland, where in olden times there stood a strongly fortified castle on the banks of the river Tweed.

Within the barren walls a young girl was kept prisoner by her father because she dared to declare her love with the young heir of a hostile clan. But love will find a way and the young gallant, disguised as a minstrel, sang his rescue plan for her to hear under her window. He told how at the sound of the moorcock's call she should steal to the ramparts where he would be waiting on the other side to throw up a rope. She was to attach it to the ramparts and then slide down into his arms, and they would make their escape. At nightfall, when the moorcock called, the young maiden was waiting. She slipped a cloak over her shoulders and ran to the top of the ramparts just as the cord swished up. She caught it and quickly tied it to the balustrade, but as she attempted to slide down the other side where her lover waited, tragedy occurred. As the poet Herrick describes:

Alas, the silken twist untied,
So she fell and bruised she died.
Love, in pity to the deed
And her loving luckless speed,
Twined her to the plant we call
Now the "flower of the wall."

Broom

I feel that broom is one of the most underrated members of the flower world. Just because it is so generous, prolific, and undemanding we are inclined to take it for granted. But the bees do not. It is said that wherever broom grows they never leave the hive. There are so many various types in this flower family, from the small delicate *Cytisus Kewensis,* so loved by flower arran-

Broom
(Cytisus scoparius).

gers, to the dazzling gold wild broom that sweeps the hillsides of Northern Europe, Australia, and New Zealand.

Above Monaco we have the sweet-smelling *Spartium junceum* (Spanish broom), each flower a golden capsule of perfume. From very early days the *Genista* has been the badge of Britanny, and, according to an early legend, the Dukes of Anjou took the name Plantagenet from a prince of their house, a man who not only murdered his own brother but took possession of his principalilty. However, remorse and grief overcame him, and it is said that after he had made a pilgrimage to the Holy Land he did penance every night by scourging himself with a rod made of *genêt,* or broom.

There are other, more cheerful broom legends, including the one wherein Count Geoffrey of Anjou, when leading his troops into battle, passed through a rocky gorge. He noticed the cheerful genista clinging from the crags. Plucking a flower from the rocks and placing it in his helmet, he announced to his men, "This plant shall be my cognizance. I will carry it on my crest into the battlefield." As he rode into combat he urged on his men with the ringing cry *"Planta genista, planta genista."* The effect was so startling that they routed the enemy. After this victory Geoffrey not only adopted the yellow broom as his emblem but also took the name of Plantagenet.

It appears that even witches have their favorites in the flower and plant world, and they love broom, thorn, and ragwort, which is called fairies' horse in Ireland. Witches are also fond of hemlock, nightshade, St.-John's-wort, and vervain.

Broom is considered by some people to be unlucky. Though farmers say that a heavy crop of broom flowers forecasts a good picking of fruit, some people attach sadness, even death, to this enchanting flower. An old proverb says:

> *If you sweep the house with blossomed broom in May*
> *You are sure to sweep the head of the house away.*

Hyacinth

The lovely mauve-blue hyacinth is another sorrowful flower. As the proverb says:

> *The melancholy hyacinth, that weeps*
> *All night, and never lifts an eye all day.*

According to the Greeks, Hyacinth was a charming youth beloved by both Apollo and Zephyrus. Hyacinth, however, loved the sun and gave his favors to Apollo. Zephyrus was skulking around one day and saw the two at play. Consumed with passion, he hurled a quoit through the air, which was carried by the wind toward Hyacinth. It struck his head and the youth fell to the

Hyacinth
(Hycinthoides non-scriptus).

119

ground. Apollo flew to his side and lifted the bleeding head tenderly from the earth, but his love was dead. From the blood that stained the earth Apollo raised a sweetly scented flower, which he named hyacinth.

Snowdrop

The snowdrop *(Galanthus nivalis)* is called by the practical French the "snow piercer," or more popularly *galant d'hiver* (winter's wooer). The name "drop" in English does not come from a drop of snow but from a drop worn as an earring, just as the fuchsia is known in parts of the English countryside as lady's-eardrop.

Peter Cotes, an English gardener and writer about flowers and gardens, claims that snowdrops are said to have arrived in England as late as 1854. His explanation is that the soldiers in the Crimean War dug the bulbs up around Balaclava and sent them home in letters to their sweethearts and wives. This may be so, but in the *Revised Herball* (1633) of John Gerard there is written: "a bulbous violet . . . but simply call them snowdrop."

There is an English fairy story that I like to believe. The gnome who made the snowdrops became tired of his job and wanted to change with the fairy who made the snowflakes. The result was so beautiful—snowflakes like blossoms and snowdrops like tiny lumps of snow—that the Almighty decided that the exchange should be permanent. If you ever examine a snowflake fluttering down in the sky you will see what I mean.

The snowdrop is also a symbol of purity and is dedicated to the Virgin Mary. The name Fair Maid of February was given to it because it bloomed on Candlemas Day, February 2. The Germans call the snowdrop *Schneeglöckchen* (little snowbell), and the Spaniards have a similar name, *campanilla blanca* (little white bell). The Welsh have given the snowdrop a special name, and they endearingly call it *clockmaben* (baby bell). The Dutch call it *witviodje* (white violet).

Of all the legends about snowdrops a German one is by far the prettiest:

At the Creation all things were colored in heavenly hues. The sky became blue, the clouds gray, the earth brown, the trees green, and the flowers all colors of the rainbow. There was nothing left when the snow approached his Lord God. He complained that as there was no color left he would be as little noticed as the wind.

The Creator looked down lovingly and asked the snow to go to the brightly colored flowers and ask if they could spare a color. All the flowers, from the haughty rose to the gay daffodil, refused to share their colors. As the snow turned back in desperation, he heard a small flower voice by his side saying, "If my white color is of any use to you, I give it to you gleefully." The

Snowdrop
(Galanthus nivalis).

Narcissus
(Narcissus augustifolia).

snow accepted, and since that time every winter in the cold lands the snow places a blanket on the ground to protect the snowdrops from the frost and keep them warm until spring arrives.

Narcissus

The fable of Narcissus is as true today as when it became one of the best known of all flower legends. In ancient Greece a thousand maidens wanted to give their hearts to a beautiful youth called Narcissus. Among them was Echo, who was rejected again and again until she grew pale and wasted away to a skeleton. One day, wearied by the heat of the sun, Narcissus lay down to rest on the grass by the side of a spring whose waters had never been disturbed. The boy bent over the pool and saw his own reflection. He was enchanted. "How beautiful," he sighed. He became so enamored of his own face that he slipped into the stream. The weeping Echo and the naiads, who were her sisters, covered his body with their long hair and asked the dryads to raise a pile of wood for his funeral rites. But when they came to find the body it was not there. It had descended down into the dark water of the Styx. Instead was found in its place a pale and melancholy flower which even now droops over fountains of water.

Violet

Next to the rose the violet was the favorite flower of the ancient Greeks. It was named *ion* after the nymphs of Iona, who were the first to present the flower to Jupiter. It became the badge of Athens, and orators wishing to gain favor with the people used to begin their addresses with the words "Athenians crowned with violets." Not only were garlands of violet worn at all fête days, but one of the prizes at the Floral Games was a golden violet. According to one tradition the violets were all white at first until one day Venus, envious of Cupid's admiration of their purity and sweetness, made them blue.

Whenever I see a cow grazing in a meadow of spring flowers in Switzerland I am reminded of the story of the beautiful young Io, priestess of Juno's temple. Jupiter was so determined to protect her from his jealous consort that he turned her into a cow! And when she was hungry and "stooped in tears, even as her lips met the grass there sprang from her perfumed breath the first white violet." Another version of this legend is even more romantic. It is claimed that after Jupiter had turned Io into a cow he fed her only with fresh violets.

But surely much more strange is the naïve violet's connection with French history and the Bonaparte dynasty. It was the *nom de guerre* of Napoleon I, who was called by his followers *Père de la Violette* (Father of the Violet). The story goes that when Napoleon left France for Elba he said that he would return again in

Violet
(Viola odorata).

the violet season. The word was spread among his followers, and in Paris, as well as on the shores of Lake Geneva, the secret symbol of recognition was the violet. They not only whispered the word *violette* but also wore rings made of a violet substance inscribed with the words *"Elle reparaîtra au printemps"* (It will appear again in the spring).

The wives of Napoleon's generals also used to wear violet ribbon in their hair, and audacious husbands used a violet ribbon instead of a golden watch chain. The violet was the symbol of liberalism, and Napoleon was toasted in the name of General Violette or Corporal Violette. When his followers met in the street, they asked the innocent question: *"Aimez-vous la violette?"* (Do you love the violet?) If the answer was yes, the inference was that the answerer was not a confederate, but if the answer was *"Eh bien!"* (Well!), they recognized a fellow conspirator and completed the sentence *"Elle reparaîtra au printemps."*

After Napoleon's escape from Elba, and his arrival in Paris on March 20, 1815, friends celebrated his re-entry to the Tuileries by throwing bouquets of violets along the route. By this time the violet and Napoleon were synonymous, so much so, that when Louis XVIII occupied the throne, it was positively dangerous to be seen wearing the poor little violet.

In England it was Queen Victoria who revived the fashion of wearing violets. During the latter part of her reign, after the death of Prince Albert, over four thousand plants were grown under glass at Windsor to supply the mourning queen.

One of the most piquant references to violets that I have unearthed was in a letter written on April 13, 1819, by John Keats to his beloved Fanny Brawne: "I hope you have a good store of double violets. I think they are the princesses of flowers, and in a shower of rain almost as fine as barley sugar drops are to a schoolboy's tongue."

In Russian literature there is a story called *"The Tzarina's Violet."* It tells how a certain sentry was put on duty guarding a particular spot that did not seem to demand much attention. Weeks and months and years went by before anyone was bold enough to ask the reason why. At last the sentry, now an old man, solved the question by saying that many years before a violet had come up unexpectedly on this spot. The Czarina, hearing of this, was so touched that she ordered a sentry to be put on guard over it. The flower had long disappeared but the sentry had continued to carry out his duties.

In recent times the violet was also the French writer Colette's favorite flower, and as an old woman sitting up in her bed, with her hair a wild halo of fuzz, and those penetrating dark-rimmed eyes, her greatest delight was a bunch of violets by her bedside.

When Gwen Robyns visited her toward the end of her life, this woman, who loved and understood flowers as few others

do, took her hand and beckoned her close to her bedside. Taking one violet from the bunch Gwen had brought, she said, *"Les yeux des violettes sont plein de rêves"* (The eyes of violets are filled with dreams).

Pansy

Pansy
(Viola Wittrockiana).

No flower has been given a more curious or prettier name than the pansy, derived from the French word *pensée*, a thought. Dedicated to St. Valentine, patron saint of lovers, it has collected such strange names as kiss me, kiss-me-quick, kiss-me-at-the-garden-gate, kiss-me-ere-I-rise, herb-trinity, jump-up-and-kiss-me, cuddle-me, three-faces-under-a-trinity, and, as Shakespeare said, love-in-idleness. King Louis XV of France is said to have selected this flower as an armorial bearing for his physician, François Quesnay, because of its "thinking" connotation.

Milk white pansies are among my favorites and once upon a time all pansies were white. It was not until this white flower was struck with a bolt from mischievous Cupid's bow that it became stained with purple and endowed with magic properties for use in love philters. Pansies are among the oldest flowers in the garden, and once they had a perfume even sweeter than that of their fragrant sister, the marsh violet (*Viola palustris*).

Christmas Rose

Hellebore
(Helleborus niger).

Helleborus niger is called Christmas rose because "it bloweth about the birth of Lord Jesus Christ." Colette loved it with an intensity that bordered on passion. Her description of this elegant winter flower is so sensitive that only she could have written it:

The hellebores hibernate, full of promise, unexpected, precious, prostrate but fully alive. As long as the snow lies over them, they stay shut, ovoid, and on the outside of each bulgy petal the vaguest suspicion of pink seems the only sign that they are breathing. The healthy star-shaped leaves, the stiff stems, so many characteristics by which the whole plant proclaims its touching determination to live.

One of the most poignant of all flower legends is that of the Christmas rose. When the Three Wise Men lay offerings of gold, frankincense, and myrrh at the feet of the sleeping baby Jesus, a young shepherd girl stood by weeping. She, too, loved the new babe, but she was so poor and the winter so severe that there was not one flower poking its head through the snow for her to pick. An angel passed by and, seeing the shepherd girl weeping, leaned down and scooped away the snow, and the tearful eyes of the girl grew wide to see nestling in the snow a single white rose. "Nor gold, nor myrrh, not yet frankincense," said the angel, "is offering more meet for the Christ child than this pure rose."

Carnation
(Dianthus Caryophyllus).

Carnation

Few flowers have inspired such ecstasies in legend as the carnation. For the Greeks it was a divine plant dedicated to Zeus, god of the elements, and it was called by the name it still retains—flower of flowers. The early Romans called it *flos Jovis*, or Jove's flower, and gave it pride of place in garlands used in coronations. Today in Italy, because of its delicious, warm clove-like smell, the carnation is called *garofano*, the word for clove. By the time the name arrived in England, it had passed through many mutations from gyroflee, girofir, gillyvor to gillyflower. In the seventeenth century the botanist John Parkinson described carnations this way: "But what shall I say to the Queens of delight and of flowers—carnations, gilloflowers whose bravery, variety, and sweete smell joyned together, tyeth every ones affection with great earnestnesse, both to like and to have them."

Carnations abound on the French and Italian Rivieras, where the hillsides are covered with carnation farms. You can see them from afar with their low-lying frames shaded with straw matting from the sun. In the gardens of the palace in Monaco, in the days of my husband's grandfather, Prince Louis II, there were terraces facing the sun devoted to growing only carnations, which were the flowers mostly used to decorate the palace.

A beautiful Italian legend concerns the house of Ronsecco. Many hundreds of years ago at the time of the Crusades, a daughter of this noble Italian house, named Margherita, loved a brave knight called Orlando. Wedding plans had been made, but Orlando was called to go with other knights to the Holy Land to deliver Christ's tomb from the infidels. Margherita wept tears and more tears as her lover clasped her in his arms. "Farewell, *anima mia*," he called. "Be true, my beloved," she sobbed. From her bosom she plucked a white carnation and pressed it to his heart.

One whole year went by before a strange horseman rode up to the castle and asked for Margherita. His tidings were sad as he told how Orlando had fallen in battle against the Saracens and from his dead body had been taken the withered flower that he had now brought back, together with a lock of Margherita's fair hair.

The arrow had pierced through the silken bag containing the carnation talisman, and the blood of Orlando had partially stained the once snow white flower to a deep crimson hue.

Margherita took the relic in her hands and was determined to bring life back to the flower. She planted and watered it, hoping that some seeds contained life. Each day she talked soft words of love to the pot until one spring day small spears of green began to sprout through the brown soil. She watered them with tears over the next few months until the first flower bud began to form. As the petals began to unfold, she looked deep into

the heart of the carnation and saw that the center was marked by a deep crimson stain, just as Orlando's blood had stained the white carnation.

This daughter of the Ronsecco family never married and she carried Orlando's love to her grave. Her father was so stirred by her fidelity that he ordered that a carnation be embodied in the family crest. Margherita left as a legacy to her sisters the red and white carnation plant with instructions that each daughter of the house of Ronsecco should receive a vase of carnations on the day of her birth.

Perhaps the carnation's most poignant role was the part it played in a final attempt on August 28, 1793, to rescue Marie Antoinette from the guillotine. She was being held in Paris, when a royalist nobleman who was willing to risk everything to save his queen entered her cell with the jailer, who was a secret friend. He threw a carnation behind the stove and signaled to the Queen that it was important. When Marie Antoinette was left alone she picked up the flower and found among the petals a tiny note from a loyal courtier. It told how money was being raised to bribe her guard, Gilbert. As she had no pen to write an answer to the nobleman, she used a needle to prick out a message on a scrap of paper, which she offered to Gilbert. The guard, confused by an offer of a large sum of money, filed an official report of the incident to his superiors. Poor Marie Antoinette was then placed under heavier security and the plan failed. On October 16 she was executed. Though the Queen had torn up the note, her tragic reply is now preserved in the National Archives in Paris.

Lily-of-the-Valley

I chose these to carry on my wedding day. The delicate little white bells with the sweetest of all perfumes are still known as May lilies; a more amusing name is "ladders to heaven," though I have been unable to find out why they are called this. In all of Scandinavia and Germany, families flock to the countryside in June to pick bunches of the Virgin's tears. The flowers are smaller than the cultivated ones, but each one is unbelievably delicate. In Germany, too, it is the custom to decorate the house at Whitsuntide with *die Maiglöckchen* (little May bells). In France the custom is to offer or wear *muguets* on the first of May.

Anemone

The anemone derives its soft name from the Greek word *anemos* (the wind), and this is why it is sometimes called the windflower. For the Greeks the gentle white anemone was the "bride of the West Wind," the gentle Zephyr. At one time the pale bride was a favorite in Queen Ghlor's court, and Zephyr was so enamored of her that at last the Queen drove Anemone from her court. Zephyr, not to be outsmarted, transformed Anemone into

Lily-of-the-valley
(Convallaria majalis).

Anemone
(Anemone nemorosa).

Winter aconite
(Eranthis hyemalis).

a delicate, star-like flower that he loved to caress.

I choose to accept the more romantic version of this legend, wherein Aphrodite, mourning her beloved Adonis, wanders weeping through the woodland. Zephyr, hiding nearby, turns each crystal tear into a flower as it falls upon the moss and leaves. And that is why to this day the most pure and beautiful white anemone is always found in the heart of the woodland.

The Romans devoted certain flowers to their deities. The poppy was given to Ceres, the lily to Juno, but it was to Venus that the anemone was given.

In Israel there is a legend that the red anemone was growing at the foot of the Cross at the time of the Crucifixion and received its color from the red blood of Christ. This species is known as the "blood drops of Christ."

Aconite

The winter aconite *(Eranthis hyemalis),* which pushes its small yellow face through the cold soil, looks like a buttercup but has a ruffle of green foliage around it. It is sometimes called New Year's gift. The Indians call the aconite *ativisha,* which means "supreme poison," and in Germany it is called *Teufelswurz,* or devil's herb, because the milk-like substance that it gives off after plucking is considered the most virulent of poisons. The common monkshood, *Aconitum napellus,* takes its name from the curious hooded upper petal.

There is a legend that the aconite was among the terrible poisons that Medea used when she tried to kill Theseus after he returned to make himself known to his father, King Aegeus. Just when Theseus had become close again to his father, the wicked Medea, "looking more beautiful than the day," offered him a golden cup of liquid.

"Drink, my hero, of my charmed cup that gives rest after toil, which heals all wounds and pours new life into the veins."

Theseus was obsessed by her. He looked into her deep, dark eyes but then suddenly came to his senses. Within these pools were the eyes of a snake. He took the cup and handed it back to Medea saying: "The wine is rich and fragrant and the wine bearer as fair as the immortals, but let her pledge me first that the wine may be sweeter from her lips." Medea feigned temporary illness but Theseus insisted. Lifting up his club, he shouted, "Thou shalt pledge me in that cup or die." Medea let out a spine-chilling cry and dashed the cup to the ground, and when the wine flowed over the marble floor the stone bubbled and crumbled. Medea knew that she had been outsmarted and, calling her dragon chariot, disappeared over the horizon.

Father and son were united, the town rejoiced, the King's heir had returned, but the aconite, the poor little aconite, henceforth ranked among the herbs of evil omen that grow in dark

and lonely places. A terrible story for such a charming flower.

Poppy

"Light headed! And jingling like a sleigh-bell, but very far from empty. Once the flower is in full bloom, a row of small tap-holes under its round corona snaps open to sprinkle a fine powder over the well pitted earth where the next poppy will grow, the poppy of the coming year, the great scarlet poppy. Good Lord, how beautifully arranged it all is! Why don't we copy this perfect model of a salt cellar, pepper-pot, or sugar-castor for strawberries?" So wrote Colette about *Papaver Rhoeas,* as the poppy of the cornfield is called. The trivial name *Rhoeas,* which means "to fall," was given to the poppy because of its ephemeral petals. Alas, no flower droops and fades more quickly than the dancing field poppy.

The poppy has inspired a host of legends beginning with Venus, who was sometimes represented as holding in one hand an apple and in the other a poppy. But it was Diana, the huntress, with whom young Greek maidens associated the poppy. A maiden used to test the fidelity of her lover by placing in the palm of his hand a poppy petal. With the edge of her hand she then slapped the poppy. If it responded with a sharp crack, it meant that he was true to her, but if it broke without a sound it meant unfaithfulness. They called the petals "telltales." I believe that in Switzerland and Italy this love test is still performed by country girls.

The poppy, which today is being destroyed by chemical weed killers, was believed by ancient Greeks to be necessary in wheat fields as a natural fertilizer, and sacrifices to Demeter, goddess of fertility, included not only wheat and barley but also poppies. They were also endowed with health-giving properties, and Greek athletes training for the Olympic games were given a mixture of poppy seed, for its high fat content, and honey and wine.

The Persians used to sprinkle poppy seeds on their sweet rice and honey cakes much as is done on some types of bread today. The Poles have a special cake, *tort Makowy,* made from poppy seed, eggs, almonds, and sugar. When the seed of *Papaver orientale* is ripe, I like to shake the large fat heads and just eat the seed as it is. It has a strange nutty taste, quite delicious. The red poppy seed, of course, has nothing to do with opium.

When Archduke Maximilian of Austria with his lovely and accomplished Belgian-born wife, Carlota, accepted the crown of the Empire of Mexico, they crossed the seas to take possession of their new country. In keeping with French tradition they wished to create an order to bestow on their subjects as a mark of honor. The Empress decided that the color of the ribbon should be bright red. When Napoleon received the request, he objected strongly as only Napoleon could. "Red," he said, "is the color I have

Poppy
(Papaver Rhoeas).

Peter Carl Fabergé, the nineteenth-century Russian jeweler, was a genius in creating jeweled flowers for the ladies of the court of Czar Nicholas II. While much of the collection has remained in Russia, there are many of these exquisite objets de vertu in private collections and museums throughout the world. This fragile spray of buttercups is in the collection of Madame Josiane Woolf in Paris.

chosen for my own Order of the Legion of Honor, and I do not wish to have it copied by anyone else." Not to be outdone, the high-spirited Empress wrote back and enclosed a scarlet poppy she had picked from the field, declaring that "the Order of Nature came before the Order of the Legion of Honor."

Each time I pass through the northern part of France in the poppy season, I get a lump in my throat when I think of the American boys who are buried there. Fields of white crosses lie alongside fields of red poppies.

Spring Crocus

"When winter, slumbering in the open air, bears on his softened looks a dream of spring, a little flower awakes, a happy flower that, smiling up from the hard, chill sod, bids us be of good cheer, for, lo! the winter is past, and the time of blossoms and the singing of birds is at hand." So wrote a romantic over a hundred years ago about *Crocus aureus*, which Sophocles called "crocus of the golden beam."

According to another legend, the crocus, hyacinth, and lotus were among the flowers that formed the couch for Zeus and Hera where they lay on Mount Ida making love, screened from the fierce rays of the sun by a cloud. This legend is said to have inspired Milton to choose the crocus to carpet the bower of Adam and Eve in *Paradise Lost*.

There is an Eastern legend telling of the birth of the Buddha. The trees bent down to shed their leaves to make a couch for Queen Maya when her time was near for the birth of her child, and the earth "put forth a thousand sudden flowers."

A similar story concerns the birth of Confucius. When the animals came to greet his mother after the birth, there was a sound of sweet music and the air was filled with flowers that fell at her feet, appearing as if from nowhere.

Cornflower

Has there ever been a bluer blue than that of a cornflower picked in dazzling sunlight. Take a small floret and hold it close to your eye. To look through the petals is like seeing sunlight streaming through a stained-glass window. The cornflower *(Centaurea cyanus)* is one of the few flowers that one wishes the horticulturists had left alone. Now we have candy pink and we have white, but neither has the character of the original blue.

In Russia the cornflower is called *basilik*, which means "the flower of Basil." According to a Byzantine legend, the name comes from a handsome youth who was enticed into the cornfields by a beautiful *rusalka*, or nymph. Alas, his happiness was short-lived, as she turned him into a cornflower.

That the cornflower was the darling of the Russian court we know from the way Peter Carl Fabergé chose it for his jeweled

Crocus
(Crocus purpureus).

Cornflower
(Centaurea cyanus).

Edelweiss
(Leontopodium alpinum).

flowers. One of the most graceful fables of the Russian writer Ivan Krylov, "The Cornflower," tells of the kindness of the Czarina to him during a dangerous illness from which he was not expected to recover. He cherished the cornflower that the Czarina had sent him, and he asked in his will that on his death it be buried with him, together with the laurel wreath presented to him by the authors of Russia at his jubilee celebration. And this was done.

There is also the charming story of Queen Louise of Prussia, who when forced by Napoleon to flee Berlin, hid her children in a cornfield. They were small and became restive, and in order to keep them quiet she made little wreaths of cornflowers for their heads. Many years later, when Wilhelm was Emperor of Germany, he remembered the blue field flower and in honor of his mother's bravery made it the emblem of unity.

Edelweiss

Anyone who has been to Switzerland will remember the edelweiss, the tough little mountain flower called *Leontopodium alpinum.* This name was given for a very odd reason: that the flower, encased in furry leaves, was supposed to resemble the paw of a lion (*leon*, lion, and *podium*, foot).

Wherever you look in Swiss villages you find the edelweiss, carved in wood and bone, and made into glass ornaments. For years inconsiderate tourists picked the flowers high in the mountains until the Swiss Government became concerned enough to make their national flower a protected plant. Today anyone caught picking a root is prosecuted.

With young Swiss girls the edelweiss is something very special, equivalent to the orchid corsage that our boy friends gave us when I was a girl. But in the case of the edelweiss this love token was not bought from a florist but had to be picked high in the mountains. And so the flower became a symbol of courage and daring, as well as love and tenderness. In earlier times the Swiss mountaineer was often so poor that he had little else to offer his beloved.

Peony

The lovely peony is one of the oldest cultivated flowers in the world. It began its life, as far as we know, in China, where it was known to have been in existence fourteen hundred years ago. In the Chinese language the name means "the most beautiful," and the fourth month of the year was called "the moon of the peony." Five thousand years ago, when the Western world was still barbaric, the Chinese had gardens of breathtaking beauty, with hillocks, waterfalls, flower-covered rock formations, miniature bridges, "islands of eternal youth," and "islands of unending happiness."

An emperor of ancient China greatly loved flowers and called

Peony
(Paeonia officinalis).

his peonies "the roses of spring." New varieties commanded a very high price and it is said that one specimen was sold for a hundred ounces of gold. Though the peony was first grown for medical reasons, soon the ladies of the Chinese court began to love it for its fragrance and delicacy. In the imperial gardens in Peking there were peony plants that were said to be two hundred years old.

The Western name of peony comes from Paean, the Greek physician of the gods. He allegedly cured the gods of their wounds by applying the root of the peony. It was said to drive away tempests, dispel enchantments, and cure epilepsy. But like many of these cures certain ceremonies were involved. For instance, the patient must not taste the root of a peony if a woodpecker were in sight, for if he did he would be instantly struck blind. Nor could the plant be taken until a certain hour at night when the moon was in a given phase. And like the mandrake it must be uprooted at night by a hungry dog enticed with the smell of rotten meat. Some of these beliefs may have existed because the seeds of the peony are said to be phosphorescent and to shine eerily in the dark. But on the other hand, the English herbalist John Gerard makes nonsense of all this and says "for the roots of peinie as also the mandrake, may be removed at any time of the yeere, day or hower whatsoever."

Chrysanthemum

It was in the autumn after the Prince and I were married that I first saw chrysanthemums in the market in Monaco. They always remind me of the fall in Philadelphia, and of football games, and in America they are considered a very happy flower, so I bought an armload of big fluffy ones to take back to the palace. My husband was horrified when he walked into our sitting room, where I had a huge bouquet of these beautiful bright yellow mums. What I had not known was that in the South of France they are regarded as flowers for the dead. In America our Memorial Day is in May and calla lilies are usually considered the mortuary flowers.

Shamrock

Though the shamrock is not a flower, I must include legends about it because of my Irish heritage. One of my treasured pieces of jewelry is a shamrock pendant made from rock crystal. I wear it often and each time think of the stories connected with this three-leaved plant, which the Irish adorn themselves with, no matter where they are, on March 17, the day of St. Patrick of Ireland.

There are many versions of the legends concerning the original shamrock. One old writer claims that the Christian Irish held the *seamrog* (shamrock) sacred because of its three leaves united on one stalk, and they dedicated it to St. Patrick because he taught

Chrysanthemum
(Chrysanthemum indicum).

them to understand the mysterious doctrine of the Trinity by means of its three leaves. According to legend, when he landed at Wicklow in A.D. 433 he found a trusting but simple people. In order to explain to them the mystery of the Trinity he plucked a trefoil from the grass and cried, "Is it not possible for the Father, Son and Holy Ghost to be One, as for these three leaves to grow together on a single stalk?"

The Irish people were convinced and were ultimately baptized by St. Patrick. This holy herb was also thought to be effective against the stings of scorpions, and, according to one legend, it was with a shamrock that St. Patrick drove out the snakes from Ireland.

The leaf that is generally recognized as the Irish emblem is that of the white clover *(Trifolium repens)*. The name shamrock seems to be generic and applies also to purple clover, speedwell, pimpernel, wood sorrel, and even watercress! Clover was used in the festivals of the ancient Greeks. For many years it was regarded as sacred by the Germans. To most Western people it is considered lucky when it has four leaves, and it is called a cruciform clover. It is said that an Irishman will sleep with one under his pillow to dream of the girl of his choice, and an Irish maiden slips one into the shoe of her lover, without his knowledge, when he takes off on a long journey. It works as a charm to bring him back safely to her.

Shamrock
(Medicago lupulina).

Rose

Of all the flowers, the rose has the most legends woven around it. Each one is more beautiful than the next. A fascinating one, I think, concerns the moss rose.

After a long and arduous day doing good on earth, an angel sought shelter from a storm in a garden, for his heart was weary. Seeing the tired angel, a young red rose opened her blushing petals to him. He crept into her heart and slept the night away. Next morning he looked at the beautiful rose and wished to thank her. There was no way he could make her more beautiful, so with a loving glance he threw about her a veil of moss to protect her beauty, then he flew to heaven.

The prettiest moss rose legend of all, which is German, concerns the lowly moss plant. "The roses," the moss sighed, "grow so high and free, and blow so sweet and red, while I lie and have neither scent nor flower." Just then Christ entered the leafy glade and cooled his feet on the soft green moss. As he passed, there sprang from his footsteps the first moss roses.

In Germany there is a touch of old folklore that tells a maiden: "Wear three roses, one dark red, one pale red, and one white, for three days, three nights, and three hours, placed above your heart in such a manner that no one can see them. Say three Our Fathers, three Hail Marys and make the sign of the holy cross

three times. Then immerse the roses for three days, three nights, and three hours in a bottle of wine and serve some of it to the object of your love without his knowing what is in the wine, whereupon he will love you with all his soul and remain faithful to you all his life."

America has its own collection of rose fables. Perhaps the best known is that of the Grant rose. In 1835, during the Seminole uprising in Florida, a settler by the name of Grant was returning home when he was attacked by Indians. After mutilating him, the Indians tracked back to plunder his house. Mrs. Grant heard them coming and took to the forest with her child, but the Indians heard their footsteps and followed them. They stabbed both mother and child to death. The ground became blood-soaked, but from it grew a rose of darkest red and great beauty.

One modern saint who has been particularly connected with roses is St. Theresa of the Infant Jesus. She is also known as the Little Flower of Jesus. While this young French girl was out walking, in the 1880s, with her father, she announced to him her desire to enter the Carmelite Order. He stopped by a low wall and showed her some little white flowers that looked like miniature white lilies. He picked one and gave it to her, explaining how God had created it and protected it to this day. Theresa wrote later: "I thought I was hearing my own story; so close was the resemblance between what Jesus had done for the little flower and for little Theresa. I received this flower as a relic as I saw Papa pick away all the roots without breaking it. It seemed destined to live and grow in other soil richer than the moss where it was found."

One of her favorite feast days was the *fête Dieu* (Corpus Christi), the Feast of the Blessed Sacrament. As a child, with her white dress and circle of flowers in her hair, she had thrown flowers in the path of the Lord. This simple gesture of a child held deep significance for her:

To throw flowers is to offer a promise
The lightest sighs—the greatest sufferings
My woes, my happiness, my little sacrifices
There are my flowers!

She had a vision of the Blessed Mother, who promised to send a shower of roses. Later, during her illness, one of the sisters placed some flowers on her lap, ". . . thinking they might give me poetic inspiration . . . I was really not looking to that just now. I much prefer flowers to stay balancing on their stems." At the time of her death the odor of certain flowers was noticed in the room, with no reason or explanation, as all the flowers surrounding her coffin were artificial. The room was filled with a strong perfume of violets, and the next day lilies, two flowers symbolizing modesty and purity.

Moss rose
(Rosa centifolia muscosa).

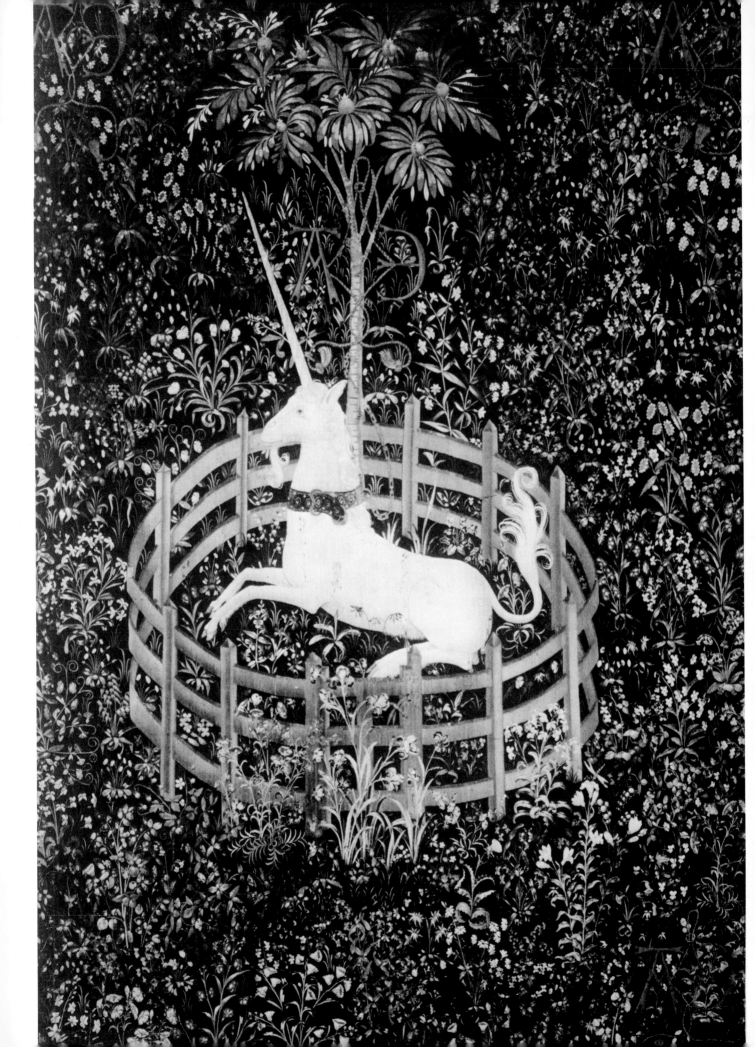

12 Art

Should the most able master in design attempt to represent by that alone a rose . . . we should have but a faint and imperfect image. Let him add its proper colours, we no longer doubt; we smell the rose.

—*Daniel Webb (1700–73)*

*W*hen man first began describing his life in sign language, the plants and flowers around him were not the first things to interest him. Paleolithic artists left plants severely alone. They concentrated on animals. There is a good explanation for this, as the pictures of the animals that were drawn on the walls of caves were meant to cast a spell over their victims and so make it easier to catch them for eating. Flowers were unimportant.

The earliest record of flower wall paintings was found by Sir Arthur Evans at Amnissos, near Knossos, Crete. It was a painting of the Madonna lily. It is wonderful to realize that fifteen hundred years before Christ the Minoans realized the decorative possibilities of this lovely flower.

The manuscript of Pedanius Dioscorides, the *Codex Vindobonensis,* is one of the earliest books known on flowers and was compiled in Istanbul at the beginning of the sixth century. It shows four

The Unicorn in Captivity *is the final tapestry in the* millefleurs *set called* The Unicorn Hunt. *Woven in silk, wool, and metal, the tapestries are sprinkled with many kinds of flowers. This tapestry, which is one of my favorites, hangs in the Cloisters Museum, New York City.*

hundred species of wild flowers of the Mediterranean, including the poppy, anemone, violet, rose and, of course, wild thyme, all of which can be found today in Greece in the spring. It is known that the Greeks produced herbal records as early as the time of Theophrastus (370–285 B.C.).

The acanthus was a favored plant of the Greeks, and it grows freely on the Riviera. When I look at its beautifully sculptured leaves and elegant flowers, I am reminded of the reason why it came to be used so much in Greek decorative arts. The saying goes that a young girl of Corinth fell ill and died. At her burial her nurse collected all her trinkets and jewelry and placed them in a basket near her tomb. To save them from being harmed by the weather, she covered the basket with a tile and placed it on the ground over a root of acanthus. With the coming of spring the sap rose and the dried roots began to produce leaves, which spread themselves from underneath the basket and then bent back again at the top by the corners of the tile. It so happened that Callimachus, a sculptor, was passing by and was so delighted with the beauty of the curved leaves and stalks that he conceived the idea for the capital of the Corinthian column. Whether this story is true, it is the kind of simple folklore that I like to believe.

The Egyptians were extremely conscious of plant and flower forms, and theirs too was a visual and practical appreciation. They took the natural form of the palm tree and used its trunk as the original for the Egyptian column. The foliage for the capital was taken from the lush vegetation indigenous to the banks of the Nile. The harmonious form of the palm appeared not only as decoration for public buildings but in everyday household objects such as textiles, ceramics, tiles, and even hand-painted materials used for clothing.

Egyptian paintings were of figures and objects in profile, and the shapes and colors used in many instances were just like those that one finds in children's art. Flowers there were, and today one can see huge murals that tell of the Egyptians' understanding of flowers and leaves in decoration.

The Romans were the first to use flowers in the same abundance as we do today. Considerations of shape, texture, and color, combined with flowers' lovely perfume, appealed to this sensuous, luxury-loving people. They used flowers for every occasion. When Roman warriors returned to their families after battle, they expected to be welcomed with flowers. At their banquets not only the tables and columns were decorated with flowers, but even the slaves who served the food!

With the establishment of the Christian church, flowers played an important part of worship. In the fourth century Emperor Constantine ordered new and often magnificent churches to be built. They differed sharply from the simple catacombs and tiny ancient chapels of before, and artists were summoned to beautify these

The column, one of the basic architectural forms, has long been designed and decorated in conformance with plant and floral motifs. The Egyptian column, often massive in girth and soaring in height, contained stylized lotus and papyrus flowers. In later times the capitals of Greek and Roman columns were often elaborately enriched by flowers, leaves and stems of a variety of plants, and Western architecture still offers countless examples of them.

new edifices. Symbols and emblems were introduced. A symbol stood for an abstract idea, whereas an emblem denoted a concrete one.

When the Virgin Mary appeared in a painting holding a lily in her hand, this was a symbol of purity, but if a lily appeared alone it was an emblem representing the Queen of Heaven. In this way flowers began to be interwoven into the pageantry and beauty of religious art.

For artists of the thirteenth century it was natural to announce an angel's goodwill by placing a branch of olive in his hand, or to illustrate the immaculate purity of the Virgin Mary by placing a pot of pure white lilies by her side. In this way ordinary people began to learn how to read the religious paintings that were beginning to adorn their churches.

If you look closely at the flower of the columbine or aquilegia, you may note that it resembles a dove in flight. In the French miniatures of the thirteenth and fourteenth centuries the columbine was always painted to represent the Holy Spirit. Flemish artists were most meticulous in their symbolism and usually painted the plant with seven blooms. These are the seven gifts of the Holy Spirit—wisdom, understanding, counsel, fortitude, knowledge, piety, and modesty.

Though the lily came to be associated with the Virgin Mary and the virgin saints, it was also attributed to the Archangel Gabriel and so became his own flower symbol. Various female saints who are always associated with the lily in religious paintings are Catherine of Siena, Clare, Euphemia, and Scholastica. It is also the attribute of Anthony of Padua, Dominic, Francis of Assisi, Francis Xavier, and Joseph, the husband of Mary. One of the most explicit of these paintings, in the Prado, Madrid, is of St. Barbara, who is seated, reading, next to an iris that is called "the royal lily."

One of the most tender of all religious paintings depicting flower symbolism is in the Uffizi Gallery in Florence. It is the *Adoration of the Shepherds,* by Hugo van der Goes, which was painted between 1474 and 1476. The painting was ordered for the chapel of the Florentine Hospital of Santa Maria Nuova. It is part of a triptych: on the sides are the donor and his family and in the center is the Adoration. The painting has a hypnotic quality. The infant Jesus lies like a naked doll in a pool of light on the floor of the manger. Kneeling beside him, her hands held in supplication, is the Blessed Mother. Angels in jeweled headdresses kneel around the edge of the picture, while the gentle oxen look on from their stalls. But it is to the front of the picture that the eye travels. Two vases of flowers, painted with exquisite precision, are the key to the picture.

There is a transparent glass vase, a symbol of the Immaculate Conception. It contains three red carnations, typifying divine love,

Here is part of the Adoration of the Shepherds *by Hugo van der Goes, which hangs in the Uffizi Gallery in Florence. Though flowers are used symbolically in this painting, the simple arrangements and the plain vases are most effective.*

and a spray of columbine, symbols of the Seven Gifts of the Holy Spirit, with which the infant was endowed at birth. The pottery vase standing next to the one of glass contains orange lilies and purple and white iris. These are not *Lilium candidum,* the flower representing the Madonna's purity, but the child Jesus's own emblem as King of Heaven, as he said, "I am the flower of the field, and the lily of the valleys." Scattered beneath the vases are white and purple violets and a sheaf of corn. The violets symbolize humility, for Our Lord lies on the ground as a babe, and the corn and the vine (pictured on the vase) are the Eucharistic substances used in the sacrifice of the Mass.

Hugo van der Goes used in his *Fall of Man* the same flowers as in the *Adoration.* Adam and Eve stand beneath a tree from which Eve reaches for an apple. A lizard-bodied tempter stands behind the tree, but in the foreground are iris, columbine, violet, a rosebush on the brink of blooming, strawberry plants, and a pansy, which was most unusual in this period.

Another outstanding religious painting filled with flower symbolism is *Paradise,* of Giovanni di Paolo, in the Galleria di Belli Arti in Siena. The panel was painted in 1453 and represents the Last Judgment. Heaven is depicted as a hill, as the prophet Esdras described it as "seven mighty mountains on which grow roses

and lilies." Though the prophet said, "Saith the Lord . . . I have sanctified and prepared for thee twelve trees laden with diverse fruit," Giovanni di Paolo took artistic license and painted only six trees, as his canvas could not contain twelve. Beneath these trees wander people in affectionate embraces. Newcomers to heaven are being welcomed by others who have gone before them. Love is everywhere. There are quite obviously no special seasons in heaven, since on the bank in the picture lilies, roses, violets, and strawberries bloom in profusion.

During the fifteenth century in Florence the lily was already attributed to the Virgin Mary as a symbol of her peerless purity, and so it became accepted through the whole of the Christian world. On the rare occasions after the fourteenth century when the lily appears in the hand of the infant Babe, its intention is to represent his perfect sinlessness.

*T*he first adorations were nearly all created by the great Florentine masters in the fifteenth century. Neri di Bicci painted roses and lilies (Accademia, Florence), and Luca della Robbia not only placed the Holy Child by a group of lilies but crowned Our Lady, who knelt before him, with royal fleurs-de-lis (Bargello, Florence). Only Botticelli, in his *Adoration,* seems to have preferred to use the daisy instead of the lily, combining it with the violet of humility and the strawberry (Uffizi, Florence).

The symbolism of the lily and the iris at first appeared to be identical in the early Flemish masters. Rogier van der Weyden painted both flowers in a vase before the Virgin and the iris alone in another picture of the Blessed Virgin with the Holy Child, which is in a Berlin gallery. Ghirlandajo placed the iris, violet, and daisy all growing from the bare ground of the stable in his *Adoration of the Shepherds* in the Accademia, Florence.

The Spanish painters were quick to recognize the symbolism of the iris, a flower that they knew well, as it grew wild on their hillsides. They invested the same idea of royalty in the iris as did the Flemish, and adopted it as the royal lily of the Virgin.

The rose has always captured the artist's imagination. One of the most beautiful of all religious paintings is in the Pitti Palace in Florence, attributed to Francesco Botticini, where angels playfully sprinkle rose petals over the Infant Jesus in a rose-trellised garden. In one of Velásquez's rare religious pictures, *The Coronation of the Virgin* in the Prado, God the Father places upon her head a chaplet of red and white roses.

In pictures of Florentine origin the rose in Our Lady's hand

has a special meaning, as it illustrates her title of *Madonna del Fiore* (Madonna of the Flower). The cathedral of Florence was dedicated to Our Lady of the Flower.

In the majority of Italian Renaissance paintings the Virgin's tomb is usually flower-filled. In the oratory of San Bernardino in Siena there is a fresco by Il Sodoma that shows the Virgin Mary ascending from the tomb brimming over with roses. From among them springs one mystic lily—her own flower symbolizing her purity. The Vatican has a similar picture by Raphael showing a single lily rising from among the roses.

As a general rule in religious paintings roses massed together, in garlands, baskets, vases, or hedges, are the symbols of heavenly joys, and single roses are the symbol of divine love. There is one exception to this. It is the Golden Rose that is the gift of the popes and is equivalent to a benediction. The sending of the rose dates from the time of Gregory the Great, when on the fourth Sunday in Lent it was blessed by the Pope and sent by him to a sovereign, church, or community. Sometimes the rose took the form of whole bushes about two feet high covered with leaves and flowers. Two such bushes—one, with long, sharp thorns curved downward (presented by Pius II), and the other, thornless (presented by Alexander VII)—are treasured by the city of Siena.

With the exception of the rose, all the flowers of Our Lady in early paintings are either white or blue, her own colors. White is the symbol of loving kindness, virginity, and charity. Blue is the color denoting chastity, innocence, and candor.

The Virgin is seldom pictured with violets, but there is one notable example. At Cologne, in the beautiful altarpiece by Stephan Lochner, the Infant Jesus stretches up his tiny, chubby hand to grasp a violet held by the Virgin Mary.

Throughout the great museums of Europe we are fortunate to have carefully preserved paintings of the early saints. Flowers play a natural part in these pictures as much for their symbolic meaning as for decoration. The most interesting painting of St. Catherine is by her friend Andrea Vanni and is regarded as one of the great art treasures of Siena. In her left hand she holds a bunch of *Lilium candidum.* Because of its association with this saint it is often called the St. Catherine lily.

The medieval *millefleurs* tapestries, which were made in France, are some of the most entrancing examples of the uses of flowers in art. In the fifteenth century the art of tapestry making had reached its height, and these works were collected by the rich with an almost manic extravagance. Whereas the sun-loving people of the Mediterranean decorated their houses with frescoes, in the northern countries tapestries were used to adorn the walls and often to keep out drafts.

Philip the Good of Burgundy was such an impassioned buyer that he is said to have had a staff of eighteen guards just for his

tapestries alone. Louis VI at his coronation insisted on hanging tapestries from the façade of his town house so the citizens of Paris could see them. According to one chronicle "there was such a multitude of them that he had them hung over one another."

During the French Revolution many of the most famous tapestries disappeared. The Unicorn tapestries were used to store potatoes in and one of the most cherished of all, the *Apocalypse,* now in the tapestry museum at the Château d'Angers in France, was used to protect orange trees and stuff cracks in walls. Happily they all survived their fates.

For flower lovers the most tantalizing of medieval tapestries is undoubtedly the Unicorn series. *The Lady with the Unicorn* set, which is now in the Cluny Museum in Paris, is a fairly straightforward metaphor relating to the five senses. For instance the cloven-footed horse with a goat's beard gazes at itself in a mirror to

*Another Florentine artist
of the fifteenth century,
Domenico Ghirlandajo, painted
this lovely* Adoration.

signify sight. The set of tapestries called *The Unicorn Hunt,* which can be seen at the Cloisters Museum in New York, is much more complex and violent. I was fortunate to be able to see both collections exhibited together in Paris and was fascinated by the contrast.

A favorite of many people is the final tapestry in the set, the *Unicorn in Captivity.* Against a *millefleurs* background he lies with an alert expression, meekly fastened by a chain to a pomegranate tree. There is a feeling of resigned acceptance of his fate. Almost all the flowers in the tapestry have been identified by botanists, and the colors are so brilliant that one might think they had been woven yesterday.

It was during the seventeenth century that flower paintings became the collector's art, especially in the Low Countries. With the establishment of the Dutch East India Company a prosperous middle class developed, and whereas previously the wealth had been in the hands of court circles, now it was the turn of the ordinary people to decorate their houses. With ships going to all parts of the world, the rich merchants living along the canals in Rotterdam and Amsterdam began commissioning flower paintings, which had become a status symbol.

When Catholicism was challenged, huge religious canvases were now less popular, and, even more important, small decorative flower paintings brought color and life into the dark, airless living rooms stuffed with heavy furniture. The painters, many of whom had done only portraits before, now turned to everyday life for inspiration in their still-life pictures. They painted fruit, fish, and vegetables as well as every kind of flower and insect.

The holds of sailing ships returning from all parts of the world contained not only cargoes "of diamonds, emeralds, amethysts, topazes, cinnamon, and gold Moidores [Portuguese and Brazilian gold coins]," but roots and cuttings, bulbs and seeds from the new lands. The dahlia arrived from Mexico, fuchsia from Santo Domingo, calceolaria from Chile and Peru, and hibiscus from Mauritius. Most notable of all were the tulip and hyacinth, which came overland from Persia. The drama of tulip mania in Holland has been well documented, with single bulbs reaching astronomical prices. There is a story that one particular tulip bloom was passed from painter to painter, as its red color flushed with yellow appeared in several paintings of the same period.

The arrangement of the flowers in these still-life paintings was highly stylized and often took as much ability to construct as the painting itself. In many cases the paintings also had hidden meanings. The regal flowers at the top represented the nobles of the court, the less important flowers in the center the middle classes, and the wild flowers at the base the peasants. The flowers were often painted so that the front, back, and sides were shown and thus they became in effect a true botanical record.

Pictures of flowers by the great masters, inch for inch, are among the most costly of all art forms, for to paint flowers perfectly demands perfection in taste, perfect brushwork, drawing, coloring, and composition. The artist must satisfy the gardener, botanist, and himself.

According to Colonel Maurice H. Grant, an English authority on the subject, "In all the three hundred known years of their production the total practitioners in flower [painting] down to 1880 is less than seven hundred and of these by no means all are florists *pur sang,* that is to say unassociated with various forms of still life." More than two hundred of these lived in the late eighteenth and nineteenth centuries and at least half were women.

Painters have always enjoyed teasing the gardening experts. As in the *millefleurs* tapestries, there were apparently no seasons with the painters: hyacinths appear in pictures with roses and early jonquils with peonies. A possible explanation is that during the four flowering seasons the artists made sketches of the various flowers to be used in later compositions. Their pictures were created in fact from a selection of sketches, much as the flower arranger chooses a particular flower from a mixed bunch to add a splash of color and create a focal point. Often drops of water or tiny insects, such as a bee or ladybird, were featured in these paintings. They were placed there as often as not so that the artist could show off his virtuosity.

We flower arrangers of today, I feel, have much to learn from the old masters such as Lodewyck Jansz van den Bosch, Jan Breughel, Rachel Ruysch, Jacobus van Huysum, and later painters such as Van Gogh, Matisse, and Picasso. They invariably chose the simplest containers, such as a basket, earthernware crock, or simple glass vase, as backgrounds for their arrangements.

There is a piquant story about the Dutch painter Elias van den Broeck, who was born in Antwerp in 1653. He was apprenticed to a goldsmith before he switched to painting. In Antwerp he worked for an art dealer from whom he received an annual grant. Just when he was most successful, he was forced to leave Amsterdam, having lost his clientele owing to a rumor started by his enemies that instead of painting butterflies in his pictures he stuck living ones on the canvas. It cost him his reputation.

It is Marc Chagall, the Russian émigré painter who now lives at Saint-Paul-de-Vence, above the French Riviera, who perhaps has summed up flowers in art better than anyone else. This wise old man once commented, "Art is the unceasing effort to compete with the beauty of flowers—and never succeeding."

The making of flower collages from tissue paper is an old-fashioned art that has been revived in recent years. The technique is quite different from that of pressing flowers, though, the results are not dissimilar.

In the Print Room of the British Museum is a remarkable collection of several hundred paper flower collages, which can be seen on written application. They are the work of Mrs. Mary Delany, and her story is as refreshing as that of Grandma Moses. This remarkable woman was born in 1700, the daughter of Ber-

nard Granville, younger brother of the notable Lord Lansdowne. Her youth was spent in the household of her aunt Ann, who was maid of honor to Queen Anne.

It was a cosseted period: the young ladies of the household were taught the gentle arts of painting, singing, sewing, and composing romantic madrigals. The household was well appointed and there is no doubt that Mary would have had every opportunity to see beautiful objects around her.

On the death of Queen Anne the Granvilles fell from favor with the Tories and Mary's social life was curtailed. In those days there was nothing left for young ladies in distressed circumstances except marriage. While staying at Longleat with her uncle, Lord Lansdowne, she met Alexander Pendarves, who was described at the time as being "a fat, sulky old man of sixty." Mary was horrified, but in accordance with her family's wishes she married Mr. Pendarves in 1717. From the start the marriage was a failure,

The simplicity of this silk brocade made during the eighteenth century in Japan is an inspiration for flower arrangers today and illustrates that sometimes the best effects come from using containers as simple as a woven basket.

The delightful paper flower collages of the Englishwoman Mary Delany, a great artist, are as delicate and fresh and clean-cut as when she fashioned them in the eighteenth century. On these two pages are, left to right, the brilliant yellow hollyhock, the Grass of Parnassus, the horse chestnut, and the Phlomis Leonurus, *known as* Leonotis Leonurus, *or lion's ear.*

a terrible failure. Fortunately it came to an end seven years later, when Mr. Pendarves conveniently died. Mary was left a comfortably off and rather attractive widow. It was on a trip to Ireland that she became acquainted with the Reverend Patrick Delany, and, although her noble London friends were indignant, she married the vicar in 1743 and lived happily with him until his death in 1768.

It was not until 1774, when she was seventy-four, that Mrs. Delany began her incredible paper collages. In the following ten years she made more than a thousand specimens, hundreds of which, alas, have been lost over the years. The precious collection in the British Museum was bequeathed in 1897 by Lady Llanover.

What makes these collages so special is their delicacy and quality. Here is a sublime artist who, with nothing more than tissue paper, a paintbrush, and a pair of scissors, created botanical pictures of sheer perfection. For instance, in the spray of lilac *(Syringa vulgaris)* not only is each flower meticulously cut from

tissue paper, but several shades have been used to give them their especial life-like quality. The green leaves are delicately painted with a water color brush to mark the veins.

Mrs. Delany's patience must have been endless, her fingers incredibly nimble, and her eye impeccable. The result is almost a three-dimensional effect that is truly lovely. Each design—and the range includes field flowers, flowering trees, and rare tropical flowers—is mounted on black tissue paper and signed MD discreetly in the lower right-hand corner. Some were made up into large albums, others left loose in boxes. The British Museum has samples of both.

Mrs. Delany's fame reached King George III, who in 1785, when she was eighty-five, gave her a house at Windsor and a pension of three hundred pounds a year, a considerable sum in those days. Here she continued her labor of love until she died three years later, leaving behind her vast collection. The collages are so beautiful that they are worth a trip to London to see.

13 Poetry

We introduce ourselves
To Plants and to Flowers
But with ourselves
Have etiquettes
Embarrassments
And awes.

—*Emily Dickinson (1830–86)*

*F*lowers have been the inspiration of poets and writers since time immemorial. Their very names—periwinkle, delphinium, dianthus, briar rose, heliotrope, columbine, and morning glory—spill from the tongue in sweet sounds.

Flowers symbolize the evanescence of human life. They are the omens of love and hope. Of beauty and promise. Even of death. The poets who write about flowers are divided into two classes, the lyricists, who give their words to the beauty of flowers, and the symbolists, who use flowers as a reflection of the human condition. I have chosen from each class, though to me it is the vividness of description that makes flower poetry so beautiful.

William Shakespeare, who spent his boyhood in the rolling green countryside of Warwickshire, had a great love and knowl-

We might never have known the soft, smooth feel of the finest silk without the mulberry tree, the food of most silkworms. Think of the many times you have read about the tree, its green leaves, and its edible dark purple fruit.

edge of the country and flowers. Though not a botanist, nor even a gardener, in the number of references he made to trees, plants, and flowers he is surpassed only by the Old Testament writers. Though Geoffrey Chaucer had a keen eye for nature, his observations were not as detailed as those of Shakespeare.

It was in 1953 that I first visited the town of Stratford-upon-Avon, or Stratford-on-Avon, as it is now called. During a recent visit I had several days in which to explore Stratford and the surrounding countryside. I was amused that in the small pubs, of which Stratford has many, the old men still refer to the bard as "Our Will," as if he had died only a few years ago. To them he is still a local lad.

As I walked through the narrow streets, it was not difficult to picture the town as it must have been in his time, for even then it had a busy market. By mentally blocking out the surrounding streets of small houses it is easy to picture meadows golden with cuckoo-buds, which was Shakespeare's name for buttercups. In *Love's Labour's Lost* he refers to them:

> And lady-smock all silver white
> And cuckoo-buds of yellow hue
> Do paint the meadows with delight.

And as I walked along the banks of the Avon I understood at once what Shakespeare meant by "swan sweet Avon," and why he made the fragile, demented Ophelia cover her head with weeds and flowers from the banks of the river. He would have seen the river every day of his boyhood and watched the village maidens garland their heads with wild flowers on heydays and holidays.

Shakespeare's parents would certainly have had an apron garden filled with homely flowers. As a child he would have been brought up with the names of heartease (pansy) and gillyvoir (carnation).

Shakespeare's heroine Imogen deserves all the flowers of the countryside. She is one of the most lovable characters in all of his works. In Act IV, Scene 2, of *Cymbeline* there are these words:

> With fairest flowers,
> Whilst summer lasts and I live here, Fidele,
> I'll sweeten thy sad grave. Thou shalt not lack
> The flower that's like thy face, pale primrose, nor
> The azur'd harebell, like thy veins, no, nor
> The leaf of eglantine, whom not to slander,
> Out-sweeten'd not thy breath.

No part of Britain is richer than Warwickshire in genuine wild flowers. I am told that if you have the ear of the fairies, besides finding bluebells, primroses, and wild daffodils, you can still see banks of the pointed-petal wild violet and, sweeter still,

Shakespeare called them "cuckoo-buds of yellow hue . . ." and we call them buttercups, certainly among the most beloved of all flowers.

"I know a bank where the wild thyme blows, / Where oxlips and the nodding violet grows," said King Oberon in the Bard's Midsummer Night's Dream.

the tiny, scented white variety.

> I know a bank where the wild thyme blows,
> Where oxlips and the nodding violet grows;
> Quite over-canopied with luscious woodbine
> With sweet musk-roses, and with eglantine
>
> —*A Midsummer Night's Dream*

Shakespeare mentions the violet no fewer than eighteen times, including this couplet, in his poem *Venus and Adonis:*

> These blue-vein'd violets whereon we lean
> Never can blab, nor know not what we mean.

Today children in Stratford take a bunch of the first cowslips to school, but in Shakespeare's day there was a prettier custom. The entire family would go to the woods to gather primroses and then make them into "tossy balls," as they were called. The heads of the flowers were bunched together into a ball and the stalks were cut so short as to be almost invisible.

In *The Tempest* Shakespeare explained how small Ariel was in this enchanting song. Immediately one has a picture of Ariel, asleep in a yellow bell.

> Where the bee sucks, there suck I:
> In a cowslip's bell I lie;

At the nearby village of Bourton-on-the-Water, one of England's most picturesque, there is a witchcraft museum, which shows how steeped in magic and fairy lore this part of the country was.

> Fetch me that flower; the herb I showed thee once:
> The juice of it on sleeping eye-lids laid
> Will make or man or woman madly dote
> Upon the next live creature that it sees.
>
> —*A Midsummer Night's Dream*

The pansy began life with the French name *pensée*, which means a "thought." As Shakespeare says in *Hamlet:*

> There's rosemary, that's for remembrance; pray you,
> love remember,
> And there is pansies, that's for thoughts.

In his details Shakespeare was always a mathematician, always exact in choosing his words and using the correct flower illusions. This is why in the setting of Athens in *A Midsummer Night's Dream* the pansy is referred to as a western flower.

> Yet mark'd I where the bolt of Cupid fell;
> It fell upon a little western flower,

A sonnet of Shakespeare also reminds us that "roses have thorns," somehow forgotten when the color and shape and, above all, the scent are present.

Before milk-white, now purple with love's wound,
And maidens call it love-in-idleness.

The marigold was used by Shakespeare on five occasions. The most engaging of all is the reference made by Perdita in *The Winter's Tale,* which was written when Shakespeare had returned to Stratford-upon-Avon after a period in London as an actor and playwright.

The marigold that goes to bed wi' the sun
And with him rises weeping.

The literature of the Middle Ages is filled with references to the marigold. It appears in one of the songs in *Cymbeline.*

Hark! Hark! the lark at heaven's gate sing,
And Phoebus 'gins arise,
His steeds to water at those springs
On chaliced flowers that lies;
And winking Mary-buds begin
To ope their golden eyes.

In Shakespeare's day the country folk of Warwickshire called daffodils by the unusual name daffydowndilly, and children chanted on their way to school:

Daff-a-down dilly
Has now come to town
In a yellow petticoat
And a green gown

Since I was a schoolgirl I have always loved Shakespeare's sonnets, and wherever I travel I try to carry a copy. These are some of my favorite lines:

Roses have thorns, and silver fountains mud;
Clouds and eclipses stain both moon and sun,
And loathsome canker lives in sweetest bud.

And yet again in that loveliest of all sonnets:

The rose looks fair, but fairer we it deem,
For that sweet odour which doth in it live.
The canker-blooms have full as deep a dye
As the perfumed tincture of the roses,
. . . but they
Die to themselves. Sweet roses do not so;
Of their sweet deaths are sweetest odours made.

In Shakespeare's reference to the garden rose there are many enchanting figurative examples.

How now, my love! why is your cheek so pale?

How chance the roses there do fade so fast?

—*A Midsummer Night's Dream*

Then let thy love be younger than thyself
Or thy affection cannot hold the bent;
For women are as roses, whose fair flower
Being once displayed, doth fall that very hour.

—*Twelfth Night*

Fair ladies mask'd are roses in their bud;
Dismask'd, their damask sweet commixture shown,
Are angels vailing clouds, or roses blown.

—*Love's Labour's Lost*

Their lips were four red roses on a stalk,
Which in their summer beauty kiss'd each other.

—*Richard III*

The *fleur de luce*, which Shakespeare frequently mentioned, was in fact a species of iris. The name came from France, where the flower was named *fleur de Louis* after King Louis VII. Many of these exotic irises were cultivated in the manor house gardens in the time of Shakespeare. Along the banks of the Avon he would also have seen the wild yellow water flag *(Iris Pseudacorus)*. This lily was found everywhere on the Continent at that time and is supposed to be the origin of the fleur-de-lis on the shield and banner carried by King Louis VII during his crusade to the Holy Land in the twelfth century.

There is also the lily (supposedly regal) of *A Midsummer Night's Dream.*

These lily brows,
This cherry nose,
These yellow cowslip cheeks

and the historic *fleur de luce* as used heraldically in *Henry VI:*

Cropp'd are the flower-de-luces in your arms,
Of England's coat one half is cast away.

Apart from Shakespeare the English poets Robert Herrick and William Wordsworth have also given us blithesome verses about daffodils. As children some of us learn them in school (at least we did at Ravenhill Academy, in Philadelphia), but they were mere rhymes. It is not until one becomes older and more mature that the beauty of the words shines through. Remember Herrick's lines?

Fair daffodils, we weep to see
You haste away so soon;

The lily, always elegant, always eloquent.

153

It is likely that few flowers are given a readier, warmer, more enthusiastic welcome than the daffodil, a greeting followed all too soon by such words as Robert Herrick's "we weep to see you haste away so soon . . ."

As yet the early-rising sun
Has not attain'd his noon.
Stay, stay
Until the hasting day
Has run
But to the evensong;
And, having pray'd together, we
Will go with you along.

Or Wordsworth's:

I wander'd lonely as a cloud
That floats on high o'er vales and hills,
When all at once I saw a crowd
A host, of golden daffodils;
Beside the lake, beneath the trees,
Fluttering and dancing in the breeze.

Robert Burns, the eighteenth-century Scottish romanticist, understood nature as few men before or since. He wrote one of the most endearing of all love poems:

O my Luve's like a red, red rose
That's newly sprung in June;
O my Luve's like the melodie
That's sweetly play'd in tune!

Surely one of the most engaging verses written about the rose is that of nineteenth-century English humorist Edward Lear:

R was once a little rose,
Rosy
Posy
Nosy
Rosy
Blows-y——grows-y
Little Rose!

Rainer Maria Rilke has left us with a rose poem of gossamer beauty. Here is a translation from the original German.

Roses, you on a throne, in antiquity
were a calyx in a simple ring.
But to us you're the full flower, an innumerably
inexhausting thing.

In your richness you shine, with garment on garment
on a body of nothing but radiance;
yet a single petal is at once the avoidance
and denial of any raiment.

Your fragrance calls its sweetest names

across the centuries to us;
suddenly it lies plain in the air as fame.

But we do not know what to name it, we guess . . .
and memory surrenders to it all
that we have begged from hours evocable.

The astonishing beauty of the American landscape and natural flora has produced over the years many outstanding poets. Three of my favorites are women who bring a gentleness and sense of fun to their words.

I am thinking of Emily Dickinson, who treated nature in such a special and private way. Her poetry has a fragility that is unique. Even today there is still a great deal of mystery around certain periods of her life, and though her sister Lavinia knew that she wrote poetry she had no idea to what extent. She only began writing seriously after she was twenty-eight. Though seven poems were published in her lifetime, the bulk of her poems, more than a thousand, were contained in forty-nine packets and kept in a locked case. They were not found until after her death in 1886.

While she was still young, she became a recluse and never left her father's property at Amherst.

I never saw a Moor,
I never saw the Sea
Yet know I how the heather looks
And what a wave must be.

It takes the special kind of poetic magic of Emily Dickinson to write a short poem like this:

To make a prairie it takes a clover
And one bee,
One clover, a bee, and . . . reverie!
The reverie alone will do,
If bees are few.

Even her poem about the rose has her very own signature.

Nobody knows this little Rose
It might a pilgrim be
Did I not take it from the ways
And lift it up to thee.
Only a Bee will miss it——
Only a Butterfly,
Hastening far from journey——
On its breast to lie——
Only a Bird—will wonder——
Only a Breeze will sigh——
Ah, little Rose—how easy
For such as thee to die!

Emily Dickinson, whose poems often show a startling economy of words, wrote: "To make a prairie it takes a clover and one bee . . ."

Each year when early spring arrives in the South of France and I see the first tall, naked stems of white lilac in the florists' shops, I remember the generosity of the lilacs of New England. Shrubs, bushes, trees bowed low with the weight of purply blossom, the air heady with their powdery scent. Here is how Amy Lowell remembers them:

Lilacs
False Blue,
White,
Purple,
Colour of lilac,
Your great puffs of flowers
Are everywhere in this my New England
Among your heart-shaped leaves
Orange orioles hop like music-box birds and sing
Their little weak soft songs;
In the crooks of your branches
The bright eyes of song sparrows sitting on spotted eggs
Peer restlessly through the light and shadow
Of all Springs.

Edna St. Vincent Millay is also a poet I enjoy immensely. Every word is written with compassion and humor, wit and love.

Oh, little rose tree, bloom!
Summer is nearly over.
The dahlias bleed, and the phlox is seed.
Nothing's left of the clover.

And the path of the poppy no one knows.
I would blossom if I were a rose.

She has that special gift of making the obvious sublime.

All the grown-up people say,
"What, those ugly thistles?
Mustn't touch them! Keep away!
Prickly! Full of bristles!

Yes they never make me bleed
Half so much as roses!
Must be purple is a weed
And pink and white is posies.

Andrew Young, a Scotsman (1885–1971), lived in England for many years. This man of few words was a village vicar and one of England's best known modern poets. A tall, rangy man with a leonine head, he was a familiar figure on the roads of Sussex as he walked with his white hair flowing in the wind and a shepherd's crook in his hands. Here is his tender poem *Daisies.*

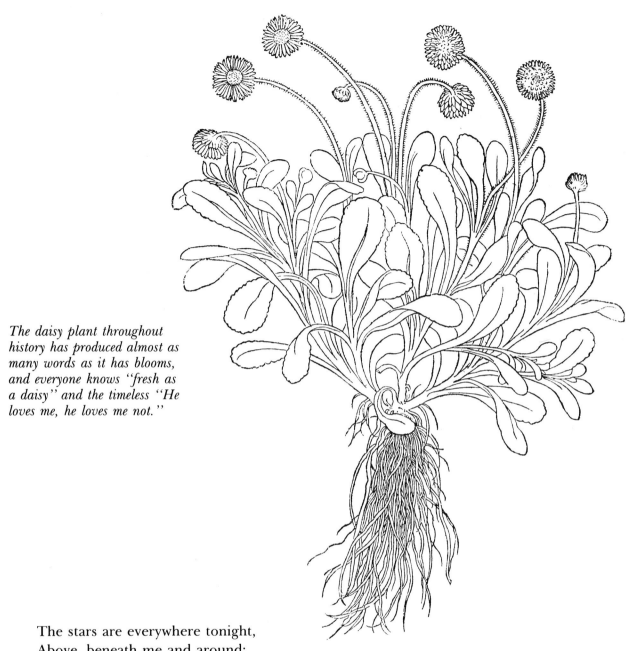

The daisy plant throughout history has produced almost as many words as it has blooms, and everyone knows "fresh as a daisy" and the timeless "He loves me, he loves me not."

The stars are everywhere tonight,
Above, beneath me and around;
They fill the sky with powdery light
And glimmer from the night-strewn ground;
For where the folded daisies are
In every one I see a star.

And so I know that when I pass
Where no sun's shadow counts the hours
And where the sky was there is grass
Through the long night in which I lie
Stars will be shining in my sky.

Gladys Mitchell, who is one of England's most engaging crime writers, has a secret life as a shy poet who loves flowers and

the English countryside. Here is her contribution to my book, her poem called *A Song of Flowers.*

Poppies are the flowers of sleep?
—Too bold their scarlet hue;
And I my dreaming hours will keep
In woods of hyacinth blue.

Pansies are the flowers of thought?
—But heartease is their name;
And who, with thinking, heart's ease bought
They *cannot* be the same!

Roses are the flowers of love?
—Ah, that may well be so;
For he, who sets the blooms above,
Has hid the thorns below.

Few American poets have captured the vigor of modern poetry better than Robert Frost. How often I remember his pertinent words in the poem *A Passing Glimpse* when I travel between Monaco and Paris:

I often see flowers from a passing car
That are gone before I can tell what they are.

I want to get out of the train and go back
To see what they were beside the track.

I name all the flowers I am sure they weren't
Not fireweed loving where woods have burnt—

Not bluebells gracing a tunnel mouth—
Not lupine living on sand and drouth.
Was something brushed across my mind
That no one on earth will ever find?

Heaven gives its glimpses only to those
Not in position to look too close.

"I always think of Mr. Ruthven Todd as a Nineteenth Century Country Clergyman who has mysteriously managed to get born and to survive in this hectic age. He is that contemporary oddity, a poet who actually seems to be happy." So wrote W. H. Auden about this Scottish poet who in 1959 became a naturalized American citizen.

Ruthven Todd was a great friend of the Welsh poet Dylan Thomas. I have chosen a verse from Todd's poem *Garland for the Winter Solstice,* illustrating his unique skill as an observer of nature, as well as his casual eloquence with words.

The sun stands still and flowers
Are all withdrawn, but memories

Give back cardinal lobelia, tall
Scarlet fountains for the humming-bird—
Vined, broken with blue and liver apios—
Beside hanging horns of jewelweed,
With pods which pop when prodded
By the idle or enquiring finger.

In June, when our orchard at Rocagel is purple carpeted with clover and humming with bees, I am reminded of the words of the English poet laureate John Masefield in his poem *The Everlasting Mercy*. It is often the simplest of poetry that remains in the head.

Where we'd go gathering cops of clover,
In sunny June times long since over,
O clover-cops half white, half red,
O Beauty from beyond the dead.
O blossom, key to earth and heaven,
O souls that Christ has new forgiven.

So many of Shakespeare's lines about flowers and plants came from the soft lands surrounding Stratford on the River Avon, Warwickshire.

PARADISI IN SOLE
Paradisus Terrestris.
or
A Garden of all sorts of pleasant flowers which our
English ayre will permitt to be noursed vp:
with
A Kitchen garden of all manner of herbes, rooies, & fruites,
for meate or sause vsed with vs,
and
An Orchard of all sorte of fruitbearing Trees
and shrubbes fit for our Land
together
With the right orderinge planting & preseruing
of them and their vses & vertues
Collected by John Parkinson
Apothecary of London.
1629

Qui veut parangonner l'artifice a Nature,
Et nos parcs a l'Eden, indiscret il mesure.
Le pas de l'elephant par le pes du ciron,
Et de l'aigle le vol par cil du moucheron.

14 Prose

Ce n'est que songe et fleurs dont nos âmes ont faim.

The only hunger of our souls is for dreams and flowers.

—*Paul-Jean Toulet (1867–1920)*

*S*ome of the most lyrical passages in the English language have been inspired by flowers, as these from the Song of Solomon.

> *I am the rose of Sharon, and the lily of the valleys.*
> *As the lily among the thorns, so is my love among the daughters.*
> *As the apple tree among the trees of the wood, so is my beloved among the sons. I sat down under his shadow with great delight, and his fruit was sweet to my taste.*

One of the best known of all essays about flowers is *Of Gardens*, written by Francis Bacon. A great English philosopher and jurist, he was born in London in 1561. This brilliant and provocative man at first angered his queen, Elizabeth I, by his peremptory behavior in Parliament. Her opinion of him changed, however, when Essex fell from favor, and it was upon Bacon's advice that Essex was finally condemned to die.

His words have great beauty and nobility:

John Parkinson, Apothecary of London, collected the plants that appeared in 1629 in this "Garden of all sorts of pleasant flowers which our English ayre will permitt to be noursed . . ."

Abigail Adams, woman of the world. In 1784, in a long letter to her niece, she described with warm eloquence her garden in Paris: ". . . so sweetly arranged with rows of orange-trees and china vases of flowers; why you would be in raptures! It is square and contains about five acres of land." She became First Lady of the new American Republic when her husband, John Adams, became President in 1796.

God Almightie first planted a Garden. And indeed, it is the Purest of Humane Pleasures. It is the Greatest Refreshment to the Spirits of Man; Without Which, Buildings and Palaces are but Grosse Handy-works; And a man shall ever see, that when Ages grow to Civility and Elegancie, Men come to Build Stately, sooner than to Garden Finely: As if Gardening were the Greater Perfection. I doe hold it, in the Royall Ordering of Gardens, there ought to be Gardens, for all the Moneths in the Yeare: In which, severally Things of Beautie, may be then in Season.

Women have been faithful recorders of the beauty of their gardens. An eighteenth-century American who kept an intimate record of her Paris garden is Abigail Adams, whose husband John had been appointed American commissioner to the court of Louis XVI in 1777. Later, after a long sojourn at their New England home, she rejoined her husband in Paris in the late summer of 1784, and they lived in the Hôtel de Verres in the Rue d'Auteuil,

of the Sixteenth Arrondissement. In a letter to Betsey Cranch, her niece, Abigail Adams writes:

> . . . The garden, Betsey! let me take a look at it; it is delightful, such a beautiful collection of flowers all in bloom, so sweetly arranged with rows of orange-trees and china vases of flowers; why you would be in raptures! It is square and contains about five acres of land. About a third of the garden is laid out in oblongs, octagons, circles, etcetera filled with flowers; upon each side are spacious walks, with rows of orange-trees and pots of flowers, then a small walk and a wall covered with grape vines; in the middle of the garden a fountain of water, in a circle walled about two feet, and a thin circle of fence painted green, in the midst of which are two small images carved in stone; upon each side and at a proper distance are two small alcoves filled with curious plants, exotics, and around these are placed pots of flowers, which have a most agreeable appearance; then a small open Chinese fence, covered with grape vines and wall fruit, encloses two spots upon each side, containing vegetables surrounded by orange trees which prevent your view of them until you walk to them. At the bottom of the garden are a number of trees, the branches of which unite and form beautiful arbours; the tops of the trees are cut all even enough to walk upon them, and look, as I sit now at the window, like one continued tree through the whole range. There is a little summer-house covered by this thicket, beautiful in ruins; two large alcoves, in which are two statues, terminate the vines; the windows of all the apartments in the house, or rather glass doors, reaching from the top to the bottom and opening in the middle, give one a full and extensive view of the garden.

Though Jane Austen did no more than mention a packet of seeds in her writings, other contemporary women authors were more generous. In the pages of *Cranford*, the nineteenth-century English novelist Mrs. Gaskell writes:

> I had often the occasion to notice the use that was made of fragments and small opportunities in Cranford; the rose-leaves that were gathered ere they fell to make into a pot-pourri for some one who had no garden; the little bundles of lavender flowers sent to strew the drawers of some town-dweller, or to burn in the chamber of some invalid. Things that many would despise, and actions which seemed scarcely worth while to perform, were all attended to at Cranford.

Mary Russell Mitford, another nineteenth-century English writer, captures all the hazy delight of a late summer afternoon in a garden in this extract from Volume III (1828) of *Our Village:*

> I know of nothing so pleasant as to sit in the shade of that dark bower, with the eye resting on that bright piece of colour, lighted so gloriously by the evening sun, now catching a glimpse of the little birds as they fly rapidly in and out of their nests—for there are always two or more birds' nests in the thick tapestry of cherry-trees, honeysuckle, and china-roses which cover our walls—now tracing the gay symbols of the common butterflies, as they sport around the dahlias; now watching that rare moth, which

the country people, fertile in pretty names, call the bee-bird; that bird-like insect which flutters in the hottest days over the sweetest flowers, inserting its long proboscis into the small tube of the jessamine, and hovering over the scarlet blossoms of the geranium, whose bright colour seems reflected on its own feathery breast; that insect, which seems so thoroughly a creature of the air, never at rest; always, even when feeding, self-poised and self-supported, and whose wings, in their ceaseless motion, have a sound so deep, so full, so lulling, so musical.

In *Consuelo*, George Sand gives a haunting description of a garden by moonlight and at daybreak when Consuelo listens to the mystic voices of the flowers.

But nothing could exceed the freshness and beauty of the flowers, still loaded as they were with the moisture of the night, and this mysterious and shadowy hour of dawn, when they open, as if to display those treasures of purity, and shed those sweetest perfumes, which the earliest and purest of the sun's rays are alone worthy to behold and possess for an instant. Examining their various altitudes and the sentiments which their several peculiarities seemed to convey, she endeavoured to seize and define the analogy existing between music and flowers. The harmony of sounds had long seemed to her related to the harmony of colours, but the harmony of both these harmonies seemed to her perfume. Plunged at this instant in a soft and dreamy reverie, she fancied she heard a voice issue from each of those painted chalices, and tell her their poetic mysteries in a language hitherto unknown. The rose spoke of burning loves, the lily of her chaste delight; the superb magnolia told of pure enjoyment and lofty pride; and the lovely little hepatica related the pleasure of a simple and retired existence. Some flowers spoke with strong and powerful voices, which proclaimed in accents trumpet-tongued, "I am beautiful, and I rule", others murmured, in tones scarcely audible, but exquisitely soft and sweet, "I am little, and I am beloved". And they all waved gracefully together in the breath of morning, and united their voices in an aerial choir, which died away gently amid the listening herbs and beneath the foliage, that drank in with greedy ears its mystic meaning.

There is a passage in *Wuthering Heights* that one never tires of reading. Emily Brontë, always perceptive, wrote:

I lingered round them under that benign sky, watched the moths, fluttering among the heath and harebells, listening to the soft wind breathing through the grass, and wondered how anyone could ever imagine unquiet slumbers for the sleepers in that quiet earth.

Gertrude Jekyll, one of the creators of the English garden as we know it today, was a shrewd observer of life. She was a splendid sight in her capacious skirt and man-size boots as she worked endless hours in the gardens she planned and maintained. Her garden wisdom is unique:

I do not envy the owners of very large gardens. The garden should

One of George Sand's favorite characters of the many created by her was Consuelo, who mused: "The rose spoke of burning loves, the lily of her chaste delight; the superb magnolia told of pure enjoyment and lofty pride; and the lovely little hepatica related the pleasure of a simple and retired existence."

fit its master or his tastes, just as his clothes do; it should be neither too large nor too small, but just comfortable . . .

Little strips in front of roadside cottages have a simple and tender charm that one may look for in vain in gardens of greater pretension. And the old garden flowers seem to know that there they are seen at their best; for where else can one see such wall-flowers, or double daisies, or white rose bushes; such clustering masses of perennial peas, or such well-kept flowery edgings of pink, or thrift, or London pride?

Hans Christian Andersen, Denmark's prodigious storyteller, was a strange man, with his brawny face, long, gangling arms, and large ugly hands. Children were frightened of him, which hurt him deeply, as his stories were often written for the young people in the manor houses where he enjoyed visiting during the summer months.

There was another side to this lonely man. He loved flowers, and whenever he was out in the countryside he used to make bouquets. He did it much as a child who cannot stop picking flowers, as an artist who is compelled to make patterns with the colors of the flowers, and possibly as a poet who transposes flowers into small stanzas.

Hans Christian Andersen, who gave the world some of its most beautiful fairy stories, also loved flowers. Here is the paper cutout doily that he created to encase the small bouquets of flowers he took to his many hostesses in Denmark. Around the edge are characters from his fairy tales. On the opposite page is a photograph of this intensely imaginative man who seemed never to stop creating.

Andersen was happy both to receive and give flowers. He himself seldom went to a florist. He had a special talent for finding and putting together a beech twig, a bunch of grasses, or a single wood flower surrounded by its own leaves. Often he composed bouquets of violent colors for his hostess, other times he gave her a spray of apple blossom in a clear glass vase, or solemnly handed her a dandelion "clock," or seed head. Whenever he went on his travels he always brought back dried flowers to remind him of these days. Some he gave away and others he kept in his room.

Hostesses who knew his quixotic approach to flowers sometimes invited him to arrange the flowers at their dinner parties. In an age when vast amounts of flowers and fernery were usually brought in from the greenhouses for such occasions, Andersen preferred simple arrangements of twigs, leaves, and moss. He was far ahead of his time as a flower arranger. For departing gifts to his hostesses—Andersen was a man of frugal habits—he often gave them bouquets he had picked from their own gardens. As one recipient remarked at the time, "You need much fame to give a lady who possesses a hot house filled with exotic flowers a withered rose from her own garden!" He did this with such style that these dead flowers as well as his paper silhouettes are treasured mementoes even today at the houses where he stayed. Sometimes he framed a bouquet with a paper doily edged with delicate figures from his fairy tales.

Andersen included flowers in many of his stories. A favorite with little girls is called "Little Ida's Flowers." It is easy to see why when you read this extract:

"Why do my flowers look so sad today?" she asked again, and showed the student her bouquet of dying flowers.

He looked at it a moment before saying: "I know what is wrong with them, they have been dancing all night and that is why they look so tired and hang their heads."

"But flowers can't dance," said little Ida.

"Sure they can," replied the student. "When darkness comes and we go to bed and sleep, then the flowers jump about gaily enough. Nearly every night they hold a grand ball."

"They mime. It's a regular pantomime. You have seen how when the wind blows, all the flowers shake their heads and rustle their leaves; what they are saying to each other is just as plain as what we say with our tongues is to us."

The student explained how all the flowers went to the castle for a ball.

"There was music. Big poppies and peonies blew on pods of sweet peas with such vigour that their faces were red. The bluebells tingled. It was a funny orchestra both to look and to listen to. At last came all the other flowers dancing; violets, daisies and lilies of the valley; as they finished their dance, they kissed each other. It was lovely to see."

I was rereading Thomas Hardy's *Far from the Madding Crowd* recently and came across this enchanting passage.

Oak and Bathsheba, arm-in-arm for the first time in their lives. Oak in a great coat extending to his knees, and Bathsheba in a cloak that reached her clogs. Yet, though plainly dressed, there was a certain rejuvenated appearance about her: as though a rose should shut and be a bud again.

Cornelia Otis Skinner, in her biography *Madame Sarah*, writes of the brilliant opening of *L'Aiglon* in 1900 in Paris.

Sarah Bernhardt and Edmond Rostand were the most talked about personages in Paris. Rostand caught pneumonia on opening night and spent the spring convalescing in Montmorency with his family. Every day Madame Sarah would drive out in her two-horse landau to pay "her poet" a visit, always bringing him a bunch of Napoleon violets.

Miss Skinner describes Bernhardt's Paris farewell, which made theatrical history:

It was one of those tumultuous occasions of Gallic rapture when strong men weep, strangers embrace like brothers and ladies can find nothing more appreciative to do than faint. The reborn star was forced to repeat her recitation twice again and each time she received the same ovation. When it was finally over, so many flowers and bouquets had been hurled across the footlights, it took the full stage crew of the Opera House to clean up the mess.

Marcel Pagnol has given the French language some of its most lyrical passages about flowers and nature. Here is one that reflects the soul of the French countryside:

All around them lay untilled land, covered with a yellowish brown

grass which the farmer told us was baouco. *It looked like dried hay, but this was its natural colour. In spring, to share in the general gaiety, it made a feeble effort to turn green, but despite its poor appearance, it was hardy and vigorous, like all useless plants.*

Here I first saw, amid the baouco, *some dark green tufts that looked like miniature olive-trees. I left the path and ran to touch their tiny leaves. A powerful perfume rose like a cloud and enveloped me entirely. It was an unknown scent, sombre and intense, which filled my head and penetrated right to my heart.*

It was thyme, which springs from the gravel of the garrigues: *those few plants had clambered down to me.*

John Clare was an eighteenth-century English poet who began life as a simple Northamptonshire farm laborer. When he failed as a farmer he took to roaming the countryside and recording with his delicate eye the joys that he found there. He was a friend of Charles Lamb, who encouraged him to write even after he had been committed to an asylum for the insane, where he lived for twenty-three years. It was during this period of his life that he wrote this fragile piece of prose called *Dewdrops.*

The dewdrops on every blade of grass are so much like silver drops that I am obliged to stoop down as I walk to see if they are pearls, and those sprinkled on the ivy-woven beds of primroses underneath the hazels, whitethorns, and maples are so like gold beads that I stooped down to feel if they were hard, but they melted from my finger. And where the dew lies on the primrose, the violet and whitethorn leaves, they are emerald and beryl, yet nothing more than the dews of the morning on the budding leaves; nay, the road grasses are covered with gold and silver beads, and the further we go the brighter they seem to shine, like solid gold and silver. It is nothing more than the sun's light and shade upon them in the dewy morning: every thorn-point and every bramble-spear has its trembling ornament: till the wind gets a little brisker, and then all is shaken off, and all the shining jewelry passes away into a common spring morning full of budding leaves, primroses, violets, vernal speedwell, bluebell and orchids, and commonplace objects.

One of my earliest experiences with nature writing was through reading Henry Thoreau. This nineteenth-century American "romantic naturalist" regarded man's communication with nature as mystical and spiritual, the same approach to nature as had Goethe and Wordsworth. Some of his most stringent and observant writing comes from the period when he moved to the New England woods by Walden Pond.

His respect for trees is perhaps best illustrated in his essay

"The Scarlet Oak," which actually tells us nothing specific about the tree! After urging the reader to climb the hills in late October, he warns that one will see nothing unless prepared for the landscape of the mind. This approach is vital to everyone who enjoys flowers and trees. We all see nature differently, but the power of transforming them into beauty lies in our minds as well as in our eyes.

As Thoreau writes:

Objects are concealed from our view, not so much because they are out of the course of our visual ray as because we do not bring our minds and eyes to bear on them; for there is no power to see in the eye itself, any more than in any other jelly . . . nature does not cast pearls before swine. There is just as much beauty visible to us in the landscape as we are prepared to appreciate—not a grain more . . . The scarlet oak tree must, in a sense, be in your eye when you go forth. We cannot see anything until we are possessed with the idea of it, take it into our heads—and then we can hardly see anything else.

Since I was a child I have loved trees. The Delaware Valley area of Pennsylvania, where I was brought up, is rich in them. They are part of the mystical wonder of nature.

One of the wittiest pieces I know of writing about a tree is an extract from John Steinbeck's engaging *Travels with Charley*. Everyone who has ever owned a dog—and my life has been filled with dogs—cannot resist the passage when Steinbeck introduces Charley to his first giant redwood.

"Charley," I called. "Look!" I pointed at the grandfather [the redwood]. He wagged his tail and took another drink. I said, "Of course. He doesn't raise his head high enough to see the branches to prove it's a tree." I strolled to him and raised his muzzle straight up. "Look Charley. It's the tree of all trees. It's the end of the Quest."

Charley got a sneezing fit as all dogs do if the nose is elevated too high. I felt the rage and hatred one has toward non-appreciators, towards those who through ignorance destroy a treasured plan. I dragged him to the trunk and rubbed his nose against it. He looked coldly at me and forgave me and sauntered away to a hazelnut bush.

"If I thought he did it out of spite or to make a joke," I said to myself, "I'd kill him out of hand. I can't live without knowing." I opened my knife and moved to the creek and I cut a branch from a small willow tree, Y-branch well tufted with leaves. I trimmed the branch ends neatly and finally sharpened the butt end, then went to the serene grandfather of Titans and the little willow in the earth so that its greenery rested against the shaggy redwood bark. Then I whistled to Charley and he responded amiably enough. I pointedly did not look at him. He cruised casually about until he saw the willow with a start of surprise. He sniffed its new-cut leaves delicately and then, after turning this way and that to get range and trajectory, he fired.

During the long reign of the Divine Sarah, passionate appreciation of her indefinable greatness was usually shown by endless showers of bouquets and single blooms landing on the stage at her feet.

"The Last Flower," a parable in pictures, is perhaps James Thurber's most beguiling story. There is a moral there for all of us! It is the story of World War XII, which brought about the collapse of civilization when all the cities and towns, forests and gardens were destroyed. Men, women, and children were reduced to being lower than the animals. Everything that was noble—books and paintings, music and decency—disappeared from the earth. Then one day a girl who had never found a flower before came across one single bloom that had escaped all the ruin. Together with a young man they tended and watered this last flower. Soon there were many and the forests and gardens began to bloom again. And happiness returned to earth.

Towns, cities and villages sprang up
Song came back into the world.

But such is human nature that before long jealousy had returned.

The liberators, under the guidance of God
Set fire to discontent
So presently the world was at war again. This time the
destruction was so complete
That nothing at all was left in the world
Except one man
And one woman
And one flower.

15 Ballet and Music

That strain again! it had a dying fall:
O! it came o'er my ear like the sweet sound
That breathes upon a bank of violets,
Stealing and giving odour!

—*William Shakespeare (1564–1616)*

Nijinsky's costume for Le Spectre de la rose *was made of fine elastic jersey into which he was sewn each night. The petals of the rose were in shades from rose to purple and were curled before each performance with a curling iron. When Nijinsky partnered Tamara Karsavina, this became the most poetic of flower ballets.*

Throughout the realm of music flowers have played an important role, and some of the greatest operas in the world have been inspired by flowers. *La Traviata* is perhaps the most famous of all, based on the novel by Alexandre Dumas, *La Dame aux camélias*. When Verdi turned the play from the novel into an opera, Marguerite Gautier was transformed into Violetta Valery and Dumas-Duval was changed into Alfredo Germont.

The appellation of *La Dame aux Camélias*, which made the life of Marie Duplessis into one of the great love stories of the world, was purely fictional. But the association had become so strong that when she died at the age of only twenty-two her husband, the Vicomte de Perregaux, bought her a grave in Montmartre cemetery. It was decorated with camellias made of stone and may still be there today.

In Georges Bizet's *Carmen* much of the drama relates to a flower. In Act I Don José, a handsome corporal of dragoons, becomes enchanted with the beautiful Carmen. She tears from her bodice a blood-red cassia flower and flings it at the soldier. Then with a toss of her head and a mocking laugh she runs into the cigarette factory where she works. Later in the same act Carmen has wounded another girl with a knife and Don José has been sent to arrest her. In one of the most forceful scenes of the opera Carmen asks, "Where is the flower I threw you?" Don José is bewitched. Later, because he helps Carmen to run away, he is put under arrest. When he is freed he comes to Carmen and, to prove his passion for her, produces from his tunic the flower she had given him, which he had kept all during the time he was in prison, singing the haunting *"La fleur que tu m'avais jetée."*

Violets are the leitmotif in Francesco Cilèa's opera *Adriana Lecouvreur*, which was first performed in Milan in 1902 with Enrico Caruso in the leading male role. The opera is set in Paris in 1730 and is the story of a famous actress of the Comédie Française, Adriana Lecouvreur, who fell in love with Maurizio, Count of Saxony. In Act I she gives him violets for his buttonhole, following their passionate love duet.

On Adriana's birthday her rival, the Princess de Bouillon, sends her the gift of a casket. Inside are the very violets she had given Maurizio the previous evening, but by now they are shriveled. She sees in them the dying of Maurizio's love for her in the area *"Poveri fiori."*

When Maurizio arrives and protests his innocence, he proposes marriage. She is overjoyed but suddenly turns pale and is convulsed with pain. The flowers had withered because they had been poisoned. Adriana dies in Maurizio's arms. The Princess's revenge was complete.

I doubt that there is any more poignant scene in opera than Puccini's flower duet in Act II of *Madama Butterfly.* The winsome Butterfly still believes that her American "husband," Pinkerton, will return to their little house overlooking the harbor of Nagasaki. When, after three years of absence, she hears a cannon shot announcing the arrival of a ship, she and her maid Suzuki decorate the house with cherry blossoms and paper flowers. As she flutters about the house, she sings "One Fine Day." Butterfly and her child sit up all night waiting for Pinkerton to return, but like so many real life love stories, all is in vain.

The flower song in Gounod's *Faust* has a haunting beauty of its own. In Act III, Siebel, a young man in love with Marguerite, places a simple bouquet of flowers for her to find, but Méphistophélès, acting for Faust, puts a casket of jewels next to them and successfully tempts her.

The rose has been used in at least three operas. Perhaps

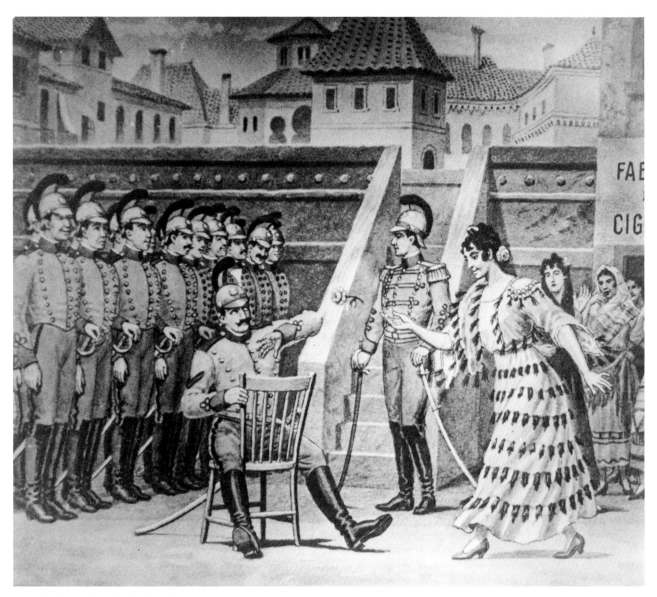

Don José cautiously fends off Carmen's flower in this old-time lantern slide print.

the best known is *Der Rosenkavalier,* by Richard Strauss. In Act II, Baron Ochs, hoping to marry Sophie von Faninal, sends her a silver rose, as was the betrothal custom in Germany. But the knight who is chosen to take it to her house is the young and handsome Octavian, and he and Sophie fall in love at first sight.

In Friedrich von Flotow's *Martha* the scene is set in a farmhouse. Martha sings a song about the last rose of summer to her employer, Lionel. He declares his love and asks her to marry him, not realizing that in fact she is Lady Harriet Durham, maid of honor to Queen Anne. In the end Lionel turns out to be the Earl of Derby, so all is well.

The rose also plays an engaging role in Edward German's light opera *Merrie England.* The "Rose of England" song is sung by Sir Walter Raleigh, who is in love with Bessie Throckmorton, lady-in-waiting to Queen Elizabeth. In Richard Wagner's *Lohengrin* the bridal procession is one of the highlights of the opera.

"The Violet" of Mozart (*Das Veilchen*), "Hedge Rose" of Schubert (*Heiden Röslein*), and "The Myrtle" (*Die Myrthen*) of Schumann are all delightful songs with flowers as their themes. Two evergreen favorites are Felix Mendelsson's *Spring Song* and Peter Tchaikovsky's *Waltz of the Flowers*.

Among contemporary composers who have written about flowers are Benjamin Britten ("The Flower Song"), Humphrey Searle ("The White Hellebore"), and Jean Françaix (*"L'Horloge de Flore"*—The White Flower Clock).

One of the most joyous of all music celebrating nature is Aaron Copland's *Appalachian Spring*. I find that it represents the true spirit of American music. It was originally composed in 1944 as a ballet for the Martha Graham company and contains tunes indigenous to its Pennsylvania setting. The occasion is a pioneer celebration at a farmhouse in spring in the early part of the last century. There is something about this music that evokes newly tilled fields, buds breaking into green on the trees, birds in chorus, orchards pink with blossoms, and young people in love. The music bursts with vitality and incorporates a set of variations on the Shaker tune "Tis the Gift to Be Simple."

*I*n the ballet world flowers have given much inspiration. *Le Spectre de la rose* was inspired by Théophile Gautier's poem and was translated into a ballet by Michel Fokine for the Serge Diaghilev company. Although balletomanes remember Nijinsky mostly for *L'Après-midi d'un faune,* for the ordinary ballet lover it was his *Spectre de la rose* that gave the most pleasure. In this ballet Nijinsky, with a single leap, appeared to cross the entire stage, floating as if suspended in air. It is said that when it was first performed a London impresario asked Nijinsky to show him his ballet shoes to see whether they had some hidden secret.

The story is disarmingly simple. A young girl returns from her first ball and recalls dreamingly the romantic impressions of the evening. She kisses the rose that her loved one gave her. Intoxicated by the warm air, she falls asleep on a chair. Suddenly the soul of the rose—an intangible, dreamlike figure—floats into the room. Not a flower, not a human being. In the soft light he stands on the sill of the window before whirling through space. He dances with the girl, offering her the essence of love. They dance until, exhausted, she falls asleep again in the chair. The spirit leans over her and gives her one soft kiss, and then leaps out through the window.

Nijinsky's costume, designed for the ballet by Léon Bakst,

Der Rosenkavalier (The Knight of the Rose) is one of the operatic triumphs of Richard Strauss. The Presentation of the Rose is a deeply touching moment in this richest of operas.

was hauntingly beautiful. Bakst had painted pongee silk in shades of rose and dark red, mauve and purple—all the tints of a fading rose. By hand he cut out the petals from the lengths of cloth. Each time Nijinsky danced the ballet, a new costume had to be made. The base was fine silk elastic jersey into which the dancer was sewn, covering his entire body except for parts of his chest and arms. Onto this were sewn the rose petals, which the wardrobe mistress would refresh with her curling iron. On his head was a close-fitting helmet of rose leaves.

Nijinsky's face was made up like that of a celestial insect, and his lips, the most arresting features of his face, were painted to resemble rose petals. The effect was breathtaking, and one felt that the whole opera house was scented with roses, and the audience was left feeling as if they had been dreaming.

Adeline Genée, the delightful Danish ballerina, wore flowers in many of her ballets. Her first international success, at the Empire Theatre in London, was a ballet called *The Rose of Shiraz.* Pavlova also danced in a rose ballet in 1911.

In the ballet *The Sleeping Beauty* flowers are a focal point. In the great scene when the male dancers fill the stage with branches of flowers to form an archway, the stage becomes a rhythmic swaying of flowing movements and myriad winged petals seem to hover over the dancers' heads.

Parts of *Giselle, Flower Festival in Genzano,* and the *Waltz of the Flowers* from the *Nutcracker* derive some of their beauty from flowers.

Though seldom danced in the Western world, the Russian ballet *The Red Poppy* is a favorite of the Bolshoi Ballet. The Red Poppy is, in fact, not a flower, but a Chinese teahouse dancer who saves the life of a Soviet ship's captain. Though originally danced by Pavlova, in the Leningrad version by Michail Lavrovsky in 1949, Galina Ulanova danced the role of Tao Hoa.

One of the most romantic ballets relating to flowers is *Jardin aux lilas,* choreographed by Antony Tudor to music by Ernest Chausson. It was first produced at the Mercury Theatre in London in 1936. The ballet is set in a lilac garden in the Edwardian period. The theme is ephemeral. Tudor illustrates his theory that people about to be parted have a desperate longing to touch and kiss each other. The beauty of the lilacs enhances the dreamlike quality of the ballet's conception.

Every year when we have our Concours International de Bouquets in Monaco, we arrange various forms of entertainment for our guests. One of the highlights is the concert in the Monte Carlo Opera House. On these occasions we choose music that belongs to the flower world, such as Tchaikovsky's *Bal des fleurs,* Weber's *Spectre de la rose,* Falla's *Nuit dans les jardins d'Espagne,* Johann Strauss's *Les Gens de la fôret* and *Rose du Sud,* and many others. It is a happy way to end a flower-filled day.

Anna Pavlova in a lace dress garlanded with flowers in the ballet The Rose, *created for her.*

16 Bridal Bouquets

Another gay garland
For my fair love of lilies and of roses
Bound true-love-wise with a blue silk ribband
And let them make great store of bridal posies.

—*Edmund Spenser (1552–99)*

*T*his is a page for nostalgia. I would like to turn for a moment to a look at the history and romance of the part that flowers have played in wedding ceremonies since the days of the ancient Greeks. Her wedding day is surely one of the most important events in a woman's life. An Athenian bride wore hawthorn twined into a wreath on her head, but the Roman bridal wreath was generally made of verbena, which had to be picked in the garden by the bride herself. Myrtle was worn only by Jewish maidens and never by a widow or a divorced woman. Today it is often used in the bridal wreaths worn by girls in villages in Germany, though in the cities the custom has long died out.

Weddings in ancient Greece were flower-filled occasions. All the wedding party was crowned with flowers, as were the bridal couple. Chaplets of lilies and ears of corn were worn by both bride and bridegroom as emblems of purity and abundance.

It is to the Saracen brides that we owe our custom of the bride carrying or wearing orange blossoms. They wore them as

Delicate laces and silk satin, all sewn with great care to create the bridal gown . . . and always flowers, chosen with as much thought as for the rest of the costume.

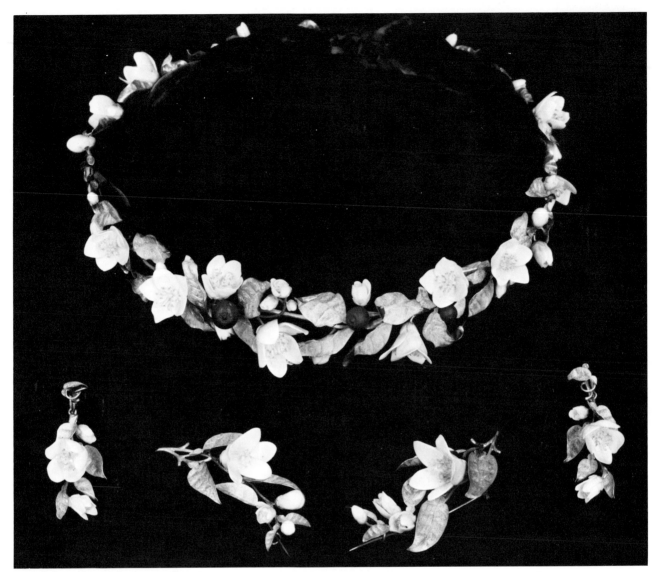

The Prince Consort was a man of many talents. He designed this wreath of white porcelain orange blossoms especially for Queen Victoria.

a sign of fecundity because the orange tree not only has pure, virginal white-scented blossoms but bears its fruit at the same time. Some say that the orange was the "golden apple" presented to Jupiter by Juno on the day of her nuptials. The tradition of wearing orange blossoms was brought to Europe at the time of the Crusaders, and happily has been with us ever since. It crossed the Atlantic and was worn by early settler brides in the 1800s.

There is a theory that it was an early king of Spain who was responsible for the wearing of orange blossoms by brides. He knew that his gardener had a daughter who longed to marry but had no dowry. He was also aware that his gardener grew in his private garden a tree bearing the sweetest-smelling white blossoms and golden fruit. The romantic king was so enraptured by this tree that he offered to give the Spanish maiden a suitable dowry in return for just one cutting. This was arranged, and on her wedding day the grateful bride made a circlet for her head from the orange tree that had brought her so much good fortune

and made her marriage possible.

In some of the Greek islands today hyacinths are worn instead of orange blossoms, and in ancient Greece it was the custom for the virgin maids attending the bride to wear crowns of hyacinths. In the island of Crete there is a folk song that tells of how the bride is lavishly bedecked with flowers. When her chaplet is placed on her head, she is given a sprig of rosemary, which is supposed to confer long life upon the bride and bridegroom.

*R*oman weddings were flower festivals in themselves. Not only was the entire bridal party garlanded with blossoms, but petals were strewn in their path as they walked from the bride's house to the chapel. The Romans chose flowers of every color and perfume, and the quantity of petals used signified the importance of the occasion. Rich ladies chose multicolored rose petals—the origin of our modern tradition of throwing small pieces of colored paper, confetti, over the bridal couple for luck. Another unique custom at Roman weddings occurred at the moment the bridegroom threw nuts among the young boys present. This was to signify and announce to his bride that he had now done with boyish pranks and was ready to settle down to being a responsible husband.

For centuries Eastern brides have worn orange blossoms, and Indian brides have a custom where they sit while their friends drop orange blossoms into a basket held in their laps.

There was tradition in Northern India in the days of the Raj when desirable princely suitors for a daughter were invited to a great banquet in the palace. When the meal was finished, the daughter, who had watched the handsome young guests from behind curtains, was brought into the room. She carried a garland of flowers, which, with beguiling gestures, she placed around the neck of the man she chose to be her future husband.

In Indian villages today some brides still honor the old custom of fetching water from the well before the wedding ceremony can be completed. This is to show proof that they consent to undertake domestic duties as well as being decorative wives.

In early Anglo-Saxon weddings both the bride and the bridegroom were crowned with garlands of flowers. The old name for meadowsweet was queen of the meadow or bridewort, as it resembled the white feathers sometimes worn by brides, and the common dodder *(Cuscuta epithymum)* was sometimes called lady's lace or bride's lace. This is not to be confused with *Daucus carota,* which in America is known as Queen Anne's lace.

Rosemary has always been considered a wedding flower. One of King Henry VIII's more fortunate wives, Anne of Cleves, wore it at her wedding. The rosemary was entwined in a wreath that had first been dipped in scented water.

The men of today have much to learn from their forebears in the art of courting. In France in the eighteenth century it was the custom for the prospective bridegroom to send his fiancée a nosegay of the finest flowers of the season every morning until her wedding day.

The Duke de Montausier was a most romantic man. When he married Julia de Rambouillet, instead of sending his loved one posies of fresh flowers he had them painted on vellum by the best artists of the time. These folios were bound into a book that was lost during the French Revolution, but later turned up in Hamburg in 1795.

In Germany, the bride often puts flax in her shoes or wears a string of flax around her leg as a garter. This signifies that she will have good luck in her married life. It has the same connotation as the jingle I remember from my youth:

Something old,
Something new,
Something borrowed,
Something blue.

Surely one of the prettiest groups of bridesmaids ever seen. They attended Princess Alexandra at her wedding to the Prince of Wales in 1863. The tulle dresses were looped up with bouquets of pink roses.

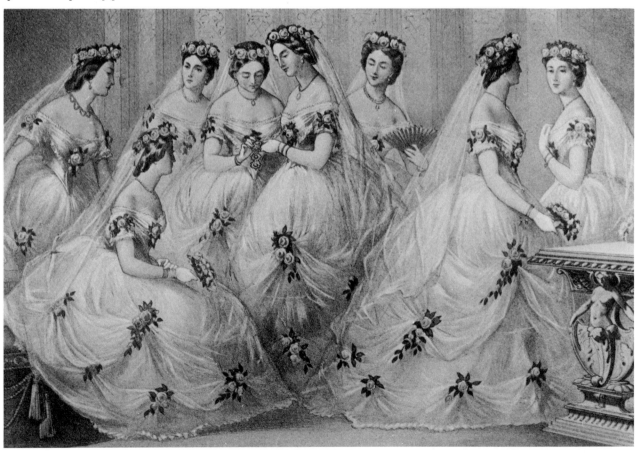

When Queen Victoria married Prince Albert, she chose a tiny bouquet of snowdrops because they were the Prince's favorite flowers. When he died, a similar posy was placed on his coffin by the Queen.

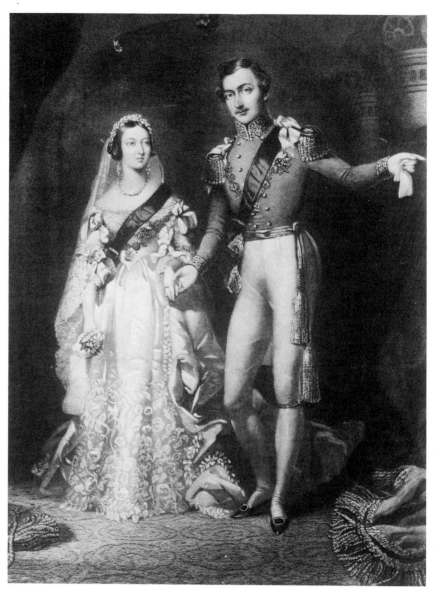

As wedding ceremonies gained in importance on the social scene, so the bride's bouquet was specially designed to suit the style of dress she wore. In contrast to her elaborate bouffant gown, Queen Victoria, in a surprising burst of sentimentality, chose a tiny bunch of snowdrops as her wedding bouquet. This was because snowdrops were her dear Albert's favorite flowers. When the Prince died, among all the magnificent flowers sent from all over the world for the funeral, the sorrowing Queen's small bunch of snowdrops was the most heartrending. It was in memory of her wedding day.

Prince Albert, who was a most artistic man, personally designed the delicate porcelain diadem of orange blossoms and fruits that the Queen wore. It is kept at Windsor Castle, but the Queen's wedding dress can be seen at the new London Museum.

As dresses in Edwardian times became more flowing, and the figure was elongated with boned collars and small trains, wed-

ding bouquets changed their shape. The tight little posies of Victorian days were replaced with elaborate cascading sheaths of gladioli, delphiniums, and lilies.

In the 1920s, after World War I, when hemlines shot up alarmingly to the knees, and chiffon and crepe de chine became the fashionable materials, bouquets became even bigger. When Miss Anita Lihme of Chicago married Prince Edouard Joseph of Lobkowicz, it was the major social event of the season there. The bridesmaids wore chiffon dresses and cartwheel hats and were almost hidden behind their sheaves of summer flowers dripping with asparagus fern and tied with large bows of tulle.

The Twenties were also a period of the great Hollywood weddings. In 1926, when Marilyn Miller married Mary Pickford's brother Jack, the ceremony took place at Pickfair, the lavish Fairbanks house. The wedding bouquets were formalized combinations of freesias and fern, and Mary Pickford's bouquet was almost as large as that of the diminutive bride.

Typical of American society weddings of that period was the marriage of Muriel Vanderbilt to Frederick Cameron Church, Jr. No expense had been spared for this Newport wedding, and Mrs. William K. Vanderbilt, Sr., had bought for her comely daughter the exquisite veil that had been worn by Marie Antoinette on the day of her marriage to Louis XVI. The American bride set a new fashion when she borrowed the idea of the head bandeau that French tennis star Suzanne Lenglen had popularized, only this time it was made of tiny orange blossoms. Her bouquet was

Cascades of gladioli, ferns, and tulle were chosen by Miss Anita Lihme of Chicago when she married Prince Edouard Joseph Lobkowicz. These massive bouquets were all the fashion in the 1920s (above). When Miss Edwina Ashley married Lieutenant Lord Louis Mountbatten at Westminster Abbey, in London, she set a fashion when she carried stalks of lilies (right).

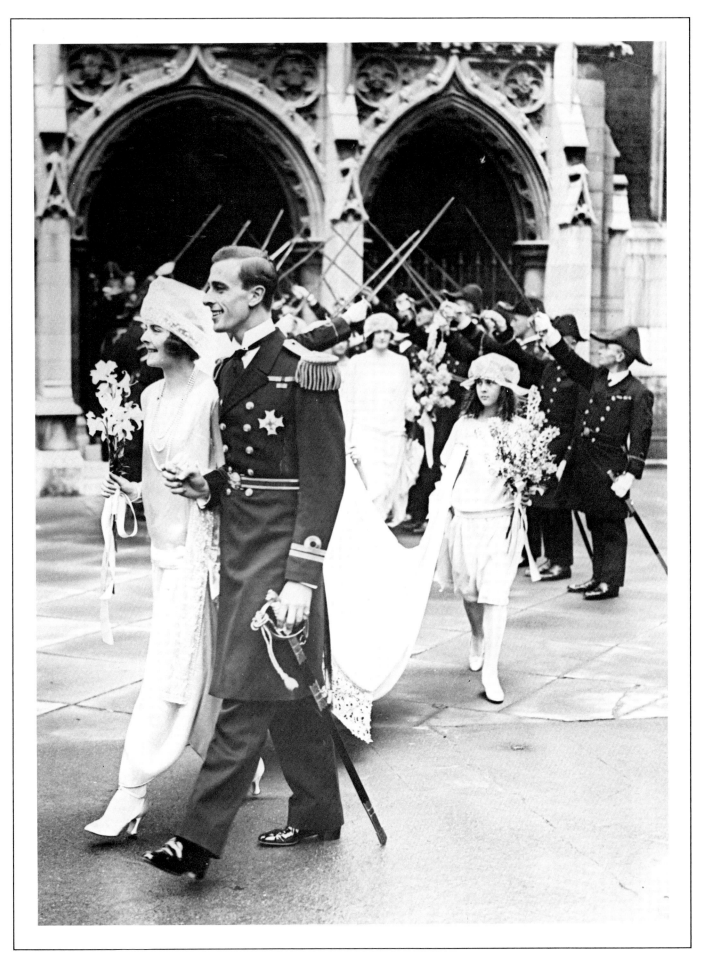

Mary Pickford's bouquet was almost as large as herself when she attended the wedding of her brother Jack to Marilyn Miller, which took place at Pickfair in 1926.

The Brussels lace makers were particularly skilled in weaving flower designs into their delicate lace. The bodice of my wedding dress was made of this lace. For my own wedding I wanted to carry lilies-of-the-valley. My matrons of honor carried bouquets of tea roses, and the flower girls white daisies.

composed entirely of white orchids and gardenias.

In England the most important wedding of the decade was that of Miss Edwina Ashley to Lieutenant Lord Louis Mountbatten, which took place in Westminster Abbey. The bride wore a column of white satin with three ropes of creamy pearls and once more set a fashion by carrying stiff stalks of *Lilium candidum.* The bridesmaids, in their mock Dutch bonnets, so fashionable at that time, proved that even stalks of delphiniums have style if carried with confidence.

For my own wedding, Helen Rose designed a full skirt of ivory peau de soie with a bodice made from Brussels lace that was over a century old and was embroidered with seed pearls. I wanted my bridal bouquet to be small and discreet, and I chose lily-of-the-valley. Even the ribbons had small sprigs attached to them. This was the bouquet that I left on the altar of the Chapel of St. Dévote after the wedding.

A great deal of thought and sentiment is given in choosing a bridal bouquet. I had forgotten how important it is until I found myself in discussion with my daughter Caroline as to what flowers she would carry on her wedding day. She wanted something small and delicate to go with her dress of flower-embroidered Swiss lace. She chose tiny white orchids.

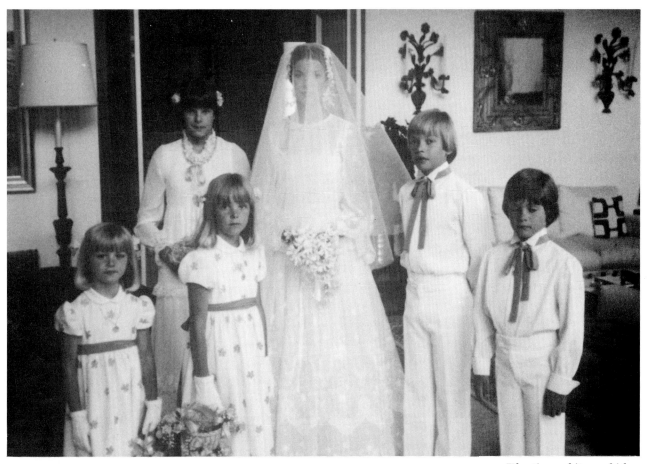

The tiny white orchids of Princess Caroline's bouquet on her wedding day in June, 1978.

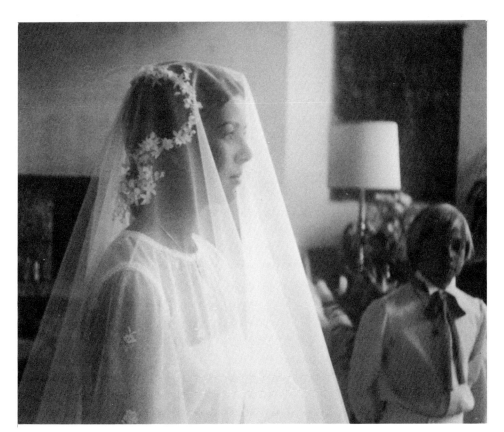

17

Americans In Europe

The greatest service which can be rendered any country is to add a useful plant to its culture.

—*Thomas Jefferson (1743–1826)*

If it had not been for John Bartram, the Philadelphia botanist who lived in the eighteenth century, this handsome tree that grew along the banks of the Altamaha River in Georgia would now be extinct. The seeds he collected were brought back to his farm and propagated into seedlings. He named the tree in honor of Benjamin Franklin. The drawing is by his son William.

Whenever I see the Schuylkill River on my visits to Philadelphia I think of my father and brother Jack, who spent so many hours on this river training as champion oarsmen. But I also think of John Bartram, a famous name in Philadelphia, the largely self-educated farmer who lived there in the eighteenth century. He is one of those tangible examples of the international brotherhood of flower lovers that stretches across the earth. It always has, and will continue, despite world upheavals.

Just as the early settlers of America set off from England, with their cuttings of plants and packets of seeds, the farsighted John Bartram set up his own transatlantic botanical enterprise and sent American flora to Europe. Of the approximate eight thousand species of plants that grew in North America then, only a half-dozen were known to Europe before 1600. When Bartram began collecting, there were about three hundred American plants known in Europe. He introduced two hundred more.

By the middle of the eighteenth century Farmer Bartram had become botanist for the American colonies to King George III of England and was in regular correspondence with the horticulture-minded Queen of Sweden. He was also held in the highest esteem by some of Europe's outstanding gardeners. Linnaeus, the famous Swedish classifier of plants, described him as "the greatest natural botanist in the world." He might also have been called "the seed salesman extraordinary."

John Bartram's love of plants began when he was a small child. As he wrote in his journal:

Since ten years old, a great inclination to plants and know all that I once observed by sight, though not their proper names, having no person nor books to instruct me.

This inquisitive boy had an instinctive knowledge of herbs and flowers and used to dose his family and friends whenever they were ill. His thirst for knowledge took him in 1730 to Philadelphia, where he poked around the market stalls and bought a small collection of books on botany. When he found that a knowledge of Greek and Latin was required to read the botanical names, he found a schoolteacher to give him lessons.

Word of mouth spread in Philadelphia botanical circles about this strange young man and his passion for collecting plants. His name became known in England, where his first overseas client was Peter Collinson, a London drapery merchant. Collinson engaged young Bartram to make a collection of American plants for him, for which he was prepared to pay five guineas a box, providing that they arrived in England in good condition.

The first box arrived in London in 1734, and the plants were perfect, all neatly labeled in Bartram's fine script. The box that contained witch hazel, cucumber tree, white cedar, bittersweet, beech, mountain laurel, and about twenty more specimens had taken less than a month to arrive.

"I can't enough admire thy industry and curiosity in descending to so many minute rarities what commonly escape the observation of most but such a prying eye as thine," a grateful Collinson wrote back.

When one realizes how many weeks, even months, are often needed to get a parcel today from America to Europe, this speedy eighteenth-century parcel post was all the more remarkable.

John Bartram was a lone collector. With large leather bags in which to store his treasures, strapped to his saddle, he set off on his horse into the wilderness. He preferred the hidden tracks of the wild bears and rattlesnakes, as he knew that the seeds and plants growing in these neglected thickets would be stronger and healthier. Though his days were never lonely, amid so much natural beauty, they were long and tiring. But his eyes were everywhere. He boasted that he did not find anything on a return

John Bartram's drawing of an evergreen shrub that he found in Florida.

Here is John Bartram's own description of the tree he named Franklinia Alatamaha, *written in his own flowing handwriting. It begins: "This fine flowering tree was first observed growing wild near Altamaha in Georgia, it grows erect, about 20 feet high . . ."*

visit to a place that he had not seen on the first trip. His notes were accurate, meticulous, and intelligent. No tree was too tall or tuft of moss too small to capture his interest.

Sometimes the trips took him as far as Virginia. He slept where he was welcome, whether it was a settler's cabin, a flea-filled Indian settlement, or one of the large family mansions where the ladies in particular enjoyed hearing about his adventures and inspecting the new plants he had found.

The sending of boxes of plants to England continued. Collinson was so delighted that he found among his friends plant lovers

who were also willing to pay five guineas for a box of seeds for about a hundred trees and flowering shrubs indigenous to America.

Bartram was no ordinary botanist, but a man with an infinite understanding of nature. After a hard day's ride gathering plants and flowers, he would spend the evenings annotating each species and giving an account of his journey.

"Continued along a fine bottom full of great wild nettles . . . on up a hill covered with spruce, oak spruce, laurel, opulus, yew with genseng and atalianthum in abundance . . . over boggy rotten places . . . to an old beaver dam."

He used some land on his farm by the Schuylkill River as a plant nursery to increase supplies of his rarer finds. Inside the farmhouse he had special cupboards built for drying and storing seeds. His specimens were packed into every conceivable type of jar, and preparing them for their sea voyage was an art in itself. Not all his orders were lucky in reaching their destinations. Some seeds were eaten by rats in the vermin-infested holds of the ships; others went moldy in the damp, dark hulks. It is also recorded that the sailors, on finding bottles of plants and insects preserved in alcohol, promptly picked out the bugs and drank the strong spirits!

There were also wars to be considered, but the gentle farmer found a way to beat the sea pirates. He used to put an alternative address on his shipments to Collinson—to Antoine de Jussieu at the royal gardens in Paris. French captains showed a marked respect for any captive cargo labeled "botanical specimens." Sooner or later the boxes would find their way from Paris to England.

Though Bartram and Collinson were never to meet, their friendship ranged over thirty years, and many of the letters between these two men have been preserved. Most of them are warm and intimate. Collinson wrote:

I am very sensible of the great pains, and many tiresome steps to collect so many rare plants scattered at a distance to show my gratitude I have sent thee a small token: a calico gown for thy wife.

But not all the letters were so amiable. They often contained critical, peevish remarks, as this one written by Bartram:
Thee supposes me to spend five or six weeks in collections for you I spend more than twice that time, annually . . . beside my neglect of business at home in following, harvest and seed time.

Bartram hungered after more and more books to study, but when Collinson found his requests a little too greedy he replied:

Remember Solomon's advice—in the reading of books there is no end!

To which Bartram riposted:

I believe if Solomon had loved women less and books more he would have been a wiser and happier man.

One of Bartram's most rewarding contributions to American botany was finding the "lost tree," as it was called. Along the banks of the Altamaha River in Georgia he and his son, William, came across a most unusual tree with large, papery white flowers. They named it *Franklinia Alatamaha* in honor of Benjamin Franklin. Bartram had noticed the tree twelve years before, but as it was late autumn he could not form any opinion as to the class it belonged to. On returning to exactly the same spot with his son, he collected seeds and sent them back to Philadelphia, where they were carefully propagated. The seedlings flourished and this beautiful "lost tree" was saved. If the Bartrams had not done this rescue operation, the tree today would now be extinct, as it mysteriously died out in its natural state.

Among the four million plant specimens in the Natural History Museum in London, one of the greatest collections in the world, there is a special cardboard container. Originally the precious contents were found in the museum tied up in a brown paper parcel, but the librarian, Miss Phyllis Edwards, realized their historical value and after they were specially mounted placed them into the specimen container. Inside, among original letters and drawings, were many carefully labeled sprays of American plants that had dried until they looked like old rope and brown paper. These were some of the original samples that Bartram had collected and sent to a Dr. Fothergill, and that, by some miracle, were preserved over the years. They can be seen at the museum today by anyone interested in the story of John Bartram. In a bound volume is a collection of letters and drawings by his son William. In Pennsylvania, the farmhouse has been reconstructed and is now a museum of Bartram memorabilia.

Bartram made another good friend in Benjamin Franklin, who acted as his agent in France when he was appointed an American commissioner to the French court. It is in this way that the seeds gathered on the banks of the Schuylkill River came to be planted in the great French gardens.

After his appointment in 1765 as "King's botanist," John Bartram was granted a salary of fifty pounds a year and a commission to explore Georgia and Florida to gather rare plants. By then he was sixty-five years of age, but by the side of this forest giant was a sapling—his brilliant young son. Years later William was to acquire his own fame as author of the classic American book *Travels Through North and South Carolina, Georgia . . . ,* which became a best seller in France as well as in America.

John Bartram's journal is as refreshing today as when it was penned over two hundred years ago. Consider this, one of the last entries that he made:

Fine warm morning. Birds singing, fish jumping and turkeys gobbling.

This delicate drawing of the nymphaea plant was made by William Bartram and illustrates the detail of his remarkable drawings.

18 At Home

Il est d'étranges soirs où les fleurs ont une âme.

There are strange evenings when the flowers have a soul.

—*Albert Samain (1858–1900)*

Flowers in every form and shape are one of the simplest ways of bringing life and color into the home. There is a very easy way to prove this. Take an empty room with four white walls and ceiling. Place a plain container holding a bunch of flowers anywhere you like in it. The eye immediately settles on this patch of color. The room is no longer empty. You can move the vase around to give different perspectives but the effect is always the same. The room has life.

Ludwig Mies van der Rohe, the German architect-aesthete who emigrated to America in 1937, said, "white is my favorite color," but this of course is the architectural purist's view. We respond to colors. Everyone does, even if sometimes unconsciously, and there are certain colors that we feel better with.

When people are decorating restaurants they often use red or orange because it excites the appetite. They are warm, cozy, congenial colors. Recently I went into a dining room in London, modern and attractive in its way, but the owners had used a purple

The Chinese covered their walls with paper until their rooms looked like enchanted gardens. This very early paper of the eighteenth century has a pattern of peonies, roses, and blossoms to entice the birds.

One of my most ambitious needlework projects was this waistcoat in petit point that I embroidered for my husband. Sprigs of flowers on a claret-colored background.

color scheme—and it was a lifeless purple. It put a dreary note into everything. I did not enjoy my meal surrounded by this sad color. It was disturbing and it felt a little sinister. I like the clean, fresh colors that make food look even more appetizing. The flowers should also be in clean, tempting colors. Unless mauve and purple are used with great skill—and it can be done—I feel that they are not suitable colors to enhance food.

For bedrooms I find that blues and greens are very restful and soothing. I once had a bedroom in pink and soft apple green, and it was an easy room to live in. For decoration a spray of green leaves picked on a walk was just as effective as a bowl of pink roses bought from the florist.

I like yellow, too. I think it is a bright and happy color to live with. I did my children's nursery in pale yellow and it was always warm and cheerful.

In my bedroom in the palace there are four panels, taken

from an eighteenth-century silk screen, that have butterflies, birds, and flowers on them. In a bedroom I once had in Paris I used a green trellis on beige walls and a flower-motif chintz for the curtains and bedspread. Inspired by something that Cecil Beaton had done, I made the lampstands myself. I made a column of chicken wire, covering it with flowers made from crepe paper and tissue paper in all the colors of the chintz. The flowers were mostly carnations, because these are easiest to make, but there were also buttercups, sweet peas, and poppies. For the poppies I found little seed heads that made pretty centers, so I just glued them in. The result was that the bedroom looked like a garden.

For parties I often cover the dinner table with a cloth of pink, green, or yellow that reaches the floor. On top of this I have a cream-colored lace tablecloth and match the flowers to whatever petticoat the table is wearing that day.

I enjoy all embroidery and often do needlepoint, which I carry with me on trains, planes, and to the hairdresser's. My most ambitious project was probably the waistcoat I did for my hus-

In America we have some very fine embroiderers who have brought a new feeling of color and skill to this absorbing craft. Each year members of the Needlepoint Guild of America come to Monaco to meet and exchange ideas. This colorful piece of embroidery by Joanne Alford is called "Gallardo Garden" and was one of the exhibits in the 1978 Needle Expressions arranged by the National Standards Council of American Embroiderers. The coloring and texture give it an almost three-dimensional effect.

Much of our modern American embroidery is inspired by embroidery in England. Crewelwork, much favored now in this country, reached high quality in seventeenth-century England. This delicate flower work on fine linen is typical of the period.

band—an old-fashioned and traditional pattern, a background of red petit point sprinkled with tiny sprigs of multicolored flowers.

Both my daughters are interested in embroidery. Stephanie recently made me a little patchwork cushion from one-inch squares. And that takes patience when you are twelve! Caroline has been making a petit point footstool with an eighteenth-century flower design.

Each year members of the Needlepoint Guild of America come to Monaco at the beginning of May. This guild was founded in Charlotte, North Carolina, and now has members all over America. They share their original and interesting ideas and have collaborated on some wonderful and ambitious projects, the most important being the peace rug that was presented to the United Nations in New York, consisting of individual squares representing the official seals of each country. It is a remarkable piece of work done with skill and love.

American embroidery has always been influenced by English traditions. Crewelwork, which is much in favor in America now, was at its peak in England during the seventeenth century. It was used for bed hangings in preference to canvas or applied work. The patterns were sent by the East India Company to China and India to be copied, and the result is often seen in the way the flowers and foliage were given an exotic Eastern touch. The bold designs had a strong influence on early American needlework, with scallops, scrolls, bold plant forms, and delicate flowers. Some of the East Indian pattern books did find their way to America in the trunks of the early settlers, but in the main the settler needlewomen had to rely on their own imaginations. Though they did copy stitches from Europe—crewel, cross-stitch, petit point—they also invented their own.

One of the fascinating aspects of this early American embroidery was the subtle dyes that were used. The Old Slater Mill in Pawtucket, Rhode Island, is now a museum where forty species

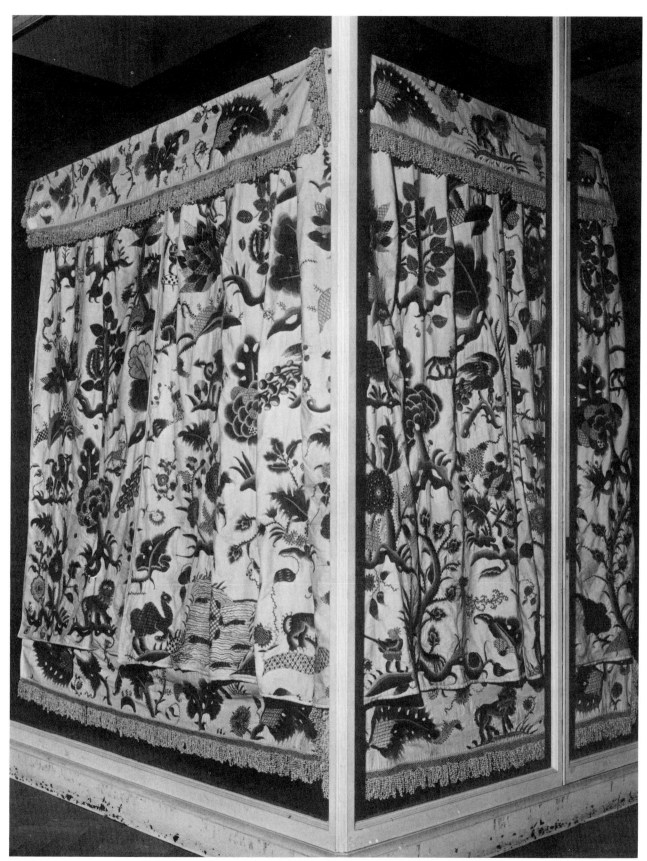

Late-seventeenth-century English bed hangings embroidered in wool and cotton. I wonder how long it took Abigael Petts to make this labor of love.

This is another fine example of seventeenth-century English embroidery. The background of the jacket is linen, and it is worked with flowers in black silk, using speckling stem braid and backstitch.

of plants are shown from which dyes were made. Yellows and dark browns came from the black walnut, golden brown from the chestnut oak, green from hickory, and a wide range of shades from turkey red to flamingo pink from the madder vine. The sumac produced gray and the petals of the poppy were used as a source of crimson.

A day at the American Museum, at Claverton Manor near Bath, England, is a joyous experience. Here they have one of the finest collections of patchwork and embroidered quilts outside of America. Some of the brides made as many as seventeen quilts, including their bridal one, during their lifetimes, occasionally taking up to two years to complete. The party tablecloths are whimsical works of art, with flowers, bees, insects, and little woodland animals.

I like complementing the flowers on our embroidered tablecloths with the flowers on the table and in the porcelain. When my husband and I went to Italy on a state visit, I remember being so impressed when I saw the table decorated with flowers that exactly matched the Meissen china. It was very beautiful. Embroidered flowers as well as fresh ones fill one's house with brightness.

One of the most delicate and beautiful porcelain patterns is

This adorable multiflowered sampler was sewn in 1776 by Lucy Symonds, age eleven years, in England. Not only is it beautifully worked, but so is its piquant message: "Sweetly blooms the rose of May, glittering with the tears of morn, so insidious smiles betray while they hide the treacherous thorn."

At Luton Hoo, Bedfordshire, England, the home of the late Zia Wernher, elder daughter of the Grand Duke Mikailovitch, is a very fine collection of Fabergé objects, including these enchanting flowers.

the famous Flora Danica from Denmark. The story of how this exquisite dinner service came to be made is an entrancing one.

In 1768, Johann Christoph Bayer was invited by the Royal Copenhagen Porcelain Factory to make a series of botanical engravings of the flowers of Denmark. It was a gigantic task, as he himself made the overwhelming majority of the floral decorations on the 1,802 individual pieces of the service. Only when his eyesight began to fail did he accept any assistance. He demanded slavish hand copying of his designs, so much so that the skilled painters attached to the factory refused to do this fine work. Experts can detect the slight variation in the patterns, which makes them more personal, I think. The original set, it is thought, was ordered by King Christian VII as a gift to Catherine II, Empress of Russia, but she died before it was completed.

The British Royal Family has an impressive collection that stems from a dinner service of 725 pieces, given by a group of Danish ladies to Princess Alexandra on her marriage to the Prince of Wales, later King Edward VII. It is now kept at Sandringham Palace, the Queen's personal residence.

Down through the years many other porcelain factories, such as Sèvres, Meissen, Royal Worcester, Spode, and Wedgwood, have specialized in flower decorations. Sèvres, which was owned by

Though papier mâché was invented in the mid-eighteenth century, it was the Victorians who found so many uses for it. Not only did they make all kinds of decorative objects, but it is recorded that one man built a papier mâché house! The material lent itself to the making of pretty bric-a-brac such as this flower-decorated work box (right). Sculptured flowers have always been a favorite with designers through the ages. This sunflower made in wrought iron was designed by Jekyll for Barnard and Bishop, the English metal foundry, in 1876 (below).

King Louis XV, was able to employ the greatest artists of the time, including François Boucher.

One of the most enchanting flower-decorated services was created by Royal Worcester in 1760. It is formed of raised leaves and rosebuds with a playful butterfly. The set was originally called "The Blind Earl," and its story is a poignant one.

The original "Blind Earl" was the Earl of Coventry, a great lover of porcelain, who lost his sight as a result of a hunting accident. No longer able to see, he ordered from Worcester a flower pattern that he could feel . . . a form of Braille in procelain. Each night at dinner he used to run his fingers over the pattern of rosebuds and leaves. The result is a plate of exceptional charm that is still produced by Royal Worcester.

Among the more recent flower designs is one done by my friend Fleur Cowles for Denby-Limoges. Fleur is a specially talented woman successful at whatever she does—writing, editing, painting, and being a hostess. Her passion for nature can be clearly seen in her paintings, which are peopled not only with overgrown flowers but with birds and beasts, all set in dream-like jungle sequences. Though she lives in England and Spain, her paintings are exhibited in galleries and museums all over the world.

Her design for porcelain was chosen by Limoges from one of these paintings. It is aptly called *Jardin des Fleurs* and is typical of her wistful, delicate flowers and butterflies.

In the eighteenth century, when houses were dark and winters even darker, flowers came into the houses of the rich in many fascinating ways, including decorations on their furniture. Apart from flower-painted furniture, which reached its peak of beauty in France, floral marquetry swept through Europe. It required a great deal of skill and patience, but as these were the craftsmen's prerogatives in those leisurely days, many extremely beautiful

This charming chiffchaff cock on hogsweed is another porcelain design by Dorothy Doughty for Royal Worcester. This was made in 1965, also in a limited edition of 500.

*These remarkably delicate gorse flowers were designed by Dorothy Doughty in 1968
and made in Royal Worcester porcelain in a limited edition of 500.*

The Flora Danica dinner service was created in 1768 when the Royal Copenhagen Porcelain Factory invited Johann Christoph Bayer to make a series of botanical engravings of the flowers of Denmark. The original dinner service, it is thought, was ordered by King Christian VII as a gift to Catherine II, Empress of Russia.

pieces were made that still exist today.

In the palace at Monaco we have a fine example of the skill of the marquetry craftsman in twin cupboards that I found in Beaulieu, in which we now show pieces of porcelain.

The woods most favored in marquetry were the fuchsia, locust, berberry, holly, acacia, brazil, pine, rosewood, and cherry. The technique was immensely painstaking. The design of flowers was first drawn on paper, then pricked through several layers to make the necessary copies. The layers of veneer to be used for the pattern were held together, sheets of paper in between, and the paper bearing the design was then pasted on top. The whole

This porcelain cup and saucer, which were made by the Frankenthal factory between 1756 and 1759, were clearly inspired by Chinese designs of that period.

thing was gripped in the "chops" of a "donkey," the terms given to the marquetry cutter's vise and bench. The craftsmen then cut along the lines with a fine frame saw. Details such as the veins of leaves or stamens of flowers were made with saw cuts through the veneers. Portions of leaves were shaded by dipping the veneer into hot sand. The whole thing was finally glued together by passing heat through the veneers, which liquefied the glue under the marquetry to harden.

Floral shellwork came into its own in the eighteenth century. It became the fashion to create whimsical grottoes with fish, animal, and flower designs. Fortunes in time and money were spent

When the Earl of Coventry became blind through a hunting accident in the mid-eighteenth century, he ordered a dinner service with raised flowers from Royal Worcester so that he could feel the pattern. The factory designed this service and called it "The Blind Earl," which is still made today.

Floral shellwork came into its own in the eighteenth century as a form of decoration in the home. This striking basket of shell flowers includes snowdrop, carnation, ranuncula, auricula, jasmine, tulip, and honeysuckle, all happily used together.

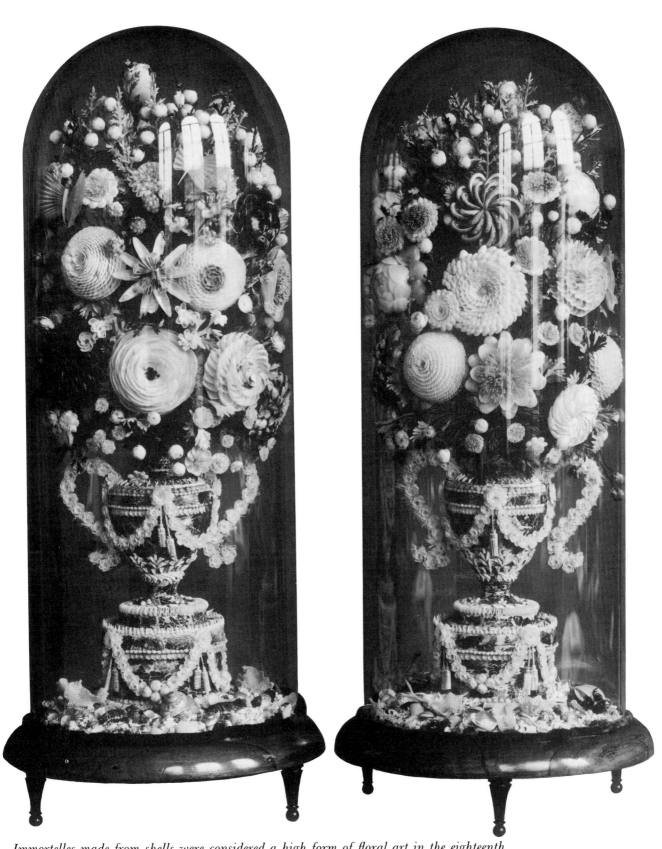

Immortelles made from shells were considered a high form of floral art in the eighteenth century. The flowers took infinite patience to arrange, and surprisingly the colors are as fresh today as when the designs were first made. This elaborate pair belonged to Queen Mary, who had a considerable collection of shell flower objects.

creating these curious and fantastic follies.

On a smaller scale, the ladies of the house made *immortelles* of flowers from shells, grasses, and even colored wools. Some became amazingly clever at it. Boswell, in his *Journal of a Tour to the Hebrides*, wrote:

> *Dr. Johnson said of Miss McLean. "She is the most accomplished lady I found in the Highlands. She knows French, musick and drawing, sews neatly, makes shell work and can milk cows. In short she can do everything."*

It was also during the mid-eighteenth century that *papier mâché* was invented, a splendid foil for flower artistry. Although formed of French words, the craft is, in fact, of English origin. The art consisted of creating objects from pulped paper mixed with a binding agent. When they were dried they were painted with flowers or romantic scenes and often inlaid with mother of pearl.

In its heyday the craze reached such hysteria that not only were small objects made, such as mirror frames, tea caddies, watch cases, letter racks, snuffboxes, and trays, but also chairs, tables, and beds. Special techniques were developed, which included japanning, painting, gilding, applying mother of pearl, inlaying,

A fine piece of marquetry work is on the sides of a nineteenth-century cupboard in which a collection of china is kept in the palace of Monaco (left). This fine example of stone inlay decorates a chest that stands in the state apartments in the palace of Monaco. I like the balance and simplicity of the flower arrangements (right).

gem laying, and marbling. Many of the finest examples can be found today in the Victoria and Albert Museum in London. Queen Mary had a remarkable collection of flower-painted *papier mâché* bric-a-brac that had been made in the Birmingham area, the center of the trade at that time.

Even leather screens were used as a background for bringing flowers into the house. The Dutch were probably the world masters in this art at the end of the seventeenth century, when they created ravishingly lovely painted screens covered with flowers and birds, which were used in the drafty houses of the period. The Spanish were also famous for their wall hangings and still do exquisite leatherwork at Córdoba.

Later it became the fashion to have fire screens decorated with flowers and grasses. These reached their opulence during the Victorian era.

I do think that the draftproof screen is a much forgotten piece of furniture. For my exhibition of pressed flowers in Paris I made a large screen of three panels covered in shantung and decorated with fatsia leaves and clematis. It was great fun to make.

As you see, flowers in every form, shape, and color in the house can bring personality and individuality to our daily lives.

APPENDIXES

1

A List of Plants for a Scented Garden

In Chapter 7, I mention the flower garden in Vienna that was made especially for the blind. The director has kindly supplied a list of plants that have been found to be most suitable for this kind of garden.

Aster dumosus
Armeria maritima
Campanula carpatica
Campanula glomerata
Convallaria majalis
Cotoneaster horizontalis
Dianthus plumarius
Echinops ritro
Erica carnea

Euonymus fortunei
 var. radicans
Festuca ovina var. glauca
Geum coccineum
Hosta fortunei
Iberis sempervirens
Iris germanica Barbate—
 Media Cruppe
Kniphofia pumila
Lonicera pileata

Monarda dydima
Nepeta mussinii
Origanum vulgari
Picea nidiformis
Pinus montana
Primula pubescens
Prunella grandiflora
Rosa rouletti
Rudbeckia fulgida
 var. Speciosa

Santolina
 chamaecyparissus
Sedum kamtschaticum
Sedum spectabile
Sedum spurium
Stachys lanata
Veronica incana
Yucca flaccida

2

Flowers in Names

"What's in a name? That which we call a rose/ By any other name would smell as sweet," so wrote William Shakespeare. I have always liked the custom of giving flower names to baby girls. And strangely enough many little girls grow up into women astonishingly like their names. For instance Mrs. Rose Kennedy has the regal bearing of a proud rose. Within her family Queen Margrethe of Denmark is called Daisy. In England, Princess Margaret was known by the pretty name of Margaret-Rose until she became a teen-ager and asked to be called Margaret only. In the family of the French President, Valéry Giscard d'Estaing, all the women have been given flower names. There is Anne-Aymone (Madame Giscard d'Estaing), and her sisters Rosamée and Marguerite, and daughters Valériane and Jacinthe.

In America, since the days of the early settlers, flower names have been popular. How inspiring to be christened Rose of Sharon! Here are several names that come to mind:

Poppy	Heather	Fleur	Jasmine	Mignonette	Primrose
Cherry	Iris	Daisy	Olive	Gardenia	Hortensia
Hyacinth	Magnolia	Honeysuckle	Hibiscus	Ginger	Honesty
Rose	Orchid	Daphne	Veronica	Delphinium	Cinnamon
Buttercup	Pansy	Chrysanthemum	Rosemary	Tulip	Fern
Rose of Sharon	Lily	Holly	Marigold	Petunia	Narcissus
Dahlia	Violet				

In French, flower names sound even more romantic:

Marguerite	Lili	Gentiane	Capucine	Camélia	Véronique
Anémone	Bouton d'or	Aubépine	Fleur	Dahlia	Primavère
Jacinthe	Daphne	Pétunia	Rose	Iris	Hortense
Violette	Fuchsia	Marjolaine	Narcisse	Olive	Eugénie
Flore	Magnolia	Valériane	Jasmine	Églantine	Eulalia

The Flower Emblems of America, Great Britain and Ireland, and France

As yet the United States has no national flower, though on looking back over old records, I find that in a poll taken in 1889 the goldenrod was generally favored because "it blooms everywhere and brightens the fall months with liberal plume-like flowers." In 1929 the America Nature Association held its own poll among 1,067,676 members, who chose the wild rose, which won in every state except Colorado, Florida, Illinois, Minnesota, Massachusetts, Vermont, and Washington. Since then every state has chosen its own flower. The selection was made in various ways, some by state legislatures, others through women's clubs, and in West Virginia in 1902 the schoolchildren made the choice of the rhododendron (*Rhododendron maximum*) "because of its bright colors." In 1908 the children of Wisconsin voted for the violet as their state flower. It is interesting that three other states selected the violet (Illinois, New Jersey, and Rhode Island). Michigan and Arkansas chose the apple blossom, and the goldenrod was selected by Kentucky and Nebraska. The Southern belles of Louisiana and Mississippi chose the magnolia, and Washington and West Virginia have both adopted the rhododendron. The rose was chosen by the District of Columbia and three states—Iowa, New York, and North Dakota. Here is the full list:

Alabama	camellia	Montana	bitterroot
Alaska	forget-me-not	Nebraska	goldenrod
Arizona	saguaro	Nevada	sagebrush
Arkansas	apple blossom	New Hampshire	lilac
California	poppy	New Jersey	violet
Colorado	columbine	New Mexico	yucca
Connecticut	mountain laurel	New York	rose
Delaware	peach blossom	North Carolina	dogwood
District of Columbia	American beauty rose	North Dakota	wild rose
Florida	orange blossom	Ohio	carnation
Georgia	Cherokee rose	Oklahoma	mistletoe
Hawaii	hibiscus	Oregon	Oregon grape
Idaho	syringa	Pennsylvania	mountain laurel
Illinois	violet	Rhode Island	violet
Indiana	peony	South Carolina	Carolina jessamine
Iowa	wild rose	South Dakota	pasqueflower
Kansas	sunflower	Tennessee	iris
Kentucky	goldenrod	Texas	bluebonnet
Louisiana	magnolia	Utah	sego lily
Maine	pine cone and tassel	Vermont	red clover
Maryland	black-eyed susan	Virginia	dogwood
Massachusetts	mayflower	Washington	rhododendron
Michigan	apple blossom	West Virginia	rhododendron
Minnesota	lady's-slipper	Wisconsin	violet
Mississippi	magnolia	Wyoming	Indian paintbrush
Missouri	hawthorn		

The Flower Emblems of Great Britain and Ireland

England	rose	Scotland	thistle
Ireland	shamrock	Wales	daffodil

The Flower Emblem of France

Fleur-de-lis

Flowers for Birthdays

Did you know that certain flowers symbolize the months of the year? If you know them, they make the giving of birthday bouquets a much more personal gift. Here is a list that also includes birthstones.

Januarysnowdrop, carnation—garnet
Februaryprimrose, violet—amethyst
Marchjonquil, daffodil—bloodstone or aquamarine
Aprildaisy, sweet pea—diamond
Mayhawthorn, lily-of-the-valley— emerald or carnelian
Junehoneysuckle, rose—agate or pearl
Julywater lily, larkspur—ruby or onyx
Augustpoppy, gladiolus—sardonyx, peridot
Septembermorning glory, aster—sapphire
Octobercalendula, cosmos—opal or tourmaline
Novemberchrysanthemum—topaz
Decemberholly poinsettia—turquoise or zircon

Suggested Books for Reading

Art of Flower Arrangement, The, Beverley Nicholl
Art of Flower Arranging, The, Marian Aaronson
Bouquets des quatre saisons, Bataille and Bries
Complete Flower Arranger, The, Amalie Adler Ascher
Composizioni e fiori, Luigia Pittaluga
Constance Spry Encyclopaedia of Flower Arranging
Dictionary of Garden Plants, Roy Hay and Patrick M. Synge
English Traditional Customs, Christine Hole
Floral Symbolism of the Great Masters, Elizabeth Haig
Flower Arrangement in Colour, Betty Massingham
Flower Arrangements and Their Setting, George Smith
Flower Paintings Through Four Centuries, Maurice H. Grant
Flowers and Flower Lore (3 volumes), H. Friend
Flowers and Their Histories, Alice M. Coats
Flowers Through the Ages, Gabriele Tergit
For a Flower Album, Colette
Fun with Flowers, Julia Clements
Garden of Herbs, A, Eleanor Sinclair Rohde
Hall's Dictionary of Subjects and Symbols in Art, James Hall
Herball or General Historie of Plantes, John Gerard
Herbs and the Fragrant Garden, Margaret Brownlow
Herbs for Health and Cookery, Claire Loewenfield and Philipps Back
Art des fleurs en Europe, L', Laurence Buffet-Challie
Jardin dans la maison, Le, Reine Chabeau
Making Your Own Pot Pourri, Culpeper
New World of Flower Arrangement, Patricia Kroh
Oxford Book of Wild Flowers, B. E. Nicholson, S. Ary, and M. Gregory
Picture Book of Flower Arrangement, Violet Stevenson
Pomanders, Washballs and Other Scented Articles, Ivan Day, The Herb Society (England)
Pressed Flower Pictures, Pamela McDowell
Pressed Flower Pictures, Ruth Voorhus Booke
Rose Garden, The, William Paul Simpkin
Rose upon the Briar, The, Helen Temperley
Royal Heritage, J. H. Plump and Huw Wheldon
Shakespeare Flora, L. H. Grindon
Shakespeare Flowers, Jessica Kerr
Species of Eternity, A, Joseph Kastner
State Names, Flags, Seals, Songs, Birds, Flowers and Other Symbols, George Shankle

INDEX

PHOTO CREDITS

Alinari/Editorial Photocolor Archives, 141; Bettmann Archive, 9, 84, 92, 95, 164, 166, 171, 175, 176; Courtesy of *Brides*, Copyright © 1976, 1977, 1978, 1979 by the Condé Nast Publications, Inc., 180; Courtesy of the Trustees of the British Museum, 146, 147, 192, 194, 197, 199; The Brooklyn Museum/Charles Edwin Wilbour Fund, 91; Church of San Trinità in Florence/European Art Color, 138; John Clark Agency, 138; Julia Clements, 25; Howell Conant, 12, 26, 28, 31, 32, 39, 40, 43, 44, 45, 48, 49, 50, 51, 52, 53, 54, 55, 56, 57, 190; Culver Pictures, Inc., 98; Denison Pequotsepos Nature Center, 76; Photo Detaille S.A., 19; By Permission of Her Majesty Queen Elizabeth II, 182; Mary Evans Picture Library, 114, 184; Folger Shakespeare Library, 148, 159; Klaas de Jong, 17; Studio Laverton, 107, 108; The Library, Les Cèdres, 34, 37; Library of the Royal Danish Porcelain Company, 212; Luton Hoo Library, 208; Library of the New York Botanical Garden, Bronx, New York, 69 (Allen Rokach), 80, 112, 113; George Lukomski, 42; Raymond Mander and Joe Mitchenson Theatre Collection, 172, 179; The Metropolitan Museum of Art, 134; Madame Meilland, 2, 3, 11; National History Museum, 111; National Standards Council of American Embroiderers, 203; New York Public Library Picture Collection, 14, 61, 64, 78, 136, 137, 160, 162; Helmut Partaj, 79; Radio Times Hutton Library, 185, 187, 189; Royal Worcester Library, 82, 210, 211; Scottish National Gallery, 103; George Smith, 20; Olga Stewart, 116, 117, 118, 119, 120, 121, 122, 123, 124, 125, 126, 127, 129, 130, 131, 132, 133; Sunday Times Library, 186; U.P.I., 8; Jean Claude Varga, 101; Victoria and Albert Museum, 62, 87, 145, 200, 204, 205, 206, 207, 209, 213, 214, 215; Madame Josiane Woolf, 128

WITH SPECIAL THANKS TO OLGA STEWART FOR HER ILLUSTRATIONS, AND TO HOWELL CONANT FOR HIS PHOTOGRAPHS